The Prints of the Pont~Aven School

Gauguin & His Circle in Brittany

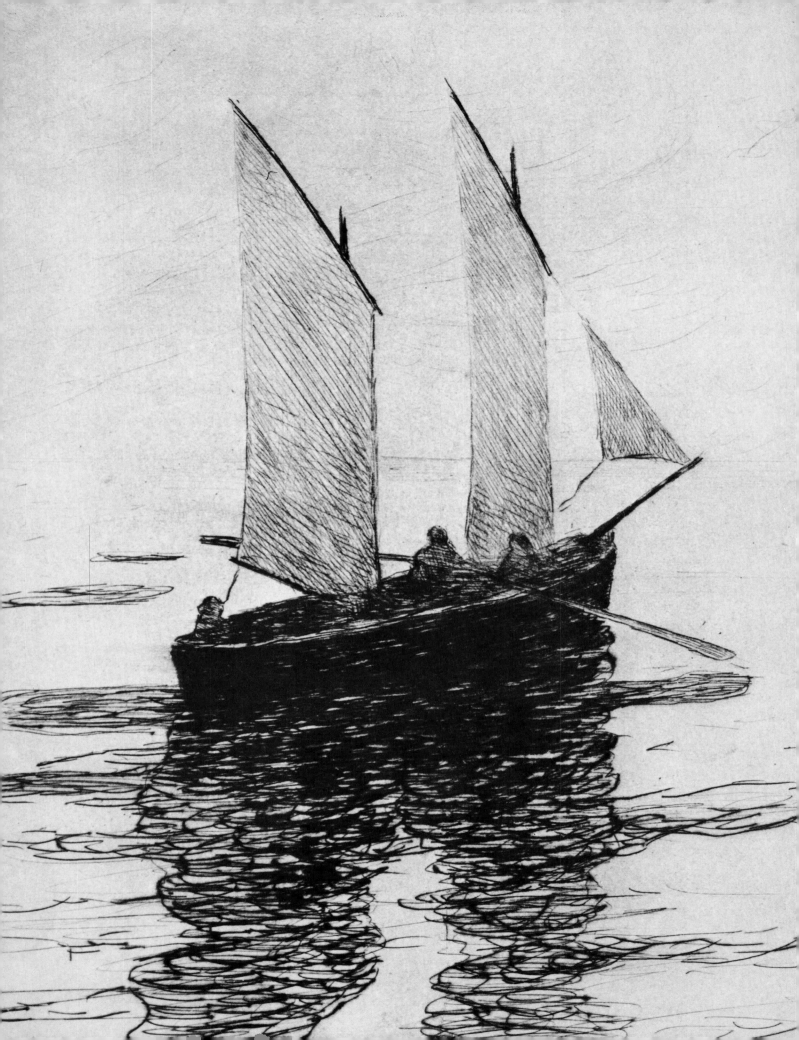

The Prints of the Pont-Aven School

Gauguin & His Circle in Brittany

Caroline Boyle-Turner

in collaboration with
Samuel Josefowitz

Foreword by
Douglas Druick

Abbeville Press • Publishers • New York

This catalogue accompanies the exhibition **"The Prints of the Pont-Aven School: Gauguin and His Circle in Brittany,"** which is traveling to the following museums from 1986 through 1989:

> Rijksmuseum Vincent van Gogh, Amsterdam
> The Phillips Collection, Washington, D.C.
> Detroit Institute of Arts, Michigan
> Art Gallery of Ontario, Toronto
> Museum of Modern Art, New York City
> Cleveland Museum of Art, Ohio
> Museum of Fine Arts, Boston
> Museum of Fine Arts, Houston
> Fine Arts Museums of San Francisco
> Art Institute of Chicago
> Royal Academy of Arts, London
>
> Smithsonian Institution Traveling Exhibition Service, Washington, D.C.

Cover
> Armand Seguin
> *Breton Woman from Pont-Aven,* c. 1896

Frontispiece
> Maxime Maufra
> *Fishing Boat,* 1894

LIBRARY OF CONGRESS CATALOGING IN PUBLICATION DATA

Boyle-Turner, Caroline
 The prints of the Pont-Aven School.

 Bibliography: p.
 1. Pont-Aven school—Exhibitions. 2. Gauguin, Paul, 1848–1905—Influence—Exhibitions. 3. Prints, French—Exhibitions. 4. Prints—19th century—France—Exhibitions. I. Josefowitz, Samuel, 1921–. II. Druick, Douglas, 1945–. III. Title. NE647.6.P58B69 1986 769.944'11 86-15465 ISBN 0-89659-742-3 (hardcover)

First hardcover edition

ILLUSTRATION CREDITS

Illus. 2a—Coll. Boyle-Turner, photo N.D. Roger-Viollet; *Illus. 2b and 2c*—Coll. Boyle-Turner; *Illus. 4 and 11*—Private collection, St. Germain-en-Laye; *Illus. 3a*—Coll. Ira and Virginia Jackson, photo Paul Hester; *Illus. 3b, 3c, 5, 6, 10, 13, 14, 15, 17*—Coll. J.; *Illus. 7, 8, 12*—Bibliothèque d'Art et d'Archéologie, Fondation Doucet, Paris; *Illus. 9*—Rijksmuseum Vincent van Gogh, Amsterdam; *Illus. 16*—Private collection, photo Malcolm Varon; *Illus. 18*—Private collection; *Illus. 19*—Tate Gallery, London; *Illus. 20 and 21*—The British Museum, London; *Illus. 22*—Kornfeld Collection, Bern.

CONTENTS

AUTHOR'S PREFACE

It is a pleasure to be able to present a large group of intriguing and beautiful works that have remained largely unknown to the public for many years. This study is by no means intended to be a catalogue raisonné of the prints made by the artists of the Circle of Pont-Aven, but is an attempt to show a representative selection of the printmaking activities of these artists from approximately 1888 to 1895.

It is hoped that this work will stimulate further research, not only in the techniques used by the Pont-Aven artists themselves, but also in the way their printmaking influenced the efforts of artists in other media. The influence of the paintings by the artists of the Pont-Aven Circle on artists of later periods, such as Henri Matisse, André Derain, Roger de la Fresnaye, and many others is by now well recognized. We believe that the prints made by these artists also had an important influence beyond their circle. To date, however, no in depth studies of such influences have been undertaken to our knowledge.

The help that I have received in the research and organization of this study has been invaluable. Without Samuel Josefowitz's generosity, encouragement and help, it would have been impossible. Sincere thanks also go to the numerous people in Europe and America who opened their collections and libraries to me, or helped with advice and the unearthing of facts. I would like to thank the following in particular: Judy Adam, Jean Adhémar, Marie-Amélie Anquetil, René le Bihan, M. et Mme Arsène Bonafous-Murat, Pierre Courtin, Priscilla England, Richard S. Field, Jane Glaubinger, Sinclair Hitchings, Colta Ives, Virginia Jackson, Roy Johnston, Eberhard Kornfeld, Paul MacGuire, Elizabeth Mongan, Daniel Morane, Jules Paressant, M. et Mme Paul Prouté, Catherine Puget, Pietro Sarto, Barbara Shapiro, P. le Toer, and Françoise Woimant.

Helpful editing was provided by Irena Hoare and Nancy Eickel. The conservation work was meticulously performed by Carolyn Horton. The staff of the Smithsonian Institution Traveling Exhibition Service is also to be thanked for its help and organizational work. This publication is dedicated to both Sam and Meg, who, each in their own way, made this project possible.

Caroline Boyle-Turner
March, 1986

NOTES TO THE CATALOGUE

This work is organized by individual artists, with their prints studied in approximately chronological order. Each print is indicated by a letter refering to the artist (e.g. "G" for Gauguin and "SR" for Sérusier) followed by a number.

The French titles are those by which the prints are commonly known. They are not necessarily titles designated by the artist himself. Since most of these prints were never published, the titles are often those assigned by dealers, collectors, or auctioneers. For a number of prints, the author had to designate titles when none were previously known. The English translations of the titles are by the author.

Dimensions are given in millimeters. Height precedes width. Every effort was made to record not only plate marks when discernible, but also the size of the image and the paper upon which the work appears. Unless otherwise indicated, each work is printed in black.

The reproductions show only the image of each print and do not attempt to show the entire sheet. Signatures, signature stamps, collector's marks and previous owners are not always identified in the catalogue.

Frequently cited sources are abbreviated in the text and footnotes. The references for the abbreviations are given in bold type in the bibliography, p. 142.

Foreword

BY DOUGLAS DRUICK

The prints made by Gauguin and his circle in Brittany during the period 1889–1894 constitute a loosely coherent body of works that can be meaningfully studied as an isolated phenomenon in the history of printmaking. Yet the motivations which led Gauguin and the other artists in this exhibition to begin making prints must be seen in the larger context of the French print revival of the 1890s. Their attitudes towards the various print media, as well as their exploration of print techniques and the uses to which they put them are an aspect of a broader contemporary renaissance of the decorative arts in France that undermined the traditional notions of the hierarchy of the arts. The young artists of the period – including Gauguin and his circle in Brittany – showed a readiness to work in media then deemed minor or the province of the artisan; this indeed included the print media.[1]

The works that signalled the beginning of Pont-Aven printmaking were the albums of "lithographs" made by Gauguin and Emile Bernard from zinc plates, so called zincographs, and that were listed as *visible sur demande* (visible upon request) in the catalogue of the independent group exhibition organized by Gauguin and his friend, Claude-Emile Schuffenecker that opened in June 1889 at the Café Volpini on the grounds of the Paris Universal Exhibition. The conception, subject matter, medium, and manner of publication of these prints reflect the general climate in which a widespread print revival was currently taking shape. These zincographs were, moreover, a major early source of dissemination of the Pont-Aven-Synthetist style; and they anticipated the concerns that would inform the printmaking activities of the Pont-Aven circle in the following years. Understanding why and how these albums came about is thus critical to understanding Pont-Aven printmaking and its place in the print revival of the *fin de siècle*.

The Volpini catalogue entry for the zincographs simply indicated an *album de Lithographies par Paul Gauguin et Emile Bernard*, thereby reinforcing the collaborative nature of the project. There were, in fact, two quite distinct albums: Bernard's *Bretonneries*, containing seven prints devoted to Breton subjects, and Gauguin's *Dessins lithographiques* (Lithographic Drawings), of eleven subjects treating Brittany, Arles, and Martinique. While Bernard's prints represented wholly new compositions, Gauguin's derived from earlier work in other media. Both Gauguin's and Bernard's albums were, however, the direct outgrowth of

earlier projects. In January of 1888 Bernard had written to Albert Aurier suggesting a publication that would include lithographs by such artists as himself, Gauguin, and Degas as well as poetry and prose.[2] Gauguin was pursuing this idea when he wrote to Vincent van Gogh the following October, shortly before joining him in Arles. In a letter now lost, he had suggested that once he, Bernard, and Laval were settled with Vincent in Arles, the four of them could work at night making lithographs that could be published periodically. Although Vincent himself had six years earlier entertained the idea of launching a lithographically illustrated periodical – as Gauguin must have known – he now reacted to his friend's "business" proposition with some scepticism and ambivalence.

> *"... You write about business, and talk of lithographs. This is ... what I think: For you, me, Bernard and Laval to make lithographs at night is all right... but I am not sure about their periodical publication so long as I am not better off... There is always something to spend money on in lithography even if you do not buy the stone.... for publishing, however modestly, the four of us would be in for at least 50 francs each... I have already had some experience with one attempt, ... besides... it would not last, and above all would never interest the public.*
> *Even if it did cost us money, I am actually all for making the lithographs in question. But as for publication... even free of cost – never. If it is at our expense and for our own pleasure and use, then I tell you again, I am for it. If you are thinking of something else, I am not for it".[3]*

Just as Gauguin had two years earlier begun making ceramics with a view to supplement his income,[4] so now his thoughts regarding lithography were largely motivated by his hope for publicity and financial gain. His reasons for seeing this potential in prints was in part determinded by his awareness of his friends current activity in the print world.

Gauguin's perception of prints as an effective means to disseminate an artist's ideas was undoubtedly enhanced by his friendship with Vincent and Theo van Gogh. Theo, the head of the Paris branch of Boussod et Valadon (formerly Goupil), had been regularly exhibiting Gauguin's work at the boulevard Montmartre gallery since 1887.[5] He shared Gauguin's great admiration of Degas and was then involved in issuing an album of lithographs by Georges-William Thornley after fifteen works by Degas in various media – a project in which Degas himself was closely involved.[6] Although the album did not appear until 1889, Theo exhibited several of its prints in the spring and again in the fall of 1888. On both occasions the lithographs attracted the attention of critic Félix Fénéon, who praised them lavishly in the pages of the *Revue indépendante,* – in one instance in the same review in which he expressed his belief in the importance of Gauguin's recent work.[7]

At roughly the same time Gauguin wrote to Vincent about his print project, another Boussod et Valadon publication was on his mind. He proposed to Theo an exchange of one of his own works for the series of reproductive prints after old

master drawings in the Louvre that were made by Degas friend Michel Manzi and issued by Theo's firm.[8] This appreciation of prints as effective vehicles for the transmission of an artist's ideas surfaced again a few months later while Gauguin was staying with Vincent in Arles. Vincent wrote to Theo, asking him to obtain some of the lithographs based on works by Delacroix that had been published decades earlier in the serial publication *Les artistes anciens et modernes* (1850–1862). Vincent wanted to have them at hand during the "electric" discussions on art he was then having with Gauguin.[9]

The prints produced by Thornley and Manzi, as well as those after Delacroix that Vincent requested were reproductive prints – prints made by professional print-makers after compositions by other artists. While reproductive printmaking was a time-honored practice, the 1880s saw a growing bias in favor of the wholly original print – the print in which the artist either translates one of his own compositions or uses the print media to invent new ones. This shift in attitude was the necessary prelude to the print revival of the following decade. A critical role in setting the stage was played by etcher Félix Bracquemond who, in 1886, had been instrumental in starting Gauguin on his career in ceramics. Two years later Bracquemond helped to found *L'Estampe Originale*, a society devoted to original printmaking. In May 1888 the society published under its name the first in a projected series of albums of prints by different artists and in a range of media. The album's critical and financial success[10] shaped Gauguin's original publishing ambitions both in suggesting that print publication might be professionally as well as financially profitable, and in focusing his attention on the new value accorded the artist's original print.

Gauguin's abortive stay with Vincent in Arles brought an end to his initial publishing ideas. However, two events within a month of his return to Paris from Arles in late December 1888 kept alive his ambition to make and publish lithographs. The first was the gift from Theo of an impression of *The Potato Eaters*, Vincent's lithograph of 1885. In early January, Gauguin informed Vincent how much he admired the "color" the latter had achieved in this "lithographed reproduction" after his painting (Rijksmuseum Vincent van Gogh, Amsterdam), and accorded it a place of honor in his studio.[11] The second event took place two weeks later, on January 23, when the first *Exposition de Peintres-Graveurs*, featuring prints by thirty-nine French and foreign artists, opened at Durand-Ruel's gallery on the rue Le Peletier. By revealing printmaking as the logical extension of the painter's and sculptor's art, this milestone exhibition aimed to dispel the belief in a hierarchy of media in which printmaking ranked inferior to painting. The participation of friends and artists Gauguin admired – Bracquemond, Degas, Camille Pissarro, Odilon Redon, and Auguste Rodin – combined with the considerable attention the exhibition received may have finally set Gauguins' resolve. Late in January 1889, he informed Vincent that "according to the counsel and under the auspices of your brother" Theo, he had "commenced a series of lithographs for publication in order to make myself known".[12]

Gauguin's zincographs, made along with Bernard's at Schuffenecker's house, were quite possibly all completed even before the plans had taken shape for the

group exhibition that was ultimately held at Volpini's cafe. As a compendium of his recent work, however, the album reflects the same eagerness to "be represented [publicly] in as big a way as possible" that led to the exhibition[13] with its accompanying poster and catalogue.

Illustrated with photomechanically prepared reproductions of drawings by Gauguin, Bernard, Schuffenecker and other participants, the catalogue – like the albums of zincographs – served as a major source of dissemination of the Pont-Aven style. Of these two sources, the catalogue was probably the more effective publicity for the style. The zincographs failed to attract the interest of either critics or collectors. Quite possibly they were seen by only a handful of people. Apparently pulled in an edition of fewer than fifty, the prints were only shown at the exhibition on request and did not benefit – despite what Gauguin implied to Vincent – from publication under the auspicies of an influential gallery such as Boussod et Valadon. The catalogues, by contrast, were more plentiful and were readily available at the exhibition. Moreover, the eight reproductions included in the catalogue reached a wider audience through their being reprinted in *Le Moderniste illustré,* the periodical Albert Aurier had recently founded.[14] Indeed, if Gauguin's sole aim had been to publicize his work, the new photomechanical printing technology of which both the Volpini catalogue and *Le Moderniste illustré* availed themselves would have better served his purpose than an album of lithographs. He was undoubtedly aware of this: since the late 1870s, illustrated periodicals such as *La Vie moderne* had demonstrated that relief plates photomechanically prepared from artists's drawings were increasingly more economical and effective for the popularization of imagery than were traditionally prepared print matrices. But it would seem that for Gauguin, as for many contemporary artists and critics, the advantages of the new technology were offset by serious drawbacks that made traditional printmaking still an attractive option.

Gauguin's ideas regarding the new versus the old means of printing images were influenced by the attitudes of his contemporaries; several of his close friends had strong views on the subject. Camille Pissarro, who was Gauguin's principal mentor from the late 1870s until the mid 1880s undoubtedly conveyed to him his "horror" of the photo-relief process used in *La Vie moderne,* while demonstrating by example his belief in the artistic importance and expressive potential of traditional printmaking.[15] Vincent too held strong feelings on this subject, and would have shared with Gauguin, as he had earlier with Theo, the aesthetic considerations that had led to his experimentation with lithography:

> "...much as I like those drawings... in <u>Vie moderne</u> still there is always something mechanical in them, something of the photograph or photogravure, and I prefer an ordinary lithograph by Daumier or Gavarni... I am afraid a new process is one of those things which cannot quite satisfy one, that it is in fact rather too smooth. I mean that an ordinary etching... woodengraving, or... lithograph has a charm of originality which cannot be replaced by anything mechanical."[16]

The convictions expressed by both Pissarro and Vincent were prophetic. The reawakening of interest in prints was partially a reaction against the great advances in photomechanical printing technology. Since the traditional print media were now threatened with obsolescence in the industry of image-making, their survival depended on a reevaluation of their *raison d'être*. In a general atmosphere of nostalgic regret for a simpler past, proponents of traditional printmaking techniques now emphasized the hand-crafted aspect of the printing matrix created directly by the artist's hand – the original print. They contrasted this with the machinemade reproduction, while promoting printmaking as integral to the painter's art. It was this bias that informed both the 1888 publication *L'Estampe Originale* and the first Peintres-Graveurs exhibition the following year. In his preface to the exhibition catalogue, print advocate Philippe Burty contrasted the "photographic print processes", the mere extension of Science for the purpose of "disseminating information", with the original print, which was, like all forms of Art, conceived "to make life germinate and bear fruit".[17] In the preface to *L'Estampe Originale*, critic Roger Marx had advanced a similar position, but with particular emphasis on the magical transformation involved in the creation of the original print:

> "It seems impossible to come across anything that attests so victoriously to the animating power of the human spirit: here is a fragment of stone, of wood or of copper; an artist comes along who in an instant makes this inert and lifeless matter palpitate, who gives it life and thought; useless yesterday, it now and forever reveals a character, reflects a temperament, discloses the very spirit of the printmaker".[18]

Marx's focus on the artistic transmutation of base materials underscored the fact, that in addition to being a leading voice of the print revival in France, he was also a major proponent of a revival of French decorative arts. He saw printmaking and the decorative arts as related. Both served to "democratize" art by penetrating the artificial barrier that separated it from daily life. The vitality of both depended on the willingness of talented artists to disregard the more recent distinction between the so-called "major" and "minor" arts in favor of a more ancient view of art as craft ennobled by genius. Gauguin's involvement in the decorative arts dated back to 1881, when he had carved a cupboard in wood; it was renewed in 1886 when he began to make ceramics.[19] His review of the ceramics shown at the Universal Exhibition published in *Le Moderniste illustré* at the time of the Volpini exhibition reveals how closely he shared Marx's attitude toward the notion of craft:

> "The ceramic art is not an idle pastime. In the most distant epochs of the past . . . one finds that art constantly in favor. God made man with a little mud. With a little mud one can make metals, . . . with a little mud and also a little genius! Now isn't the material most interesting? This doesn't stop nine out of ten educated people from passing by that section with extreme indifference. What would you have? There is nothing to say: they don't understand".[20]

Gauguin, however, clearly *could* understand prints and feel the attraction of printmaking in the spirit Roger Marx had evoked in his preface.

Gauguin's choice of a graphic medium like his interest in printmaking, was partially conditioned by contemporary developments. Since mid-century, the use of lithography as an adjunct of industry had made it less attractive than etching to artists, critics and amateurs. This bias was reflected in the *Peintres-Graveurs* exhibition of 1889. But during the 1880s, attitudes towards lithography had begun to change.[21] Vincent's interest in lithography – in part a response to the relative ease of execution afforded by recent improvements in transfer lithography – was symptomatic of this new perception.[22] So too were the prints Gauguin made in the early months of 1889. However, they were also a wholly personal response to current developments. In them we find a consonance between the artist's attitude toward printmaking and the views on craft and materials, that he clearly expressed in his article on ceramics as well as in his own ceramics and woodcarvings.

Gauguin's and Bernard's decision to do their lithographs on zinc plates rather than on the traditional Bavarian limestone could have been motivated by simple practical considerations: zinc plates were at once cheaper and more portable than lithographic stones. But the manner in which the two men worked – using both crayon and washes (*lavis*) – strongly suggests that the choice was as much aesthetic as pragmatic. Although zincography had been continually refined since the 1840s, it was still true that zinc plates were preferable to lithographic stones only when economy took precedence over artistic considerations.

L'Imprimerie, the leading French periodical devoted to the printing industry, noted in 1887 that "what best explains the inferiority" of impressions pulled from zinc plates, is the fact that "zinc is not as sensitive (*sensible*) as the [lithographic] stone"; for this reason, it was advisable to use the simplest means possible of drawing on the zinc plate.[23] The technique of working in lithographic washes – *lavis* – was extremely complex; while professional lithographers such as Achille Sirouy (1834–1904) and Paul Maurou (1848–1931) were beginning to favor it in the late 1880s, it was generally considered too technically demanding for the debutant painter-lithographer. In his influential *Traité de lithographie artistique* of 1893, the printer Duchatel advised the painter-lithographer against the technique: "almost everyone who has made zincographs has most often been disappointed with the results" since few plates print as anticipated.[24] To essay this technique on zinc further complicated an already complex procedure. Printmaker Félix Buhot – whose lithographic procedures, communicated by Theo, fascinated Vincent in 1882 – succinctly advised *"lavis* on zinc is almost impossible."[25]

Gauguin strongly believed that different materials have different expressive potentials. In his article on the ceramics shown at the Universal Exhibition, he stressed that the artist must work "in harmony with his material", and he exhorted artists to carefully study "this [fundamental] question of adaptation" of style to medium. "Plaster, marble, bronze, and fired clay" he continued, "ought not to be modeled in the same fashion, considering that each material has a different character of solidity, of hardness, of appearance."[26] Hence, in making lithographs on zinc

plates and employing the technique of *lavis* Gauguin – and Bernard – were not ignoring the common wisdom; rather they were making a very conscious choice. Zincography evidently appealed to them because of its perceived drawbacks. The coarse, grainy textures that it so naturally yielded – aspects that artistic lithography traditionally avoided – suited their purpose.

While Gauguin's love of craft can be viewed in the broader context of the anti-positivist sentiments voiced at the *fin de siècle,* his reaction against the new scientific and industrialized society was intensely personal. He loved Brittany because there he discovered a relatively "savage" and "primitive"[27] way of life which retained the simplicity and vestiges of a spiritual purity that had been forever lost in the sophisticated modern world. Similarly in the realm of the crafts, Gauguin preferred materials that evoke simplicity rather than sophistication, that seem naturally to abet expressive directness. Later he was to criticize some of Seguin's more technically complex etchings arguing that "the craft is too much in evidence" and calling for "more simplicity".[28] In his own prints of 1889, Gauguin sought a medium with inherent potential for ruggedly simple effects. The same interest had led Bernard the previous year, to make woodcuts, the earliest, most primitive form of print-making.

What Bernard and Gauguin now discovered and exploited in zincography was the possibility of achieving similarly bold effects with much greater ease than in woodcut. This association between the two media was reinforced by Bernard who, by handcoloring impressions of his zincographs, recalled at once the popular colored woodcuts of the fifteenth century as well as those still being produced at Epinal.[29] Gauguin too underlined the coarse effects he achieved on the zinc plates by having them printed on bright canary-yellow paper. His choice of paper has been linked to certain Japanese prints (see page 37). It must also be remembered that for the 1880 Impressionist exhibition, Pissarro had mounted his etchings on yellow paper and put them in violet frames. Gauguin's inspiration, however may, have come from a more popular source. The bold effect created by printing in black on yellow paper recalls the commercial posters that Emile Levy and others had printed on the same garish yellow paper in the 1870s and 1880s.

The zincographs of 1889 thus conformed to the ideology of the nascent print revival as outlined by Marx and Burty, while at the same time they deviated from it: the interest in craft was typical of the moment, but the choice and use of medium were not. Similarly, the zincographs equivocally shared in the aesthetic of the *belle épreuve,* a conceptual leitmotif of the print revival first advanced by Burty in 1875 and definitively restated in his *Peintres-Graveurs* preface of 1889. This concept of printmaking was part of the strategy employed to validate traditionally made prints, now that the new technology of photomechanical reproduction was rapidly usurping their role of disseminating imagery. It placed emphasis not on the multiplicity of impressions a single printing matrix could yield, but rather on the uniqueness and beauty of the individual impression. Critical to the realization of a *belle épreuve* were careful attention to both the inking of the matrix and its printing, as well as to the choice of papers used in the printing. Gauguin and Bernard rejected

the usual emphasis of preciousness and refinement that the concept naturally entailed; however their willingness to make impressions of their prints unique through handcoloring and their readiness to create matrices that would ultimately be printed in relatively small numbers can be seen in this context.

While Gauguin's zincographs failed to attract much attention at the time of the Volpini exhibition in 1889, they were known by his friends and, through them, may have been seen by some of those artists included here, who had not met Gauguin prior to his departure for Tahiti in April 1891. One can safely assume that the exhibition of these prints at the Galerie Boussod et Valadon in November 1891, eight months after Gauguin's departure for Tahiti, led to a broader awareness of them. Since Theo was no longer involved at the Gallery – he had left his position at the end of 1890 and had died in late January of 1891 – and since Boussod et Valadon had not published Gauguin's album of zincographs, it remains unclear why they were put on display. But it *is* clear that they caught the attention of a least one important critic – Camille Mauclair in the *Revue indépendante* – and were seen by many who would hitherto have been unfamiliar with them.[30]

For those artists who followed Gauguin's work, the public reappearance of these prints would have enhanced the recent image of Gauguin as painter-printmaker, fostered by his portrait of poet Stephane Mallarmé etched earlier that year. Perhaps inspired by Vincent's portrait of Dr. Gachet etched in 1890[31], that of Mallarmé – the only etching Gauguin was to produce – communicated an attitude towards printmaking consonant with the prints of 1889. The decision to limit the edition to roughly a dozen impressions printed on a variety of supports – including parchment and fine antique paper – reflects the values of the *belle épreuve;* the bold, coarse almost rough-hewn line, on the other hand, displays an approach to etching at odds with accepted notions of the graphic vocabulary suitable for Rembrandt's chosen medium.

By the end of 1891, the print revival was well underway, and each month there were new developments that reconfirmed its vitality. The events of that year included the third Peintres-Graveur exhibition, the retrospective Exposition générale de la lithographie, Degas return to lithography, as well as the first attempts in that medium by such artists as Forain and Toulouse-Lautrec. It was also a pivotal time for the artists of Gauguin's circle in Brittany who are represented in this exhibition. Robert Bevan had just recently begun etching, and Armand Seguin began working in the same medium under the tutelage of Henri Delavallée. Within a year both artists would begin experimenting with lithography, while Paul Sérusier, Roderic O'Conor, Maxime Maufra, and Cuno Amiet would have become peintres-graveurs.

The prints by these artists are products of the revival and testify to its general spirit. This is nowhere more clearly visible than in the fascicules of *L'Estampe Originale,* the quintessential publication of the period begun by André Marty in 1893; in addition to prints by such leading exponents of the revival as Redon, Toulouse-Lautrec, and Fantin-Latour, this periodical included works by Sérusier, Maufra, and Seguin, as well as by Gauguin and Bernard. Yet the influence of

Gauguin's earlier prints is felt in those by the artists under discussion. Both in Seguin's and Sérusier's use of zincography – sometimes in conjunction with colored papers – and in the often brutal etched line of Seguin and O'Conor, one detects the persistent influence of Gauguin's printmaking. They shared the bias he and Bernard held for the vitality of popular prints over the refinements of the *belle épreuve*.

Like Gauguin, the *peintres-graveurs* of Pont-Aven sometimes looked to printmaking as a means of disseminating their images; at other times they turned to the print media as vehicles for private experimentation. In their willingness to explore the unique expressive resources of lithography, etching, and woodcut, they reflect the changes in attitudes to printmaking that led to the modern perception of the original print.

1. On the relationship between the print and decorative arts revivals, see Douglas Druick and Peter Zegers, *La Pierre Parle: Lithography in France 1848–1900*, Ottawa, 1981, pp. 96 ff., and Druick, "Toulouse-Lautrec: Notes on an Exhibition", *The Print Collector's Newsletter*, vol. XVII, no. 2, May–June 1986, pp. 45–46.

2. Unpublished letter from Bernard to Aurier, 17 January 1888, cited in Bogomila Welsh-Ovcharov, *Vincent van Gogh and the Birth of Cloisonism*, Toronto, 1981, p. 264.

3. Letter from Vincent to Gauguin appended in the letter to Theo, 10 October 1888, in *The Complete Letters of Vincent van Gogh*, 2nd edition, Greenwich, Conn., 1959, vol. III, letter 549, p. 72. For Vincent's earlier plans for a journal see Juliana Montfort "Van Gogh et la gravure, histoire catalographique", *Nouvelles de l'estampe*, no. 2, (March–April, 1972), pp. 5–13.

4. See Christopher Gray, *Sculpture and Ceramics of Paul Gauguin*, Baltimore, 1963, pp. 5, 9, 13, 20–23.

5. On the relationship between Gauguin and Theo van Gogh, see Douglas Cooper, *Paul Gauguin: 45 Lettres à Vincent, Théo, et Jo van Gogh*, The Hague, 1983, pp. 16–225.

6. On this project see Douglas Druick and Peter Zegers, "Degas and the Printed Image, 1856–1914," in Sue Walsh Reed and Barbara Shapiro, *Edgar Degas: The Painter as Printmaker*, Boston, 1985, pp. lvii–lviii.

7. Félix Fénéon, "Calendrier d'avril. VII. Aux vitrines dans la rue," *La Revue indépendante*, May 1888 (with the mention of Gauguin); "Calendrier de septembre. III. Chez M. Van Gauguin", *La Revue indépendante*, Octobre 1888, reprinted in Félix Fénéon, *Œuvres plus que complètes*, vol. I, Geneva, 1970, p. 111 and 119.

8. Letter from Gauguin to Theo van Gogh, 7 or 8 October 1888, in Victor Merlhes, ed., *Correspondance de Paul Gauguin*, vol. I, Paris, 1984, letter 167, p. 247. On Manzi, see Druick and Zegers, "Degas and the Printed Image", pp. lviii and lxx.

9. Letter from Vincent to Theo, 3rd week December 1888, *The Complete Letters of Vincent van Gogh*, vol. III, letter 564, pp. 108–109.

10. On the relationship between Bracquemond and Gauguin, see Gray, *op. cit.* L'Estampe Originale album was warmly received by Alfred de Lostalot, "La gravure au Salon," *Gazette des beaux-arts*, September 1888, p. 224. The preface to the album was printed in the influential *Journal des artistes*, 29 July 1888. By late 1889, the album had been sold out.

11. Letter from Gauguin to Vincent, about 9 January 1889, Cooper, *op. cit.*, letter 34, p. 251.

12. Unpublished letter from Gauguin to Vincent, late January 1889, Institut Neerlandais, Paris, cited in Bogomila Welsh-Ovcharov, *op. cit.*, p. 194.

13. Letter from Gauguin to Schuffenecker, March 1889, cited in Wladyslawa Jaworska, *Gauguin and the Pont-Aven School*, New York, 1974, p. 75.

14. *Le Moderniste illustré*, 1ère année, nos. 15–18; 3, 10, 17, 24 August 1889.

15. Pissarro expressed this dislike in a letter to his son of 10 February, 1884, when he was spending considerable time with Gauguin, who was living nearby in Rouen. See Janine Bailly-Herzberg, ed. *Correspondance de Camille Pissarro*, vol. I, Paris, 1980, p. 282. In the years from 1877, when he met Pissarro, until 1886, when Gauguin broke with him, Pissarro made over fifty etchings.

16. Letter from Vincent to Theo, November or December 1882, *The Complete Letters of Vincent van Gogh*, vol. I, letter 254, p. 515.

17. Philippe Burty, preface to the catalogue *Exposition de Peintres-Graveurs*, Paris, Galerie Durand-Ruel, 11 rue la Peletier, 23 January–24 February 1889.

18. Roger Marx, preface to the *Premier album publié par les artistes membres de la société l'Estampe Originale*, Paris, May 1888.

19. Gray, *op. Cit.*, pp. 3 ff.

20. Paul Gauguin, "Notes sur l'art a l'Exposition universelle," *Le Moderniste illustré*, no. 11, 4 July 1889, p. 86, translated in Christopher Gray, *Sculpture and Ceramics of Paul Gauguin*, Baltimore, 1963, pp. 29–30.

21. For a discussion of these changes see Druick and Zegers, *La Pierre Parle,* p. 90 ff; and also Douglas Druick and Michel Hoog, *Fantin-Latour,* Ottawa, 1983, p. 275 ff.

22. On Vincent's transfer lithographs, see Montfort, *op. cit.*

23. Anonymous, "Zincographie," *L'Imprimerie,* 31 July 1887, pp. 1346–1347.

24. E. Duchatel, *Traité de lithographie artistique,* Paris, 1893, p. 21.

25. On the relationship of Vincent, Theo, and Buhot, see *The Complete Letters of Vincent van Gogh,* vol. I, Fall 1882, letters 241–256, pp. 477–521. Buhot's advice was included in a letter of 28 May 1896 to the young printmaker, Eugène Béjot, cited in André Fontaine, "Felix Buhot, peintre-graveur 1847–1898," manuscript, Cabinet des estampes, Bibliothèque nationale, Paris, pp. 304–305.

26. Paul Gauguin, "Notes sur l'art a l'Exposition universelle (suite)," *Le Moderniste illustré,* 1ère année, no. 12, 13 July 1889, p. 91, translated in Gray, *op. cit.,* p. 30.

27. Letter from Gauguin to Emile Schuffenecker, last week of February or 1 March 1888, *Correspondance de Paul Gauguin,* vol. I, letter 141, p. 172.

28. Paul Gauguin, preface to the exhibition catalogue of Seguin's work held at Le Barc de Bouteville, February 1895, reprinted as "Armand Seguin," *Mercure de France,* February 1895, p. 224.

29. On the woodcut and the artists of the Pont-Aven circle see Jacquelynn Baas and Richard Field, *The Artistic Revival of the Woodcut in France: 1850–1900,* Ann Arbor, 1984.

30. The exhibition of these prints in 1891 has not, to the author's knowledge, been previously cited in the Gauguin literature. Camille Mauclair's mention of them in "Des lithographies interessantes de Paul Gauguin" appears in "Beaux arts: Galerie Boussod et Valadon", *La Revue indépendante,* December 1891, p. 429.

31. Gauguin acknowledged receipt of an impression of the Gachet portrait in a letter to Vincent of approximately 24 June 1890, Cooper, *op. cit.,* letter 42, p. 321. In a letter to Theo of approximately 17 June 1890, Vincent proposed doing a portfolio of etchings that Boussod and Valadon might publish and mentioned doing etchings in conjunction with Gauguin. He may also have communicated this to Gauguin in the letter, now lost, to which Cooper letter 42 is the response.

Introduction

In the Spring of 1889, Paul Gauguin announced the opening of an exhibition at the Café Volpini entitled *"Peintures du Groupe Impressioniste et Synthétiste."* This was the first public display of the works of a new movement in art, now known as the "Pont-Aven School"[1]. The artists identified with this movement included among others, Gauguin, Emile Bernard, Paul Sérusier, Maurice Denis, Jacob Meyer de Haan, Armand Seguin, Charles Laval, Jan Verkade, Charles Filiger, Maxime Maufra, and Roderic O'Conor. They worked with each other or individually in Paris and various Breton villages such as Pont-Aven and Le Pouldu.

While several of these artists, especially Bernard, developed important new visions of their own which, at times, were adopted by Gauguin, the more mature and more aggressive Gauguin was considered by most of them to be the main driving force in the movement. He taught and inspired the others to abandon academic restraints and to explore the theories of a new style, termed "Synthetism," characterized by flat forms, harmonious colors, rhythmic patterns, and, more often than not, a depiction of the people and landscape of Brittany that so fascinated all of them.

The importance of the paintings of the Circle of Pont-Aven was long overlooked by most art historians and by the greater public, largely because of the almost overwhelming impact of Gauguin's later paintings. Even pioneering texts by John Rewald, Charles Chassé, Wladislawa Jaworska, and Denys Sutton[2] only slowly awakened general interest in the group. Until recently, even Gauguin's own paintings of the Brittany period were looked down upon by many scholars and collectors who considered that the only important contribution of the master dated from his two periods in the South Seas.

The lithographs, zincographs, woodcuts, and etchings produced by these artists have until now remained practically unknown, despite the fact that Gauguin and a number of the other artists of the group found in these media different and challenging solutions to the artistic problems posed by their evolving theories of Synthetism.

The reason that this creative outpouring has been overlooked until now is that many of these prints are extremely rare. Often only two or three proofs of a plate were printed and given to friends or fellow artists. Even those works for which editions of ten, twenty, or even fifty impressions were planned have become scarce because of the persistent absence of a market for them. Some of the planned

editions were probably never completed, and many impressions were destroyed over the years because they were considered of no value. There is, indeed, no museum or public collection owning a representative group of these prints. While some of the works in this exhibition have been studied previously[3], an examination of the prints of the Circle of Pont-Aven as a whole allows us now to discover the exciting printmaking activities of the group, and in that context, the stylistic advances and technical experimentations made by the individual artists.

The study of the prints of the Pont-Aven group also allows us more clearly to define the role of Gauguin in the activities of that group. While his position as the main driving force behind Synthetism is by now questioned by few, his dominant role as a printmaker in the years 1888−1894 must be reexamined in the face of the bold and technically intriguing work of some of his colleagues.

Pont-Aven is a small picturesque village on the south coast of Brittany. (illus. 1) It lies only seven kilometers from the sea, on the Aven river, which provided a harbor for commercial, seagoing boats and power for the town's numerous mills. Clear sharp light, green rolling hills, large rounded granite boulders, trees and farms with lush fields neatly bordered by stone fences or hedges, and wild rocky coasts characterize the area. The Bretons who lived there in the late 19th century were simple village and country people who were, for the most part, superstitious and religious. To the artists from Paris and abroad, their starched lace coiffes and collars, embroidered jackets, and wooden shoes presented an almost exotic, picturesque charm (illus. 2).

The town had already been a summer artist's colony for French and foreign artists for many years before it attracted Gauguin in 1886[4]. He spent several months there that year and again, intermittently, from 1888−91 and 1894−95. Neither he nor any of the artists who were close to him ever settled in Pont-Aven permanently. Yet, this village has given its name to an aesthetic phenomenon that flourished from 1888 to about 1895.

The label *"l'Ecole de Pont Aven"* has been in use since the 1890s[5]. The artists of the Circle of Pont-Aven, however, also spent a great deal of time in Paris and in the seaside village of Le Pouldu, twenty kilometers from Pont-Aven and also frequented other Breton villages such as Doelan, Châteaulin, and Huelgoat. The term "Circle of Pont-Aven" applied to a given work or artist does not, therefore, necessarily denote a work executed in that very village or of artists who actually lived there. The title is based instead on the stylistic attributes shared by its member artists which we define as Synthetist.

THE CIRCLE OF PONT-AVEN

While it is difficult to define rigidly any classification of creative endeavors, the style of the artists of the Circle of Pont-Aven has two distinct components: Synthetism and an emphasis on Breton themes as the subject matter.

The reasons for the artists' attraction to Brittany are complex. Gauguin was

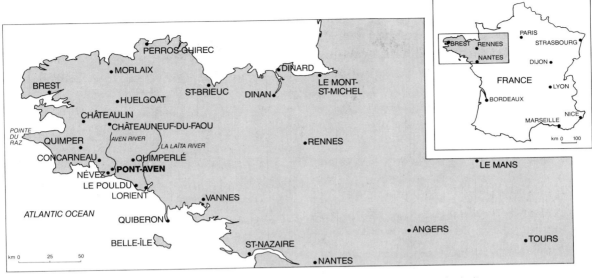

Illustration 1. MAP OF BRITTANY, showing the location of the principal sites preferred by the artists of the Pont-Aven Circle.

initially drawn to it by financial considerations. He found living there inexpensive, which was probably also important to many of the other artists of the group. Soon, however, this practicality was superseded by an admiration for the light and the rugged landscape, as well as for the Bretons and their simple way of life.

The painters felt that the peasants' lives had not changed since medieval times. They were also fascinated by the mystical character of the Bretons' Catholicism. Some of the artists were themselves practicing Catholics[6], but in their minds, Breton piety was more closely linked to medieval and pagan superstitions and folklore[7] than to the modern Church. The many dolmens, menhirs, calvaries, and simple Gothic churches with their crude sculptures covered with lichen added further appeal[8].

In 1888, Gauguin wrote: *"I love Brittany; I find there the savage, the primitive. When my clogs resound on the granite soil, I hear the muffled, dull, powerful tone that I seek in my painting"* [9]. Despite this assertion, Brittany was *not* entirely the desolate, poor and primitive place sometimes described by tourists or suggested in popular paintings of the late nineteenth century[10] (illus. 2). However, the artists from Paris certainly ignored signs of industrialization, wealth, and encroaching urbanization. Just as Gauguin was later to avoid the Europeanized aspects of Tahitian society, he also overlooked the encroachment of Parisian tastes and life styles in Brittany.

The artists naively believed that Breton peasants were still living in a primitive state of unsophisticated bliss and chose to ignore the profound changes occuring in the Breton way of life and the growing complexity of its social structures[11]. They thought that all of modern civilization's scientific, social, and philosophical advances, as represented by the city of Paris, were here unsought. They usually saw the Bretons only as picturesque peasants (B.4), troubled by simple passions (G.2)

21

or hard at work in a never ending cycle of toil in their fields (SR.1 and S.20). In their depictions of peasants, the artists acknowledged their hard lives and hopelessness of betterment but offered no criticism or sociological statements. While the peasants were often pictured as physically rough and unattractive, the painters also idealized their appearance by often depicting them at work in their Sunday and festival clothing, disregarding the fact that these elegantly starched and embroidered clothes were never actually worn for daily chores.

In their landscapes, the artists all but ignored signs of industry and wealth, but concentrated instead on the austere physical aspects of the land and sea (M.4, O.1–15, and S.13–18). Yet despite the often abstract, formal concerns evident in many of these landscapes, it is remarkable how each image manages to convey a feeling for the light, wind, and ruggedness of the Breton countryside.

LE POULDU

During the years following 1889, the small, isolated town of Le Pouldu, on the windswept southern coast twenty kilometers east of Pont-Aven, became the gathering place for many of these artists. No other painters from Paris were there and the

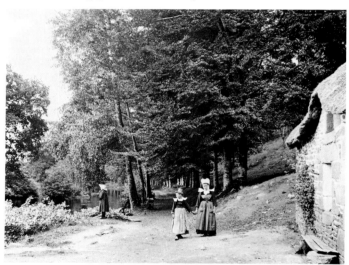

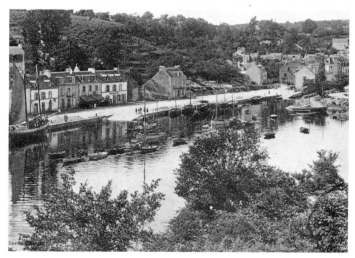

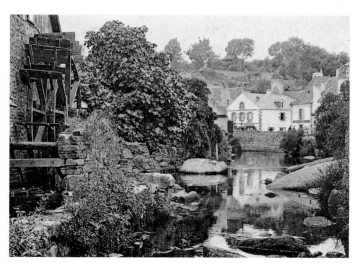

Illustration 2. THREE VIEWS OF PONT-AVEN, ca 1900 – "The Bois d'Amour", "The Harbor", and "The Mills". (Three postcards of the period). In the 1890's, Pont-Aven was already a large, bustling village with numerous mills and a busy harbor. The Pont-Aven artists, however, preferred for their work the rural charm of the nearby farms and woods, such as the Bois d'Amour bordering the Aven river, where they could observe the villagers on their outings, dressed in their picturesque festival coiffes and embroidered vests.

people were much less sophisticated than those of Pont-Aven, who had grown accustomed to the waves of Parisian and foreign artists that engulfed the village every summer[12]. In Le Pouldu, the artists lived primarily in the smaller of the two local hotels, the one owned by Marie Henry, and later in rented rooms scattered throughout the village and on nearby farms. The artists were barely tolerated by the populace, except by Marie Henry, called *Marie La Poupée,* who bore the child of one of them, probably Meyer de Haan[13]. As in Pont-Aven, the artists never really became part of the community but remained observers of it.

Many inhabitants of Le Pouldu today argue, with some reason, that the title of this school of painters should be the "The Circle of Le Pouldu". Yet, while many of the artists probably spent more time together in this village than they did in Pont-Aven, the basic ideas that launched Synthetism were unquestionably established at Pont-Aven.

With all of this said, it must not be forgotten that the aesthetic questions these artists found most intriguing were primarily abstract. Their concerns were line, color, rhythm, and harmony, and their subjects were chosen for their ability to best allow the exploration of these non-objective ideas. The coiffes, rolling hills bordered by fences and hedges, the coasts, cottages, and animals were ideal vehicles for the expression of the smoothly flowing lines and repeated forms that characterize Synthetism.

SYNTHETISM

The late 1880s was a period of great ferment in European cultural history. Fundamental questions concerning the nature of art, music and literature were being debated and redefined. Great changes were in the air as artists working in all media questioned accepted standards of beauty and means of expression. The artists gathered around Gauguin in Pont-Aven in 1888 felt that the Impressionist approach to nature was a purely visual analysis. Their aim, on the other hand, was to adapt what they saw in nature to their own emotional experience and graphic sensibilities. Bernard and Gauguin, in particular, had been tentatively exploring these new ideas separately in their work before late 1888. Their individual searchings finally came to fruition in the late summer of that year when they met in Pont-Aven.

A stimulating atmosphere of discovery permeated the gatherings of Gauguin, Bernard, Sérusier, Laval, de Haan, and others throughout the summer and fall of 1888. In the cafés and hotels, particularly the Pension Gloannec, they discussed their ideas and work, exchanged the latest news from Paris, and voiced their opinions regarding the work of Van Gogh, Seurat, Cézanne, and the other avant-garde artists whose works they had seen in reproduction or during their stays in the capital. This creative environment and exchange of ideas was undoubtedly one of the stimulating factors for all of the artists involved, including Gauguin himself. The rivalries that later occured between some members of this group, especially between Bernard and Gauguin, had not yet surfaced[14].

Synthetism, as it evolved between 1888 and 1895, is an aesthetic theory concerned with creating a synthesis between impressions of nature and abstract forms. As Gauguin wrote: *"Art is an abstraction! Study nature and then brood on it and treasure the creation which will result"*.[15] The formal vocabulary used to express this interpretation of nature stressed the abstract qualities of line, color, and shape.

Surface rhythm, patterns created by repetition of forms and colors, arabesques, smoothly curving lines, and simplification of details all outweighed concerns for realistic depiction. Pure abstraction was never suggested, as underscored by Maurice Denis's famous summation of Synthetist ideas: *"Remember, that a painting, before being a battle horse, a nude or any kind of anecdote, is essentially a flat surface covered with colors organized in a certain order"*.[16] That is, while abstract concepts of harmonious lines and color must take precedence, a battle horse, nude or whatever, *still* must be present. It took another twenty years before European artists dared abandon that foothold in realism.

Synthetism drew upon sources as diverse as Japanese prints, Italian primitive art, medieval stained glass, and the works of Puvis de Chavannes, among others. At its basis was a working method that incorporated both the close observation of nature and memory.[17] The subject matter was observed and possibly sketched *in situ*, but the final work was finished in the studio. In this manner, the mind would retain its initial impression of the subject, whether it was a certain color, linear construction, or feeling. Inessential details and visual distractions would be forgotten and rearrangements and distortions allowed, so that the final picture would convey accurately the initial impression, even if it did not exactly reflect the motif itself. Finishing the work in the studio allowed the artist to concentrate on non-representational questions of design, unencumbered by the restraint of realistic details.

The design principles of the Pont-Aven Circle were frequently described in musical terms, as Gauguin noted when he wrote, *"...painting has entered a new musical phase"*.[18] The contemporary Symbolists, whom many of the Pont-Aven artists visited when they were in Paris, had also enthusiastically embraced Wagner's theories concerning the *Gesamtkunstwerk*, ideas sprinkled with musical references[19]. Rhythm and harmony became two of the Synthetists' paramount design goals, to be achieved by repetition of forms, colors, and flowing lines. The viewer's eye was encouraged to explore freely the picture's surface, noting the smooth rhythms created by the colors and lines. Colors were often those close together on the color wheel, and lines were rarely rough or jagged. Gauguin is even supposed to have threatened Seguin with a revolver if he dared use complementary colors. While this may well be apocryphal, the fact remains that artists of the Circle of Pont-Aven mostly avoided the frank use of complementary colors[20].

Two-dimensionality was another characteristic of Synthetism. Modeling of forms, spatial recession, and aerial perspective were rejected as *trompe l'oeil* and too reminiscent of the much despised contemporary style of Realism. The risk of Synthetism was that the artist could easily lapse into purely flat, decorative compositions, as did Bernard in some of his prints and paintings of the early 1890s.

Although Gauguin fully exploited the two-dimensionality of Synthetism in both his prints and paintings, he also maintained a sense of weight and inner movement in his figures[21]. This was done in his prints through grey tonalities, which really offered little modeling, and through the use of lines of varying thickness and irregular contours around his figures. Bernard, Sérusier, and Seguin shared these characteristics in their early prints, but in some later ones, especially those of Bernard and Seguin, the contours became smoother and less variegated, flattening the forms even further and making them appear weightless.

Many prints of the Circle of Pont-Aven contain strong elements of spatial recession. This effect is not achieved by applying the laws of perspective, but by piling up horizontal, flat elements that suggest depth only by their relative placement. In these compositions, the distant fields, skies, or water are indicated, but their elements also interact formally with the shapes and lines in the foreground and middleground of each work, creating two-dimensional patterns. Thus the artists managed to suggest both depth and flatness at the same time.

Synthetism, as we have defined it, is a formal vocabulary of line and color, rather than a philosophy of subject matter. This sets it apart from contemporary Symbolism, a predominantly literary style that concentrated on subject matter, without defining the means of expression. Gauguin's circle, however, was well aware of the Symbolist view that art must rise above banal reproduction and trite morality. They sympathized with the Symbolist aim to express an "Idea," that is, an intangible concept that could only be suggested and never specifically delineated[22].

A sense of mystery also characterised many Symbolist prints, paintings, poems, and theatrical productions. In Gauguin's Breton works, hints of lurking menace, or fears of undefined primitive and mystical forces are not uncommon. While Bernard, Sérusier, and Seguin often explored the same interrelationships between the Breton peasant and his environment, their works rarely embody the profound disquiet, sense of mystery, or undefined melancholy Gauguin so subtly suggested.

THE VOLPINI EXHIBITION

In the spring of 1889, the *Exposition Universelle* was scheduled to open in Paris. Synthetism had only recently coalesced, yet Gauguin felt that he was ready to present his ideas to the public[23]. Officials hostile or indifferent to their art refused to make exhibition space in the official French arts pavilion available to Gauguin or other avant garde artists. Lacking funds or generous sponsors like those enjoyed by Manet and Courbet, both of whom had built their own pavilions during previous exhibitions, the artists around Gauguin stubbornly sought whatever space they could get. His friend Emile Schuffenecker finally managed to secure the walls of a café animated by an orchestra of female Russian violinists on the grounds of the Exposition for an exhibition of over 100 works by Gauguin, Bernard, Anquetin, Schuffenecker, and others.

The exhibition's title, *Peintures du Groupe Impressioniste et Synthétiste,* was a confusing reference to the artists' ambiguous stand on Impressionism and their emerging dedication to the ideals of Synthetism (illus. 3). The exhibition is often referred to today as the "Volpini exhibition" after the name of the café owner upon whose walls the works were shown. While it was a financial failure, it did manage to introduce a small number of artists, collectors, and critics to the new ideas and young artists of the Circle of Pont-Aven[24].

A notice on the last page of the exhibition's small catalogue announced that an album of "lithographs" by Bernard and Gauguin could be seen upon demand. This "album" was in fact two separate sets of zincographs,[25] one by each of the two artists. Gauguin's album consisted of ten zincographs plus a cover, Bernard's, six plus a cover. Despite the low price of twenty francs, the albums aroused little interest[26].

During the two years following the Volpini exhibition, Gauguin temporarily abandoned printmaking, except for producing an etched portrait of Mallarmé in 1891 (Guérin 12). He moved between Pont-Aven, Le Pouldu, and Paris, attracting an ever growing following of young artists for whom painting was the primary preoccupation. Beginning in 1891, however, printmaking again attracted the attention of some of them.

THE ROLE OF GAUGUIN

A number of the artists discussed here travelled in many artistic circles, absorbing and exchanging ideas as they went, even working in several different styles at the same time. Consequently, they cannot be labelled as belonging solely to the Circle of Pont-Aven, the Nabis[27], or the Symbolists. Sérusier, for example, was simultaneously an active member of both the Nabis and the Circle of Pont-Aven, and Bernard pursued ideas based on the styles of Gauguin, Cézanne, and even Michelangelo.

Posterity has justly awarded Gauguin the predominant role among the group of young artists gathered around him at various times during his prolonged stays in Brittany from 1886–91 and 1893–95. His was certainly a powerful personality, not only igniting sparks of creativity amongst the painters who were stimulated by his ideas, but also encouraging them to adopt and develop some of the ideas of his younger colleagues, especially those of Emile Bernard.

In printmaking, however, the situation was quite different. Gauguin produced only twelve prints before he left for the South Pacific (Guérin 1–12). While eleven of these prints are beautiful and important representatives of his Synthetist ideas, Gauguin only realized his full potential as a printmaker much later, in his woodcuts of South Seas themes. Indeed, during the major part of the Pont-Aven group's printmaking activity from 1889–1893, Gauguin was not even present and did not execute any prints. This by no means implies that he did not influence the activities of these artists despite his absence. Several of the artists after all had seen his prints

GROUPE IMPRESSIONNISTE ET SYNTHÉTISTE

CAFÉ DES ARTS

VOLPINI, Directeur

EXPOSITION UNIVERSELLE

Champ-de-Mars, en face le Pavillon de la Presse

EXPOSITION DE PEINTURES

DE

Paul Gauguin	Émile Schuffenecker	Émile Bernard
Charles Laval	Louis Anquetin	Louis Roy
Léon Fauché	Daniel	Nemo

Affiche pour l'intérieur

Paris. Imp. E. WATELET, 55, Boulevard Edgar Quinet.

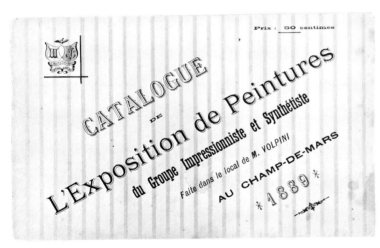

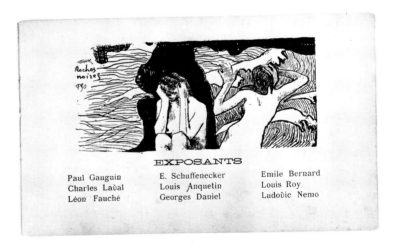

Illustration 3. POSTER, COVER, AND FRONT PAGE OF THE CATALOGUE FOR THE VOLPINI EXHIBITION (1889). Gauguin, Bernard, and Schuffenecker exerted themselves to publicize the "unofficial" exhibition held on the ground of the *Exposition Universelle* at the Café des Arts owned by Monsieur Volpini. Its catalogue was widely distributed and its illustrations, reproducing a drawing by each of the exhibiting artists was instrumental in making their works better known. Note that Gauguin chose for his illustration an image similar to the one in his zincograph *Misères Humaines* (G. 2). (Poster 280×400 mm, Cover 157×250 mm).

at the Café Volpini exhibition of 1889, at the Galerie Boussod et Valadon in 1891[28] and at Le Pouldu, where some of them hung on the walls of their hotel, and a number of the artists owned sets of them.

Bernard, Seguin, and O'Conor especially, however, give evidence in their prints of a bold grasp of abstract design principles and technical achievements that often go beyond what is seen in Gauguin's café Volpini zincographs. They used nature only as a starting point for their designs, the abstract qualities of which remained their main preoccupation. In their exploration of the technical properties of print-making, these artists also showed a remarkable boldness and inventiveness.

Paul Sérusier was considered the theorist for the Pont-Aven circle, just as he was for the Nabis. A well educated young man, he was extremely didactic and fasci-nated by the challenge of establishing clearly defined theories for any artistic practices that interested him. He and Bernard were both aware of the debates then raging in Paris over such subjects as Theosophy, Wagnerism, Rosicrucianism, and the occult. Well versed in classical literature and art history, they provided a framework and a vocabulary for Gauguin's often intuitive and spontaneous ideas. As early as 1889, Sérusier began to organize his theories based upon Gauguin's work[29], and he expanded upon them over the years, often adding his own Theosophical interpretations[30]. As he attempted to express his own feelings about Brittany, many of Sérusier's prints of the 1890s show the strong stylistic influence of Gauguin.

Emile Bernard was a precocious man of twenty when he began to work with Gauguin in 1888. His great enthusiasm for new ideas served him well in the early years of Synthetism. His disregard for established notions, his fertile imagination, and ability to verbalize his discoveries presented a constant stimulus and challenge to the forty year old Gauguin.

Bernard might have shared Sérusier's position as group theorist if he and Gau-guin had not grown apart after 1890. They worked closely together only in 1888−89, while Sérusier spent two entire summers with Gauguin in Brittany in 1889 and 1890, as well as a great deal of time in Paris from late 1888 until 1891 and then again in 1894−95. Furthermore, Bernard's use of Synthetist ideas is essentially limited to the years 1888−93, while Sérusier intermittently continued to use Syn-thetist vocabulary throughout his career.

Bernard, Sérusier, and Gauguin shared many similarities of style, as can be seen in the prints. There are, however, important differences in approach. Bernard, for example, was less interested than Gauguin in maintaining a tension between two-dimensional decoration and three-dimensional modeling. Bernard's prints more often stressed two-dimensional rhythms and repetitive patterns; his lines and silhouettes were usually smoother, his compositions more archaic Sérusier's works also tended to be more two-dimensional than Gauguin's during the period of 1889−91. After Gauguin left for the South Seas in 1891, Sérusier's images became harsher and his rhythms more jagged. He eventually abandoned printmaking in the late 1890s. Bernard, in turn, left France for the Middle East and Egypt in 1893 and, although he continued to create prints, his style changed almost immediately.

Contact between Maxime Maufra and Gauguin was less frequent and less intense. Maufra was not a philosopher, nor does he seem to have been interested in the debates surrounding Synthetism[31], yet he and Gauguin remained friends despite their differences[32]. Maufra did absorb, however, some of the Synthetists' ideals and applied them to his prints of the 1890s that depicted the Breton landscapes and seascapes he so admired.

Maurice Denis met Sérusier, Seguin and Verkade at the Académie Julian in 1888 and became one of the founders of the Nabi movement. While he spent his summers mostly in Northern Brittany, and only visited Pont-Aven and Le Pouldu a few times, notably in 1890, he kept in close contact with several artists of the Circle of Pont-Aven during their stays in Paris. His theories expressed as early as 1890 in the journal *Art et Critique* influenced them considerably. His two zincographs done in 1890, *Les Lavandières* (illus. 4) and *Feuille de Croquis* as well as several of the lithographs and woodcuts done to illustrate Verlaine's *Sagesse* and André Gide's *Voyage d'Urien* can be related directly to the printmakers of the Circle of Pont-Aven.

Armand Seguin and Roderic O'Conor did not meet Gauguin until his return to France in 1894. Their knowledge of Gauguin's ideas had come from seeing his prints and paintings at the Volpini exhibition and from other members of the Circle of Pont-Aven. This may explain why their works of 1888−93 are less consistently Synthetist in style than are those by Bernard and Sérusier[33]. Not until their collaboration in Le Pouldu during the summer of 1893 did either of them demonstrate a consistent use of Synthetism in their work. The prints resulting from this joint effort (O.1−15 and S.10−18) pushed Synthetism beyond the limits of simplicity and abstraction Gauguin attained in his prints four years earlier (G.1−4).

By the time Gauguin returned from Tahiti in 1893, most of the Circle of Pont-Aven artists were well launched on their respective artistic paths. They had absorbed Synthetism and remained attached to Brittany but had also moved off in other directions. Gauguin's arrival did not rekindle the excitement of a lost leader

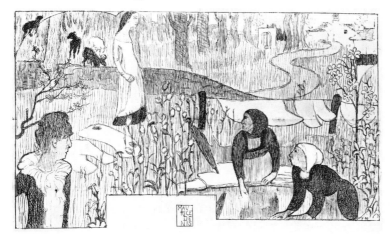

Illustration 4. MAURICE DENIS, *LES LAVANDIERES BRETONNES,* (1890, zincograph, 277×462 mm) and *ILLUSTRATION FOR SAGESSE* having served as design for the woodcuts of Beltrand to illustrate page 13 of *Sagesse* by Paul Verlaine (1893, 85×47 mm).

returning to take up his reign once again. With Bernard, for example, he had no more contact. He saw Sérusier, but the latter had already begun to withdraw into the religious philosophies that would so govern his later work. O'Conor had lost interest in printmaking. Only for Seguin, did Gauguin's presence create a powerful stimulus to try new media (S. 23) and to experiment with new subject matter (S. 24, S. 25).

There are many other artists besides those mentioned above who were part of the Circle of Pont-Aven. Several, such as Cuno Amiet and Robert Bevan, passed quickly through the group, absorbing much and then going on in other directions. Others were frequent habitués of Pont-Aven and Le Pouldu and strongly allied to Synthetism and Breton subject matter but do not appear to have produced any prints. Still others who created prints, such as Henri Delavallée, Charles Cottet and Pierre Emile Colin, were influenced by the artists of the Circle of Pont-Aven but did not actively participate in the development of its ideas or pursue its theories in their own work with any consistency.

PRINTMAKING

One of the reasons that more of the Circle of Pont-Aven artists did *not* create prints may have been the lack of technical facilities in Brittany. The fundamental black-and-white nature of printmaking may have been another. Color, after all, was a key concern for many of these artists. Nonetheless, a number of the Pont-Aven artists were fascinated by new techniques and anxious to meet the challenges and try the new methods of self-expression printmaking offered them. Discussions of individual prints in this study will demonstrate how bold and daring their aesthetic and technical experiments were at times.

There were no social motives behind their prints, nor was there any effort to disseminate particular ideas through large editions. Many of the prints were never published at all but were pulled in only one, two, or three proofs that were kept or given to friends. Few were professionally printed. Of the few prints that were actually published, the editions remained small, with no more than one hundred and in most cases less than twenty impressions made of any print.

While we might assume that a desire for greater exposure and income were at times factors in the production of prints – for example, the Volpini albums of Gauguin and Bernard and the exhibitions at the gallery of Le Barc de Boutteville – unfortunately, none of these attempts proved to be a commercial success.

One of the characteristics of the style of the Pont-Aven Circle is fluidity of line. Lithography provided a technical opportunity for this because of its relative ease of execution. In fact, lithography at the end of the 19th century specifically sought to approximate drawings in appearance[34]. The artist after all, draws freely on the surface of his stone (or zinc plate, in the case of zincography) and can easily make corrections if he wishes. The complexities of the lithographic process begin only

after the image has been fully drawn and these can then be taken care of by a trained technician.

In the 1880s, large numbers of "lithographs" actually were done on zinc plates, rather than on cumbersome, expensive lithographic stones. That is, lithographic crayons, inks, washes, and tusche were used in the same manner as in traditional lithography, but zinc or zinc-plated metal plates replaced the stones[35].

Printmaking manuals extolled the superiority of zinc over stone when the artist used transfer paper to produce so-called transfer lithographs. This process freed the artist from having to draw his designs directly onto the stone or zinc plate in the printing studio. With lithographic crayon or ink, he could draw on special paper, called transfer paper, as simply as if he were making an ordinary drawing. A printer then transferred the drawing to a stone or zinc plate, and proceeded as usual[36]. This process had the additional advantage that the original drawing was reversed when transferred to the stone or plate and then was reversed again during the printing itself to achieve its original appearance, whereas in a lithograph directly drawn on the stone or plate, the image appears in reverse in the print.

The Pont-Aven artists almost always preferred for their printing the cheaper zinc plates, which are charactrized by a graininess not seen in lithographic stones, whose fineness of texture did not in any case concern them[37].

Most of the zincographs done by the Circle of Pont-Aven printmakers exhibit either extensive tusche work or lavis. Lithographic tusche is generally a grease-based liquid, often containing wax, tallow, soap, shellac, and lamp black[38], although most printers and manufacturers have their own preferred· formulas. Lithographic lavis is usually a mixture of grease-based ink and water, which is applied on transfer paper, stone, or zinc plates with a brush as if it were gouache or thin oil paint. Both tusche and lavis give the finished print a distinct, painterly appearance. (See Gauguin's and Bernard's Volpini prints, G. 1–4, and B. 4–8, for example.) Despite later technical processing by the printer, the tusche and lavis suggest that the artist's creative impulse was given free reign.

Etching is a more technically demanding medium for the artist than zincography, and it particularly attracted the attention of Seguin, O'Conor, Maufra, and Amiet. They may have preferred its emphasis on line over the broader, more painterly qualities of zincography. After all, as Bracquemond wrote, the drawn line least imitates nature, allowing for abstract arrangements where ornamental principles dominate[39]. These principles were consistent with the Pont-Aven style, yet each of these four artists also experimented with aquatint, plate tone, and sugar lift[40] in order to add half-tones, atmosphere and "color" to their etched work.

Bernard completed a few woodcuts (B.2, B.9) as did Seguin (S.23, S.31). Gauguin later used the technique for images of the South Seas but not for his 1889 Breton subjects. It is difficult to explain why woodcuts were not more popular with the Pont-Aven artists. Such prints, after all, were associated with some of the medieval and primitive societies and Japanese prints[41] the artists admired. Gauguin and Bernard had done some woodcarvings in the months preceding their Volpini album. Bernard also may have experimented with transferring woodblock images

either directly or with transfer paper onto zinc plates in order to produce zincographs having the appearance of woodcuts (see B.3). This process enabled the artist to make changes in his image on the transfer paper or even on the zinc plate, which would be impossible on a carved woodblock.

Printmaking can be a complicated, messy, procedure, often involving acids and greasy inks. It is easy to discolor and stain the plate with fingerprints; even simple humidity can cause marks. This explains the appearance of fingerprints, scratches, stains, and pitmarks on many Pont-Aven prints, and suggests that the artists often did not simply hand their drawings on transfer paper or their etched plates to professional printers for printing, but were actually involved themselves in the whole process[42].

While most etchings of the Pont-Aven artists were undoubtedly pulled by themselves or with the aid of other artists, others were professionally printed in Paris. Edouard Ancourt seems to have done some of the zincographs[43]. Correspondence names Auguste and Eugène Delâtre as the printers of some etchings by Seguin and Maufra[44]. Seguin may have had a simple press in Le Pouldu, where he and O'Conor could have printed their etchings of 1893[45]. Seguin also purchased a press with his English friend, the artist Mortimer Menpes, in Pont-Aven during the summer of 1895[46]. Unfortunately, few records have been found detailing printers or editions, so information is based primarily on circumstantial or second-hand information.

The technical creation of a number of these prints was so complex that at times even master printers have difficulty defining exactly what techniques were used. Furthermore, to these artists, the creative process did not stop whith the drawing of the image. The ink, the quality of the paper, and the technical treatment of the plates all contributed to the final result. The extent of their experimentation reflects their uncompromising search for true Synthetism in their work.

1. The term "Pont-Aven School" or "Ecole de Pont-Aven" is usually applied to this movement and is, therefore, used in the title of this study. In fact, however, there was no school as such, nor was there a static "Group". We prefer to use the title "Circle" wich is more descriptive of the actual dynamics of the relationships between the artists.

2. Jaworska; London, 1966; Johnston, 1985; Musée du Prieuré, 1985; Denys Sutton, "Roderic O'Conor," *The Studio*, Vol. 160, no. 811, November, 1960, pp. 168–74, 194–96 and "Echoes from Pont-Aven," *Apollo*, vol. 79, no. 27, May, 1974, pp. 403–406 and numerous other articles by Sutton in *Apollo*; See bibliography for more references.

3. Guérin; Field; Johnston, 1984, 1985.

4. The word *Nabi* means prophet in Hebrew. Note that the name of the group was *Nabis*, but individual members were *Nabi*, without a final "s", not *Nabis*, as is often noted in books in English.

5. The twelfth print is Gauguin's portrait of Mallarmé, an etching of 1891 which is not Synthetist in style.

6. For more on Pont-Aven's history, see Denise Delouche, *Peintres de la Bretagne: Découverte d'une Pro-vince*, Rennes, 1977; Bertrand Quéinec, *Pont-Aven 1800–1914*, Bannalec, 1983; and David Sellin, *Americans in Brittany and Normandy, 1860–1910*, exhibition catalogue, Phoenix Art Museum, 1982.

7. Field, p. 16.

8. Albert Aurier, "Le Symbolisme en Peinture, Paul Gauguin," *Mercure de France*, II, 1891, pp. 155 ff.

9. Two of them, Verkade and Ballin, went so far as to convert to Catholicism. Verkade then became a monk.

10. There are numerous contemporary books compiling old Breton legends; see, for example, Claude Tchou, ed., *Histoires et Légendes de la Bretagne Mystérieuse*, Paris 1968.

11. See Henri Waquet, *L'Art Breton*, 2 vols., Grenoble, 1933.

12. Paul Gauguin, *Letters to his Wife and Friends*, London, 1946. February, 1888, p. 46.

13. See Fred Orton and Griselda Pollock, "Les Données Bretonnantes: La Prairie de Représentation," *Art History*, vol. 13, no. 3. Sepember, 1980, pp. 314 ff.

14. See Theodore Zeldin, *France, 1848–1945*, vol. 1., "Ambition and Love," Oxford, 1979.

15. Caroline Boyle-Turner, "Le Pouldu en 1889," *Le Chemin de Gauguin,* exhibition catalogue, Musée du Prieuré, St. Germain-en-Laye, 1985, p. 102.

16. Maxime Maufra, for example, used it in his article "Gauguin et l'Ecole de Pont-Aven, par un des ses admirateurs de l'Ecole de Pont-Aven," *Essais d'Art Libre,* November, 1893.

17. In the evolution of the Pont-Aven style, writers and historians have attributed various roles to Bernard, Gauguin, Louis Anquetin, and others. While there is no question that Gauguin was the oldest and most forceful personality in the group and that he, in time, surpassed his colleagues, there is every indication that during the summers of 1888–89 there was a true interplay of ideas between most of the artists, especially between Gauguin and Bernard, that led to the development of common artistic goals.

18. Gauguin used the term in August, 1888, in a letter to Schuffenecker. *Correspondance de Paul Gauguin,* Paris, 1984, no. 159, p. 210.

19. Maurice Denis, "Définition du Néo-Traditionnisme," *Art et Critique,* 1890. Reprinted in Maurice Denis, *Du Symbolisme au Classicisme, Théories,* Paris, 1964, p. 33.

20. *Correspondance de Paul Gauguin,* no. 159, p. 210.

21. Paul Gauguin, *Racontars de Rapin,* Paris, 1951, p. 50.

22. See Téodor de Wyzewa's numerous articles on "La Peinture Wagnerien," in *La Revue Wagnerienne,* Paris, 1895–86. Also, Jack Stein, *Richard Wagner and the Synthesis of the Arts,* Detroit, 1960.

23. Jaworska, p. 140.

24. Musée du Prieuré, 1985, pp. 115 and 127.

25. Paul Gauguin, *Letters to his Wife and Friends,* December, 1888, pp. 114–115.

26. See Rewald, pp. 278–83, for more information on the exhibition.

27. See below, pp. 30–31 for a discussion of zincography.

28. See the Foreword by Douglas Druick, p. 16 above. Although we don't know of any sales to dealers or collectors at the exhibition, a number of artists acquired some of the sets either through gift or purchase. Sérusier, Slewinski, and de Monfreid, for example, owned sets of the zincograhs. Nor do we know if the twenty francs was for one artist's album or both.

29. Paul Sérusier, "Correspondance," in *ABC de la Peinture, suivi d'une Correspondance inédite recueillie par Mme Paul Sérusier et annottée par Mlle Henriette Boutaric,* Paris, 1950, summer, 1889, pp. 43–45.

30. See Caroline Boyle-Turner, *Paul Sérusier,* Ann Arbor, 1981, chapters 3–6.

31. Arsène Alexandre, *Maxime Maufra,* Paris, 1926, pp. 115–116.

32. These differences were acknowledged by Gauguin, who said to Maufra: *"Nous suivons une voie differente, la votre est bonne et vous n'avez qu'à continuer."* ("We are following different paths, yours is good, you have only to continue") quoted in Alexandre, *Maxime Maufra,* p. 71.

33. For more information on Seguin, see Field; and on O'Conor, see Johnston, 1984 and 1985.

34. Frances Carey, Antony Griffiths, *The Print in Germany 1880–1933,* exhibition catalogue, The British Museum, 1984, p. 33.

35. Clifford Ackley, "Edgar Degas: The Painter as Printmaker" in Sue Welsh Reed and Barbara Stern Shapiro, *Edgar Degas, the Painter as Printmaker,* exhibition catalogue, Museum of Fine Arts, Boston, 1984, p. ix.

36. There are numerous printing manuals from the 1880s. See, for example, Lorilleux, *Traité de Lithographie,* Paris, 1889, pp. 161–2.

37. Lorilleux, *Traité de Lithographie,* p. 163.

38. Donald Saff and Deli Sacilotto, *Printmaking: History and Process,* New York, 1978.

39. Felix Bracquemond, *Du Dessin et de la Couleur,* Paris, 1885, pp. 23–36.

40. *Aquatint* "can produce an effect similar to a watercolor wash. The key to it is a special variety of etching ground which consists of minute particles of resin which are fused to the plate and act as a resist to the acid. Since the ground is porous, the acid bites into the plate in tiny pools around each particle. These tiny depressions retain the ink when the plate is wiped and when printed give the effect of a soft grain. The particles can be of varying fineness; if large the individual pools of ink will be visible to the eye, but if very small, they will produce a film of tone which looks very similar to a watercolor wash." Anthony Griffiths, *Prints and Printmaking,* The British Museum, London, 1980, p. 91.
Sugar Lift: "The artist brushes his design onto the plate with a fluid in which sugar has been dissolved. The entire plate is then covered with a stopping-out varnish and immersed in water; as the sugar swells, it lifts the varnish off the plate, leaving the original brush drawing exposed as bare copper. These areas are then covered with an aquatint ground and bitten in the usual way, while the stopping out varnish protects the rest of the plate." Griffiths, *Prints and Printmaking,* p. 93. The process can also take place without an aquatint, resulting in a direct biting of the plate.
The term *plate tone* is used to define the tone of the print which the artist or printer creates by leaving a film of ink on the surface of the plate after he has wiped off the excess ink.

41. Jacquelynn Baas and Richard S. Field offer plausible explanations in *The Artistic Revival of the Woodcut in France 1850–1900,* exhibition catalogue, The University of Michigan Museum of Art, Ann Arbor, 1984, pp. 36, 66, 108.

42. Compare the differences between Maufra's *La Vague,* (M. 4) and Seguin's *La Pêche* (S. 10). The first was probably professionally printed, the second was probably printed by Seguin himself.

43. Information from Sérusier, cited by Guérin, p. v.

44. Unpublished correspondence between Delâtre, Seguin, and Maufra, (Coll. J.).

45. Richard S. Field in conversation with the author, 1984.

46. Correspondence between Seguin and Delâtre, (Coll. J.).

Paul Gauguin

(1848–1903)
The Volpini Show

Having heard that Emile Schuffenecker had found exhibition space for their work in a café on the grounds of the Exposition Universelle, Gauguin was elated. In choosing the artists to exhibit with him, he sought to present a homogeneous impression of new stylistic ideas[1]. Yet he also wanted to assert his leadership in the new movement. He wrote to Schuffenecker:

> *"Only remember it is not an exhibition for the others. So let us arrange it for a little group of comrades, and from this point of view, I want to be represented there as fully as possible. Do your best in my interests to secure good positions for my pictures".*[2]

The final list of exhibitors included Gauguin, Emile Schuffenecker, Emile Bernard, Charles Laval, Louis Anquetin, Léon Fauché, Louis Roy, and Daniel de Monfreid.

Gauguin decided to return to Paris from Pont-Aven in the late spring of 1889 in order to personally supervise the exhibition. There, he helped to convince sympathetic critics to write positive reviews[3], distributed posters throughout the city (illus. 3), and published a small catalogue that included reproductions of drawings by each artist.

Despite this hard work, the exhibition was a financial failure. Not one of the over 100 works exhibited was sold. Nonetheless, the works were seen by many young artists, such as Paul Sérusier, Maurice Denis, and Aristide Maillol. Another important fact, pointed out by John Rewald, was that "this exhibition opened a new chapter in Gauguin's life, for it earned him a few new friends among young authors and painters and greatly contributed to his emergence as the head of a new art movement".[4]

GAUGUIN'S ZINCOGRAPHS FOR THE VOLPINI EXHIBITION

During the winter of 1889 before the Exposition Universelle, Gauguin was in Paris only briefly after his ill-fated sojourn with Van Gogh in Arles the previous fall. Gauguin preferred to return to Pont-Aven, where he had spent most of the previous two years. There he could live cheaply and continue to study Breton landscape and peasant themes in the Synthetist vocabulary he had explored earlier.

Before leaving for Pont-Aven, Gauguin executed eleven zincographs — his first effort at printmaking. These are the prints that were announced in the Volpini exhibition catalogue. While painting was his major preoccupation, he was, nonetheless, fascinated by the idea of exploring different techniques of artistic expression. Over the years, he successfully tried printmaking, sculpture in wood, furniture decoration, ceramics, and painting on glass.

Gauguin's interest in creating prints may have been stimulated by his own sculpture in wood and Emile Bernard's printmaking activities. In 1888 Gauguin was carving wood in Brittany and had also taught Bernard how to do so. Together they carved bas reliefs for wooden cupboards for Le Comte Antoine de La Rochefoucauld and Henri-Ernest de Chamaillard. To record their designs they pressed paper onto the painted reliefs, which resulted in a coarse impression of the carving[5]. While woodcuts, the logical successor to such an experiment, would preoccupy Gauguin a few years later, it was zincography that caught his interest when he returned to Paris for the winter of 1888−89.

Exactly how and why Gauguin turned to zincography is not known, but Emile Bernard may have been the instigator. It seems likely that the two artists kept in contact when both had returned to Paris from Brittany in 1889. Bernard had been working previously in woodcuts (such as B.2), but in 1887 or early 1888, he did his first zincograph, *La Chanteuse* (B.1). Bernard probably then introduced the technique to Gauguin, whose zincs are known to have been printed by Ancourt[6]. Theo Van Gogh also played a role in encouraging Gauguin to experiment with prints at this time[7].

According to Bernard, the two artists executed their zincs separately, without seeing the other's work. Bernard claims that after Gauguin had seen his prints, he then did two more, "in the manner that I had discovered"[8]. This "new" method refers to a mixing of ink and water, called a lavis, which was then applied to the zinc plate with a brush in order to obtain the variegated greys that so effectively create the intermediate tones in both artists' zincographs.

Gauguin's series can be dated quite accurately because it contains two scenes from Arles (illus. 5), which he visited from October to December 1888. Since the prints were exhibited in May 1889, they must have been completed in Paris during the winter of 1889, between his trip to Arles and the opening of the Volpini exhibition[9].

Bernard's prints for his Volpini set (B.4−8 and illus. 6, 10, 12) show a unity of subject matter, whereas Gauguin's album represents various subjects taken from earlier works. This suggests that Bernard set out deliberately to depict a unique theme in his set, while Gauguin may have considered his album as a sort of showcase of his previous work.

Desperate for money during this period, according to Bernard, Gauguin tried to sell his prints even before they were exhibited at the Exposition Universelle[10]. He may well have seen these prints not only as an intriguing experiment with a new technique but also as a way to generate interest in his paintings and to earn a little money. They were almost a prospectus showing the variety of images he had

produced over the years. The motifs he chose reveal his own preference for at least some of his paintings.

After his Volpini zincographs, Gaugin created only two other prints with lithographic ink (Guérin 50, 51) plus two etchings (Guérin 12) and the *Femme aux Figues* (G.5a), which many attribute to Seguin. In 1894, he started to make the woodcuts for which he has become rightfully famous. Even though many of these may have been done in Brittany and Paris, they are essentially visions of Tahiti and represent aesthetic goals different from Synthetism and the Circle of Pont-Aven. They are not, therefore, included in this study.

Stylistically, the Volpini prints are unique in Gauguin's printed work. They also differ from contemporary printmaking ideals in their depiction of light, for in the 1880s, luminosity was a primary goal of many French printmakers. It was usually created by light areas rendered with fine hatchings and by large, undrawn white spaces. Bracquemond, who Gauguin knew and whose wife he tutored in painting, stood among the chief apostles of luminosity. Gauguin, nonetheless, rejected this Impressionist concern for light and luminosity, preferring to use light and dark solely for design purposes. He also shied away from defining forms with precise juxtapositions of light and dark areas, which Felix Vallotton did a few years later, and with the sharp outlines and flat shapes characteristic of Japanese prints.

Gauguin's painterly preoccupations and his evident fascination with the various tonalities of ink washes led him to create marvelous grey tones in his prints that ranged from almost solid black to pearly light greys (illus. 5). These painterly qualities were so strong that Gauguin did not need to add color to his prints. Bernard, on the other hand, watercolored many of his Volpini prints and his impressions in black and white are less powerful than those by Gauguin.

In a few rare cases, Gauguin did experiment with coloring his prints with watercolor and gouache, such as on the cover of his Volpini album (G.1)[12]. On the whole, however, his passion for color was satisfied by the brilliant canary yellow paper on which he printed his zincographs. In choosing this paper, Gauguin demonstrated an understanding of the optical effects created by the juxtaposition of black ink and yellow paper. When black ink is printed in various tones on white paper, greys result. On the bright yellow paper, however, the halftones create warm, brownish-black tones whose color seems to vary in a subtle way depending on the intensity of the black. Gauguin even printed one of his zincs in brown (G.2), indicating how much, for him, even the ink and the paper contributed to his desired aesthetic effect. The result was so successful that Sérusier and Vallotton, among others, used a similar colored paper in later works[13].

The canary yellow paper further underscored Gauguin's enthusiasm for Japanese art[14]. The same shade of yellow can be found in the background of many Japanese prints, on Surinomo (New Year's) cards[15], on the covers of Japanese books such as Hokusai's *Manga*[16], as well as in French publications in the 1880s about Japanese art[17].

Gauguin's yellow paper is so extremely soft and delicate that the plate mark of the zinc is crisply defined in some pristine editions of the series and imprints a frame

Illustration 5.

THE GAUGUIN ZINCOGRAPHS
of the Café Volpini Show (1889)

1. COVER: *Projet d'Assiette – Leda et le Cygne.* G. 1; Guérin 1.
2. *Joies de Bretagne.* Guérin 2.
3. *Baigneuses Bretonnes.* Guérin 3.
4. *Bretonnes à la Barrière.* Guérin 4.
5. *Misères Humaines.* G. 2.; Guérin 5.
6. *Les Laveuses.* G. 3; Guérin 6.
7. *Les Drames de la Mer, Bretagne.* G. 4; Guérin 7.
8. *Les Drames de la Mer (une Descente dans le Maelstrom).* Guérin 8.
9. *Pastorale Martinique.* Guérin 9.
10. *Les Cigales et les Fourmis (souvenir de Martinique).* Guérin 10.
11. *Les Vieilles Filles (Arles).* Guérin 11.

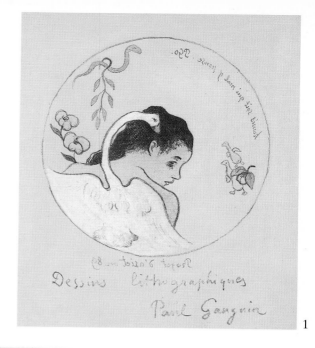

1

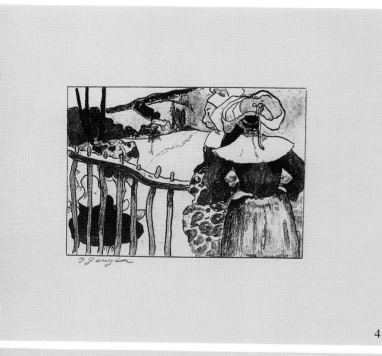

4

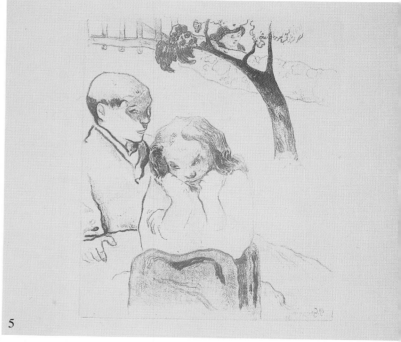

5

8

9

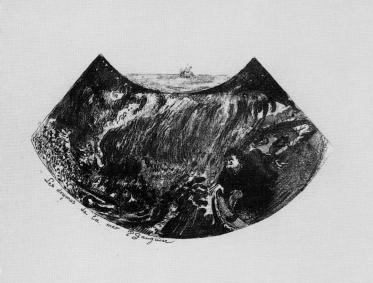

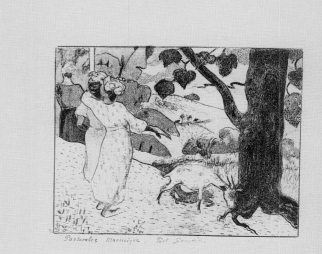

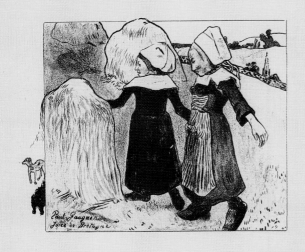

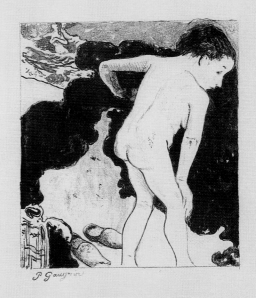

2 3

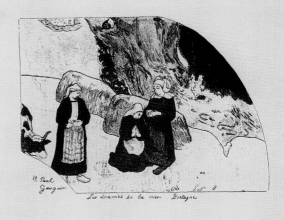

6 7

10 11

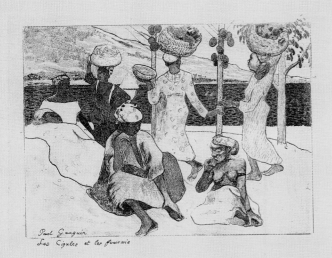

around the image. The softness permits the printed lines to stand out strongly, creating a high relief.

At first glance, the subjects of Gauguin's Volpini prints (illus. 5) appear curiously grouped. Martinique women, Bretons (G.2,3,4), and matrons from Arles seem to have little in common. And why were they combined into one album? As already suggested, the album may have been a showcase of his previous work. In addition, Gauguin consistently repeated certain images in his *oeuvre* and motifs in the Volpini album were all taken from paintings and drawings of the previous two years. Conversely, some of the images in the prints were subsequently used again by the artist in later paintings. The Volpini prints, in general, do not differ stylistically from Gauguin's painted work of the period. Rather, they employ the same vocabulary that balances decorative concerns with evocative themes. Only the liberal use of blank spaces differentiate them in style from his more densely packed contemporary paintings. Unlike Seguin and O'Conor, however, Gauguin used printmaking as an extension of his painterly concerns at the time, rather than a means of formal experimentation. Finally, he was intrigued by the idea of people as a reflection of their environment. This formed a theme in many of his paintings, and is the thread that unifies his Volpini album. Bretons at work or confronted by problems, relaxed and easy-going Caribbean women, and cold, distant Arlesians all fascinated him.

Gauguin seems to have intended to have his zincographs published in an edition of thirty to fifty prints. It is questionable, however, whether the complete edition was ever printed. In view of the printing costs, as well as the lack of commercial success, production may have been stopped before its intended completion.

Gauguin's prints were not all assembled into albums. Each was printed on a very large sheet of yellow paper, approximately 500×648 mm (the standard French size called *Raisin*). Few, if any, were sold during the exhibition at the Café Volpini: In a 1889 sketchbook, sales of some albums were recorded to Jean de Rotonchamp, de Chamaillard, the art dealer Portier, and Theo Van Gogh. Gauguin gave several sets and individual prints to friends such as Sérusier and de Monfreid and some of the prints decorated the walls of Marie Henry's inn at Le Pouldu.

When he sold or gave away a set of the prints, Gauguin apparently cut the papers down to fit into a cardboard cover purchased for the occasion from the shop of C. Guédon, whose label can still be found inside the covers[18]. Different sizes of the prints may be accounted for by the fact that Gauguin only assembled the sets as needed into whatever size carton was available. Prints sold or given away individually and those that remained unsold were left in their original format of large-sized paper.

After the printing by Ancourt, Gauguin gave the zinc plates to his friend Schuffenecker, who later sold them to Vollard who, according to Guérin, used them in the mid 1890s to publish an edition of fifty on white, simulated Japan paper. These prints of inferior quality, have lost all of the subtleties of the grey washes and the painterly qualities conferred by the rich black or brown ink and the canary yellow paper.

1. Rewald, p. 280.

2. Gauguin, *Letters to his Wife and Friends*, London, 1946, to Schuffenecker, Pont-Aven, March, 1889, p. 114.

3. Albert Aurier, "A Propos de l'Exposition Universelle de 1889," *Le Moderniste*, May 26, 1889. Félix Fénéon, "Autre Groupe Impressionniste," *La Cravache*, July 6, 1889.

4. Rewald, p. 286.

5. Guérin, xiii.

6. Guérin p. xi.

7. *Oeuvres Ecrites de Gauguin et Van Gogh*, exhibition catalogue, Institute Néerlandais, Paris, 1975. Letter G. 19.

8. "...*dans la manière que j'avais trouvée*." Emile Bernard, "l'Aventure de ma Vie," unpublished manuscript, Bibliothèque du Louvre, p. 79. Gauguin, however, used this technique in all of his prints, not just in two, making it useless to speculate upon the accuracy of Bernard's account. Nonetheless, since Bernard was a more experienced printmaker, it seems reasonable to assume that Gauguin looked to him for technical advice in the execution of his prints.

9. Bernard refutes this by stating that the prints were done before Gauguin went to Arles. Postmarks on his letters from Pont-Aven and Arles, however, prove that Gauguin was in Paris for only ten days at most before going to Arles. This was hardly enough time to learn a new technique and execute eleven prints, while also organizing his trip to the south. The images of Arles in the series, moreover, contradict Bernard's later reminiscence. Bernard, "l'Aventure de ma Vie," p. 79.

10. Bernard, "l'Aventure de ma Vie," p. 79.

11. One on stone, *Manao Tupapau*, (Guérin 50) and one on zinc, *Ia Orana Maria*, (Guérin 51).

12. Watercolored impressions of other prints in the set are in the Museum of Fine Arts, Boston, the Library of Congress, Washington D.C., and Coll. J.

13. See Sérusier's *Fin du Jour* (S.2) and Vallotton's series of seven zincographs entitled *Paris Intense* (1893–4). Vallotton also did a woodcut printed on white paper and mounted on a canary yellow sheet with the dry stamp of the Estampe Originale, published in 1894 by the Estampe Originale (8th issue, October-December 1894).

14. This passion for Japanese art was shared by most of the Circle of Pont-Aven artists. See Yvonne Thurion, "l'Influence de l'Estampe Japonaise dans l'oeuvre de Gauguin," *Gazette des Beaux Arts*, XLVII, January-April, 1958, pp. 95–114; Weisberg, Cate, Needham, Eidelberg, Johnston, *Japonisme*, exhibition catalogue, Cleveland Museum of Art, 1975; Colta Ives *The Great Wave, The Influence of Japanese Woodcuts on French Prints*, Metropolitan Museum of Art, New York, 1974; and *Japonisme in Art*, ed. The Society for the Study of Japonisme, Tokyo, 1980.

15. Pointed out by Colta Ives, in a conversation with the author. See examples in the Metropolitan Museum of Art's Far Eastern collection, New York.

16. See the copy in the Metropolitan Museum of Art, New York.

17. i.e. Louis Gonse, *l'Art Japonais*, Paris, 1883, and *Le Japon Artistique*, 1889, a journal published by Siegfried Bing.

18. All other covers seen by the author contain the same label.

GAUGUIN

G.1 PROJET POUR UNE ASSIETTE – LEDA
(Project for a Plate Decoration – Leda)

Guérin 1. Colored with watercolor and gouache by Gauguin

202 mm diameter (image)
On canary yellow wove paper: 301×257 mm
Mounted on a cardboard folder: 508×330 mm

Inscribed in plate: "*homis* [sic] *soit qui mal y pense*. P. GO" and "*Project d'asiet* [sic] *en 1889*" Signed in brown ink below the image: "*Etudes lithographiques Paul Gauguin*"

This print served as the cover for Gauguin's Volpini album, with the yellow paper cut down and then glued to the front of a cardboard folder that was covered with a blue marbled paper. The inside of the cardboard cover bears a label saying: "C. Guédon, Papetier, relieur, fabricant, 59—61 Rue Saint André des Arts." Apparently Gauguin colored with watercolor and gouache all of the proofs of this image that were actually cut down and glued. Unsold proofs seem to have been left uncolored on their large sheets of yellow paper.

The composition of this print derives from an 1888 vase and the preparatory drawing Gauguin did of it for Chaplet[1]. Leda is shown eyeing the swan, whose intentions are reflected in the symbolism of the snake above her head and the apple to her right. The girl's face is a slightly refined version of the figure seen in the print *Les Baigneuses* (illus. 5) and similiar to two of the faces in the painting *La Ronde Bretonne* (W 251).

Stylistically, the print relates to Gauguin's contemporary painting, *Still Life with 3 Puppies* (W 293, Museum of Modern Art, New York). In both works, design supersedes the importance of conventional composition and perspective. In addition, the proportional sizes of various elements in both the painting and the print are arbitrary, and finally, a similar thick outline around each object unites them in an overall, decorative, two-dimensional pattern.

The design for *Leda and the Swan* was one of three Gauguin did for circular plates, all on the subject of love[2]. The inscription, "Homis [sic] soit qui mal y pense" ("Those in glass houses shouldn't throw stones")[3], relates to his fascination with society's mores and hypocrisies concerning sexual relations. This

theme is reflected in the other two plates entitled "Long live the joy's of love" and "The follies of love."

Of all of the prints in the Volpini series, this one is the most obvious in its symbolism. Gauguin, however, localized the traditional symbols of mankind's fall by including goslings in his design, a common Breton motif.

Gauguin may have first drawn his design on transfer paper before it was applied to the zinc plate. The faint lines seen in the print are from either transfer paper or an initial sketch in lithographic crayon; the darker ones are his reworking of the image in lithographic ink before printing.

1. See Merete Bodelson, *Gauguin's Ceramics*, London, 1964, figs. 50 and 52.

2. The other two designs are pictured in Rewald, p. 300.

3. translation by Bogomila Welsh-Ovcharov, *Vincent Van Gogh and the Birth of Cloisonism*, exhibition catalogue, Art Gallery of Ontario, Toronto, 1981 p. 195.

references: Chassé, 1921, p. 90; Pont Aven, 1961, no. 9; London, 1966, no. 63i; *Paul Gauguin*, exhibition catalogue, Tokyo, 1969, no. 86, 97; Bodelson, *Gauguin's Ceramics*, p. 71; Colta Ives, *The Great Wave*, exhibition catalogue, Metropolitan Museum of Art, New York, 1974, no. 100; Welsh-Ovcharov, *Vincent Van Gogh and the Birth of Cloisonism*, no. 58a.

GAUGUIN

G.2 LES MISERES HUMAINES
(Human Misery)
Guérin 5

287×229 mm (image), 287×230 mm (plate mark)
On canary yellow wove paper: 496×648 mm
In brown/sanguine, pencil line around lower and left-hand edges.

Signed in plate in reverse: "P. Gauguin 89"[1]

In October of 1888, Gauguin went to Arles to work with Van Gogh. Two images from his Arles period can be seen in zincographs made just after his return to Paris on December 24: *Les Misères Humaines* and the *Vieilles Filles d'Arles* (illus. 5). The young girl pictured in *Les Misères Humaines* appears in a 1888 painting of the same name (W 304), as well as in the painting *Nature Morte aux Fruits* (W 288), and in a later print (Guérin 69). A sketch for the scene in the print shows that a great deal of wash was applied to achieve a painterly effect[2]. This is the only print in Gauguin's

Volpini series to use a colored ink. The sanguine may have been chosen for its warmth and earthiness, both of which relate to the ambiguous theme.

The young woman's disturbed, pensive face must have haunted Gauguin all of his life, for he used her image in different contexts when he worked in Arles, Brittany and the South Seas. That the scene in this print actually took place in Brittany is suggested by the background woman's coiffe. It may be that Gauguin considered this Breton girl, who is often shown in conjunction with a young man, to be a symbol of sexual conflict, a familiar theme in his contemporary work[3]. In the nineteenth century, after all, no respectable Breton woman over the age of twelve would be seen without her coiffe until her wedding night and, thereafter, only by her husband in the privacy of their home. Removing a coiffe in public, as the girl in the print has done, was considered sexually provocative and scandalous.

The composition of *Les Misères Humaines*, with its large scale foreground figures on one side of the scene is typical of Gauguin's work[4]. The discrepancy in scale between these figures and the background tree and figure derives from Japanese prints and is clearly seen in his *Vision après le Sermon*, 1888, (W 245). The motif of the diagonally placed, partially cut-off tree is also evident in this latter painting[5].

A faint border appears around the image on the zincograph. Slightly inside the image itself, this border seems to have been at least partially erased on the plate by the artist, who then went back and added a border in pencil, outside the image, on each of the prints that the author has been able to see. Sometimes this pencil border exists on all four sides, sometimes it is on two or three sides only[6].

1. Stamp of "Vente Sérusier" on verso, see footnote 1, entry G. 3.

2. John Rewald, *Gauguin's Drawings*, New York, 1958, no. 21. An impression of the print exists which was completely reworked by the artist with watercolor and gouache (Coll. J).

3. See *Eve Bretonne* (W 333—34) and the wood relief, *Soyez Amoureuses et vous serez Heureuses*, for example.

4. See *Au Café*, 1888, (W 305), *Dans le Foin*, 1888, (W 301), and *Mme Roulin*, 1888, (W 298) for example.

5. Yvonne Thirion, "L'Influence de l'Estampe Japonaise dans l'Oeuvre de Gauguin," *Gazette des Beaux Arts*, XLVII, January-April, 1956, pp. 95-114.

6. See impressions in the collections of the Metropolitan Museum of Art, New York, Museum of Fine Arts, Boston, and the Fondation Doucet, Paris.

References: Thirion, "l'Influence de l'Estampe Japonaise dans l'Oeuvre de Gauguin," pp. 106—108; *Paul Gauguin*, exhibition catalogue, Tokyo, no. 90. Bogomila Welsh-Ovcharov, *Vincent Van Gogh and the Birth of Cloisonism*, exhibition catalogue, Art Gallery of Ontario, Toronto, 1981, no. 58e.

GAUGUIN

G.3 LES LAVEUSES
(The Laundresses)

Guérin 6.

208×263 mm (image), 223×278 mm (plate mark)
On canary yellow wove paper: 330×472 mm

Signed in plate, lower right: "P Gauguin"[1]

Gauguin took his image directly from a painting done in Arles, *Les Lavandières à Arles* (W 303)[2]. He first used lavis over the lines created by the lithographic crayons and then a pen with lithographic ink over that in order to emphasize his forms more clearly. In a few areas, he scratched through the ink to expose tiny white lines for additional texture and modeling.

Wildenstein identifies the washing women in Gauguin's painting of the laundresses as Arlesian. He also notes, however, that the coiffe and cow are more reminiscent of Brittany than of Provence[3]. Geographical exactitude, however, was never really Gauguin's aim. In describing his painting of *Les Misères Humaines*, (W. 304), he noted defiantly, "It is an impression of vineyards that I saw in Arles. I put in some Bretons — so much for exactitude"[4]. The women appear in typical Pont-Aven clothes: the kneeling woman wears what is called a "*coiffe de travail*," while the other woman wears either a "*coiffe de basin*" or a mourning coiffe. Their shawls are also in a style typical of Pont-Aven as is the wooden washboard.[5]

Women washing laundry along the edge of a river was a common, everyday sight in both Arles and Pont-Aven. Each house bordering the river in Pont-Aven had a special washing place, where the women could congregate to work and chat. While there were also common wash areas along the river, much of the work seems to have been done in smaller groups behind each house. The Aven River, as it flows through Pont-Aven, is shallow in parts, rocky and full of eddies and swirls in others, just as Gauguin depicts. On the only known watercolored proof of this print (Museum of Fine Arts, Boston), he colored the upper left-hand area beige, suggesting a beach or sandy bank. The composition

also exists in a watercolor on silk, which Rewald identifies as a study for the painting[6].

Gauguin used the same bird's eye viewpoint of the water in this print as he did in *Les Drames de la Mer* (G.4). The water appears as a flat, abstract entity, full of decorative swirls and curving shapes that bear only a vague resemblance to waves and eddies[7]. Their schematized forms were inspired by Japanese prints, as were the cut-off forms of the cow and the woman to the left.

The cow in the lower left corner of the print is very similar to the cow in Bernard's cover for his *Les Bretonneries* (illus. 6)[8]. In fact, the large scale of the figures, the use of one figure with her back to the viewer facing into the scene, and the full, rounded forms of the women are all characteristic of Bernard's contemporary work, suggesting the mutual influence exercised by the two artists. In his zincographs, however, Bernard's space is usually narrow, whereas Gauguin prefered plunging perspectives and distant vistas. Nonetheless, in all four of the Gauguin zincographs discussed here, the apparent three-dimensionality of the settings is contradicted. In *Les Misères Humaines* (G.2), a blank middleground divides the foreground and background. The curve of the tree, however, links the two and helps the viewer to comprehend the design as a two-dimensional series of curves. In both *Les Drames de la Mer* (G.4) and *Les Laveuses*, the absence of sky and horizon line helps to flatten the space. The treatment of the water in terms of shapes and textures causes it to be seen as a flat backdrop to the figures and not as a receding element. In this mannner one can read the surfaces of each design as a series of curves and shapes, rhythms and repeated patterns.

1. This particular impression is from the Sérusier estate, as noted by the stamp "Vente Sérusier" on the back, referring to the estate sale, Hotel Drouot, Paris, June, 1984.

2. The image in the painting is the reverse of that in the print, a normal occurrence since the direct zincograph printing process, unlike that of a transfer lithograph, reverses the image drawn on the plate.

3. W. 303, p. 112.

4. "C'est un effet de vignes que j'ai vu à Arles. J'y ai mis des Bretonnes – Tant pis pour l'exactitude." Paul Gauguin, *Correspondance de Gauguin*, vol. 1, Paris, 1984, November, 1888, p. 275. Translation by the author.

5. Information from Catherine Pujet, Curator of the Musée de Pont-Aven.

6. John Rewald, *Gauguin's Drawings,* New York, 1958, no. 17.

7. For a similar treatment of the water, see George Lacombe's three paintings, *The Grey Sea*, 1890 in the Museum of Fine Arts, Utah and *Les Falaises à Camaret* and *La Mer Jaune,* both of 1892 in the Musée des Beaux Arts, Brest.

8. Pointed out by Bogomila Welsh-Ovcharov in *Vincent Van Gogh and the Birth of Cloisonism,* exhibition catalogue, Art Gallery of Ontario, Toronto, 1981, p. 198.

References: Yvonne Thirion, "l'Influence de l'Estampe Japonaise dans l'Oeuvre de Gauguin," *Gazette des Beaux Arts,* XLVII, January-April, 1956, p. 107; London, 1966, no. 63 vi; *Paul Gauguin,* exhibition catalogue, Tokyo, no. 91; Colta Ives, *The Great Wave,* exhibition catalogue, Metropolitan Museum of Art, New York, 1974, no. 104; Welsh-Ovcharov, *Vincent Van Gogh and the Birth of Cloisonism,* no. 58f.

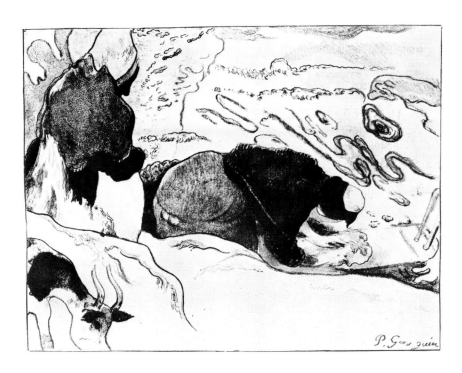

GAUGUIN

G.4 LES DRAMES DE LA MER, BRETAGNE
(Dramas of the Sea – Brittany)
Guérin 7

168×225 mm (image – irregular shape),
203×284 mm (plate mark)
On canary yellow wove paper: 305×448 mm

Signed in plate, lower left: "89 Paul Gauguin" and in center: "Drames de la Mer Bretagne"

The backwards "9" in the inscription suggests that Gauguin drew this image directly onto the zinc plate with a hard lithographic pencil and then went over some of the lines with pen and brush-applied lavis. He obviously delighted in the textural varieties made possible by the lavis, especially in the turbulent sea behind the figures. He went back over it with a pen in order to make the outlines firmer.

The use of two different perspectives – the bird's eye view of the sea and an almost frontal view of the figure – is distinctly Japanese in style, yet also relates to the locale. Along the coast near Pont-Aven the fields often go right to the edge of the high cliffs, which then plunge steeply down to the sea. Gauguin's painting, *Au dessus de la Mer* (W 360) of 1889, depicts a similar plunging perspective. In the painting, the sea effectively recedes into the distance, while in the print, the movement seems to be from bottom to top rather than front to back[1].

The title, *Les Drames de la Mer*, refers to a story by Edgar Allen Poe about a terrible whirlpool off the coast of Norway and three fishermen who are driven into it by a storm[2]. Gauguin illustrated the story in another print of the same name in the Volpini series (Guérin 8, illus. 5), showing a sailor reaching out for his drowning

brother, immediately before being swept into the whirlpool himself. In this print, he used the same title but added "Bretagne" to it, thus refering to the story but changing the locale to Brittany. By moving the scene from Poe's Norway, he depicted the familiar and emotionally charged scene of Breton women praying for the safety of their husbands at sea in a storm. This theme was also a popular one in Academic circles, often seen in Salons of the end of the century[3].

The theme of Breton women praying in the open air brings to mind Gauguin's *Christ Jaune* (W 327, Albright Knox Gallery, Buffalo.) In this painting, three women pray below a crucifix planted in the midst of a field near Pont-Aven. The focus of their devotion is represented on the cross, while in the print only the inscribed title below the work indicates the nature of the women's prayers.

The kneeling figure is reminiscent of another one of Gauguin's religious scenes: *Breton Calvary: Pardon in Brittany*, 1889[4]. The cow stands in a position similar to that in *Les Laveuses* (G.4) and the standing figure to the left resembles the one on the left in Gauguin's painting of *Les Misères Humaines*, 1888 (W 304).

While Gauguin's technique in *Les Drames de la Mer – Bretagne* incorporates a striking use of the lavis, an unusual bird's-eye perspective, and a Japanese style in the cropping of the cow, the figures themselves lack the bold cropping or monumental presence of either those in the *Christ Jaune* or those in some of the other zincographs, including *Les Laveuses* and *Bretonnes à la Barrière* (illus. 5).

The curved shape of the print is almost a half fan and may relate to the *Drames de la Mer* (Guérin 8, illus. 5), done in the shape of an inverted fan, which suggests the whirlpool described in that print. Here, it may also be Gauguin's device to emphasize the feeling of a story illustration rather than of an actually observed scene.

1. Welsh-Ovcharov argues that the site could be Le Pouldu. Gauguin certainly could have visited Le Pouldu during the summer of 1888, although no specific references to such a trip are known. The coiffes of the women in the print, however, are not those of Le Pouldu, but of Pont-Aven. Bogomila Welsh-Ovcharov, *Vincent Van Gogh and the Birth of Cloisonism*, exhibition catalogue, Art Gallery of Ontario, Toronto, 1981, p. 198.

2. Edgar Allen Poe, *Histoires Extraordinaires*, trans. by Charles Baudelaire, Paris, 1884.

3. See, for example, Edward Emerson Simmon's *Awaiting his Return*, 1884, pictured in David Sellin, *Americans in Brittany and Normandy, 1860 – 1910*, exhibition catalogue, Phoenix Art Museum, 1982, p. 106.

4. Welsh-Ovcharov, *Van Gogh and the Birth of Cloisonism*, p. 209. Not in Wildenstein.

References: Chassé, 1921, p. 87; London, 1966, no. 63 vii; *Paul Gauguin*, exhibition catalogue, Tokyo, no. 92; London, 1980, no. 38a; Welsh-Ovcharov, *Vincent Van Gogh and the Birth of Cloisonism*, no. 58g.

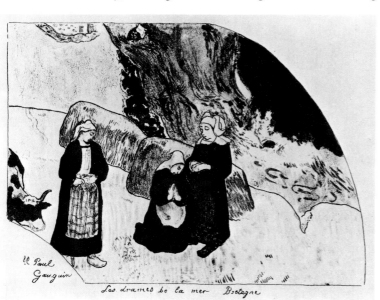

Emile Bernard

(1868–1941)

Emile Bernard's interest in printmaking probably began as early as 1887 [1] when he was working closely with Van Gogh. During the spring of that year Van Gogh, who possessed a large collection of Japanese prints of his own [2], organized an exhibition of Japanese prints at the Café le Tambourin. Bernard admitted his debt to Japanese prints in the development of "Cloisonism," a style he and Louis Anquetin were exploring in 1887 [3], that involved the use of flat planes of color bounded by thick outlines reminiscent of stained glass windows. Medieval art fascinated Bernard; he admired it not only for its simplicity and emotional intensity but also, naively, as a symbol of a lost way of life once based on religious values.

Bernard respected medieval woodcuts and turned to this medium himself in *La Dame au Manchon* (B.2). As Jacquelynn Baas has pointed out: "The Romantic nostalgia for material as well as spiritual purity, common to artists of his generation, was an obvious factor in Bernard's attraction to the sidegrain woodcut in 1888" [4]. "Sidegrain" is a way of cutting wood so its grain runs the length or width of the block, as opposed to endgrain blocks which are cut across the grain. The latter were used extensively in the late nineteenth century for what are also called "wood engravings" [5], a technique rejected by Bernard, who preferred the cruder appearance that can be obtained in prints taken from a sidegrain block. Although he completed a few woodcuts before 1890, he embraced the medium with gusto only after that date. He is supposed to have founded journals entitled *Le Bois* in 1891 and *Le Livre d'Art* about the same time. Both of these were intended as vehicles for publishing his woodcuts. Whether or not the first journal was really ever published is uncertain, but his frontispiece exists [6]. His woodcuts were also published in *Ymagier,* a short-lived journal founded by Alfred Jarry and Rémy de Gourmont in 1894.

The friendship and collaboration of Bernard and Gauguin began in the late summer of 1888, when the younger man came to Pont-Aven. Together the two artists enthusiastically explored the ideas of Cloisonism adopted by Bernard and Louis Anquetin in Paris during the previous two years. They also discussed the abstract notions of harmony and rhythm in art developed by the Symbolists during those same years [7], as well as Japanese art and other non-Western sources. The fruits of these discussions were then grafted onto their mutual fascination with images of Brittany.

A well-educated and brash young man, Bernard tended to formulate new aesthetic and stylistic theories in addition to painting. The older Gauguin, who was more reflective and intuitive, often provided the creative spurts of genius for the use and development of these joint ideas. The two artists worked together for several months, but further collaboration was prevented by Bernard's father, who resented his son's artistic career and considered Gauguin a bad influence. Bernard was subsequently forbidden to go to Pont-Aven when Gauguin was there and had to rely on letters and encounters in Paris in order to maintain their exchanges of ideas. He continued, however, to see and admire Gauguin's works in Paris galleries and collections until their friendsship ended in 1891[8]. Bernard did not abandon Brittany; he spent time on the northern coast, at St. Briac, during the following years and visited Pont-Aven in 1892 when Gauguin was in Tahiti.

During the winter of 1888−89, just after his return from Pont-Aven, Bernard executed a series of seven zincographs (B.4−8, illus. 6, 10, 12)[9]. These were announced in the Volpini catalogue in the spring of 1889 and were available for viewing at the exhibition. The edition must have been extremely small since these prints are very rare indeed. It is not even known if an actual edition was ever printed. The words "available upon request" in the Volpini catalogue suggest that they may have been printed only when ordered. The zinc plates were professionally printed, probably in the atelier of Edouard Ancourt, who printed Gauguin's zincs of the same winter.

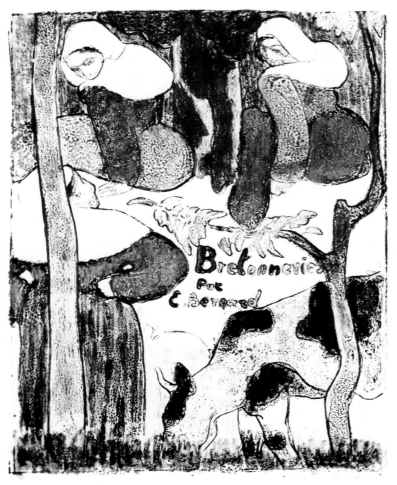

Bernard seems to have watercolored most of these impressions , experimenting widely with colors, making each print unique. He may have had color in mind when he drew these zincographs, as he did with his polychromed wood-carvings. This may explain not only why almost none exists in black and white, but also why Bernard's black and white images do not have nearly the presence of Gauguin's uncolored zincographs.

After being watercolored, many of Bernard's prints were individually

Illustration 6. EMILE BERNARD, Cover for *LES BRETONNERIES*, (1889, zincograph with watercolor, 314×245 mm). This is the cover for Bernard's series of six watercolored zincographs first shown at the Volpini exhibition. The album explores the theme of Breton women at work or play in their festival coiffes. The formal concerns of Synthetism, however, outweighed any attempt at making a sociological statement about the people who served as models.

glued to a green cardboard backing. There is no evidence that his Volpini series was assembled in a cardboard folio as was Gauguin's. Unlike Gauguin, however, he titled his album, *Les Bretonneries* (illus. 6).

Bernard conceived his album as a coherent, unified exploration of the theme of Breton peasants at work or play. His fascination with Japanese prints and knowledge of thematic albums of prints by such Japanese artist as Hiroshige and Harunobu may have influenced him as he planned his work[10].

Albums of prints based on a particular theme were not unique in French art of this time. The following year, for example, Camille Pissarro and his son, Lucien, planned a series of six wood engravings entitled *Travaux des Champs* which they called their *Manga* after Hokusai's album of genre scenes[11]. The *Manga* was also admired by Gauguin, who used one of the figures in his 1888 *Vision après le Sermon,* a painting well-known to Bernard. The subject matter chosen by Bernard and Pissarro differed from that in Japanese albums, which contained mainly views of peculiar places or "exotic" people, such as actors and courtesans. Aside from the *Manga,* their series rarely showed anything as common as peasants, except when they served as small figures populating landscapes. French artists of the late nineteenth century, from Millet to Pissarro and the Pont-Aven artists, however, were fascinated by the life of peasants[11]. Bernard as well as the other Pont-Aven artists saw the peasant as the personification of all the qualities they so admired in Breton culture, including simplicity, harmony with nature, religious fervor, and freedom from Parisian standards of sophistication and beauty.

A stylistic analysis of Bernard's work is complicated by his rapid absorption of new ideas and their simultaneous translation into a number of different styles. Chronology is difficult as well, due to the backdating of some of his works[13]. Fortunately, a few of the prints can be dated with confidence, allowing us to delineate the basic sequence of his printed works.

Bernard's earliest prints, such as the zincograph *La Chanteuse* (B.1), are close in style to the works of his friends Toulouse-Lautrec and Anquetin. Like them, he chose Parisian themes; his lines are also thick and heavy and his forms flat. Japanese design principles are evident, especially in the way figures are cut off.

The period of collaboration with Gauguin beginning in late 1888 led Bernard's lines to become more supple and lively while his forms became more consciously repetitive. Following the principles of Synthetism, he superimposed a concern for decorative forms and surface harmony onto his themes of Breton peasants.

The lines of the 1889 prints are delightful: they are thinner than in *La Chanteuse* and create less of a confining border around each form than those heavy, dark outlines that were a key element of Bernard's Cloisonism. These later lines flow rhythmically, distort nature freely but never abandon their reference to natural shapes. The smoothly curved, flat areas inside the lines have weight and substance. By the absence of detail, these forms melt into the harmonious composition created by their repeated forms.

Little symbolic content can be inferred from *Les Bretonneries*. While Bernard was an intensely philosophical man and very conversant with Symbolist theories as

well as Classical ideas, he seems to have been more concerned with form than with content in these prints.

The change in style as well as subject matter between *Les Bretonneries* of 1889 and *Les Cantilènes* (B.10−13) of 1892 is striking[14]. This latter series of nine zincographs loosely illustrated Jean Moréas' group of forty-one poems entitled *Les Cantilènes,* which was first published in 1886. Paul Fort intended to publish the prints in his *Livre d'Art,* but the project was never completed[15].

While the landscape backgrounds in some of *Les Cantilènes* prints evoke the feeling of those in *Les Bretonneries,* the figures are drawn in a totally different style: the forms are flat, elongated, and defined by a continuous, sinuous line with none of the swelling amplitude that characterizes the figures of *Les Bretonneries.* As in many of his paintings of the early 1890's, Bernard had become interested in flat, two-dimensional shapes with lines stretched long and thin to create patterns that are strikingly Art Nouveau in appearance. As in the earlier series, Bernard experimented widely, using black ink in some editions with no coloring (B.12a), sanguine colored ink in others (Metropolitan Museum of Art, New York), and watercolor in others (B.10,11,12b,13).

The subject matter of *Les Cantilènes* further indicates Bernard's changing and expanding interests in 1892. He moved rapidly from contemporary Breton peasants and their physical environment to a fascination with religious and medieval themes. This shift resulted from his many visits to Brittany, which he described in this way:

> *"I became a Catholic, ready to fight for the Church, the upholder of all traditions and the generous symbol of the most noble sentiments...I became intoxicated with incense, with organ music, prayers...and I returned to the past, isolating myself more and more from my own period whose preoccupations with industrialism disgusted me. Little by little, I became a man of the Middle Ages; I only loved Brittany".*[16]

While the theme of *Les Cantilènes* is medieval, the prints have a theatrical quality, as if they each were a scene from a play. All the figures are large, frontal, and occupy most of the picture area, as if on a small stage. Even the backgrounds are more like stage decors than landscape settings.

Bernard turned increasingly towards Renaissance and Medieval sources for inspiration in the years following his joint efforts with Gauguin, which led to a multitude of styles. He finally left Europe in 1893, not to seek the primitive societies for which Gauguin yearned, but to explore the roots of Christianity. He eventually settled in Cairo and did not return to France until 1904[17].

1. Baas points out earlier student efforts in Baas, Field, 1984, p. 65.

2. *Japanese Prints Collected by Vincent Van Gogh,* Rijksmuseum Vincent Van Gogh, Amsterdam, 1978.

3. Emile Bernard, "Notes sur l'Ecole dite de Pont-Aven," *Mercure de France,* XII, 1903, p. 676. For more on Cloisonism, see Bogomila Welsh-Ovcharov, *Vincent Van Gogh and the Birth of Cloisonism,* exhibition catalogue, Art Gallery of Ontario, Toronto, 1981.

4. Baas, Field, 1984, p. 18.

5. Baas, Field, pp. 14−17.

6. Foundation Doucet. Pictured in Baas, Field, 1984, fig. 14, p. 65.

7. See H.R. Rookmaaker, *Gauguin and 19th Century Art Theory,* Amsterdam, 1972.

8. Beginning as early as 1889, certain critics such as Félix Fénéon and Albert Aurier consistently ignored Bernard's role in the development of Synthetism. Gauguin encouraged the emphasis of his own role as the sole genius behind the new movement and dismissed Bernard's claims that it was in fact he who had "discovered" Synthetism and had "revealed" it to Gauguin. After 1891, the two artists became bitter enemies as each tried to defend his own position.

9. Exactly how many zincographs were in Bernard's set has been debated. The grouping of the seven discussed here is based on impressions found in the Fondation Doucet, Paris. Six of these are numbered in pencil, 1−6, in what could be Bernard's own hand. Jacques Doucet acquired the set directly from Bernard, who annotated them sometime before they entered the Fondation Doucet's library between 1911 and 1914. All but one of these prints show evidence of having been glued to the same green colored cardboard. *Le Moissonneur* (B.8) is not numbered in the Doucet set. Impressions of it in the Rutgers University Art Gallery, New Brunswick, New Jersey, and the Metropolitan Museum of Art, New York, however, were glued to the same green colored cardboard. Other watercolored zincographs by Bernard are in the same style, similar in size, and on similar paper. None seen by the author shows evidence of either the green cardboard backing or numbering. In numbering the Fondation Doucet's set many years after the fact, either Bernard may have forgotten that *Le Moissonneur* had originally been part of the set, or impressions of it were included in only some sets. Since the whole zincograph project for the Volpini show was a financial failure, Bernard may even have changed the contents of his albums in subsequent sales or gifts.

10. Hiroshige, *100 Famous Places in Edo,* and *36 Views of Mt. Fuji.* Harunobo, *8 Views of indoor Life.*

11. Christopher Lloyd, "Camille Pissarro and Japonisme," *Japonisme in Art,* Tokyo, 1980, p. 182.

12. Richard and Caroline Bretell, *Painters and Peasants in the 19th Century,* Geneva/New York, 1983.

13. Erroneous dates were put on works by both Bernard and his son, often many years after their execution. A number of different prints have been seen with the notation in Bernard's hand "Mon Ier bois," notably *Head of 2 Women* (Jim Berquist, Boston) and *La Dame au Manchon* (Fondation Doucet, Paris).

14. The Metropolitan Museum of Art, New York, has a trial proof for one of the prints of this series, signed and dated 1888 (*La Femme Perfide*). The signature, in pencil, was undoubtedly added later in another example of Bernard's frequent backdating of his works. Since several of the *Cantilènes* prints are dated "92" *in the plate,* we should accept 1892 as the date for all of the prints in the series.

15. The Bibliothèque Nationale includes the series in an album entitled by Bernard, "Epoque de Pont-Aven, 1888−1892," with a special cover by Bernard.

16. Emile Bernard, "Introduction," *Lettres de Paul Gauguin à Emile Bernard,* ed. Pierre Cailer, Geneva, 1954, p. 38. Trans., Rewald, pp. 437−8.

17. Many posthumous editions exist of Bernard's prints. Especially common is a photomechanical reproduction of a colored set of *Les Bretonneries* made in Scandinavia in the 1950s. Some of these were crudely stenciled and colored with gouache. A posthumously printed set of six of *Les Cantilènes* is in circulation, published in Paris in the late 1950's by la "Guilde Internationale de la Gravure, Geneva". The prints were heavily inked and printed on simulatated Japanese paper. *La Lessive* was posthumously printed by the Guilde de la Gravure in an edition of 200 in 1953. These are usually stamped with an "E B" signature, and some have a stamped signature, "Emile Bernard".

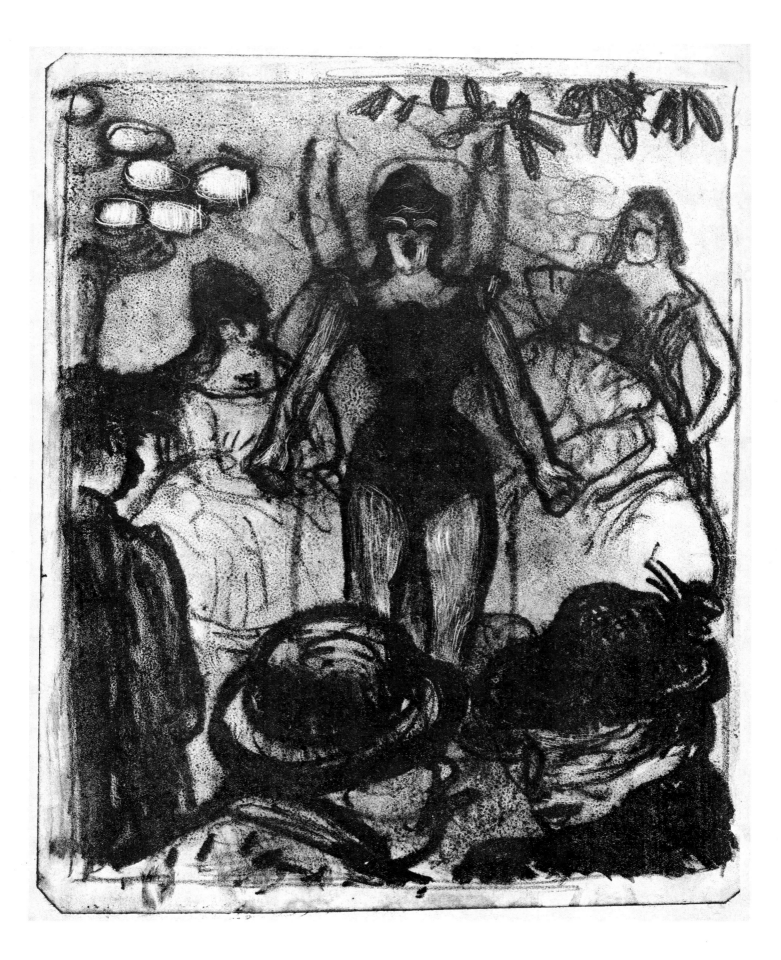

B.1 LA CHANTEUSE, c. 1887
(The Singer)

Early state, zincograph

280×227 mm (image): 299×238 mm (plate mark)
On cream wove paper: 329×249 mm

The subject of this print suggests Bernard's interest in the theme of the "Café Concert," an interest shared by his friend and fellow student at Cormon's studio in Paris, Toulouse-Lautrec. While the form's dark outlines and the emphasis on flat shapes in the final state (illus. 7) suggest the style of Pont-Aven, the print probably, in fact, predates Bernard's involvement with Gauguin. The almost caricature-like features of the figures, as well as the subject, suggest the date of 1887. The date of 1884 on an impression in Quimper is unreasonable since Bernard was only sixteen years old at the time.

Two different states of this print are known, allowing a rare insight into Bernard's mind as he thought out his composition and struggled with the questions of lighting and emphasis of the figures. When this, the early state, is compared to the final state, it is evident that Bernard made considerable changes. For example, he moved the background figures around and darkened their heads so that the features were obscured. He also added more foliage and raised the singer's arms.

In this early state, Bernard obviously experimented with three different positions for the singer's arms. He also highlighted her arms and legs by the wiping of the plate and by scratching white lines through the black ink. Another version exists in which Bernard colored the central figures and the foreground in pale chalk colors (Fondation Doucet). In the early state, he also emphasized the figures themselves, whereas in the final state he flattened, blurred, and subordinated the figures to the lighting effect of the whole. Lighting effects and modern subject matter became, in the end, Bernard's major concerns in this pre-Pont-Aven work.

Reference: Quimper, 1958, no. 104 (signed and dated 1884)

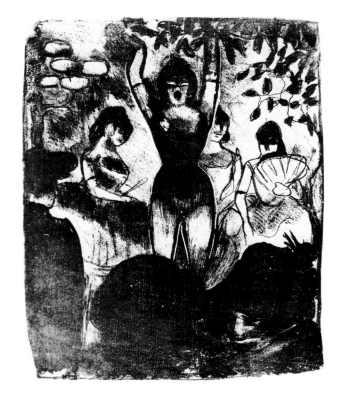

Illustration 7. EMILE BERNARD, *LA CHANTEUSE,* (ca. 1887, zincograph, 280×227 mm). This is the final state of Bernard's print of a café concert singer. Done in Paris before he became closely associated with Gauguin, it stresses Cloisonist outlines, lighting effects, and a contemporary Paris theme, rather than the Synthetist emphasis on linear rhythms, flat patterns, and Breton images that will preoccupy Bernard in 1888–89.

B.2 LA DAME AU MANCHON, c. 1888
(Woman with a Muff)

Woodcut

330×107 mm (image)
On medium-weight beige wove paper: 400×167 mm.

Stamped in grey, lower right with estate stamp:
"Emile Bernard"

This sidegrain woodcut of an elegant Parisian is one of Bernard's first prints. The wavy lines are reminiscent of prints by Anquetin and of contemporary works by Toulouse-Lautrec, with whom Bernard attended art classes at the Atelier Cormon in the mid-1880s. Bernard and Anquetin continued to work closely together in 1887 and 1888 exploring Cloisonism.

Anquetin's paintings, drawings, and prints are often characterized by a wavy, nervous outline, as well as by the frequent depiction of elegantly dressed women, both of which can be seen in Bernard's print[1]. The woman's cut-off figure and the flat form of her dress are Japanese in inspiration, another common characteristic of Bernard's early works. Additional sources of influence may have been Japanese woodcuts by Eisam, Eizan, and Kuniyoshi in Van Gogh's collection[2], which also portray elegantly dressed women filling the picture plane.

An undated drawing in the Altariba Collection shows a similarly clad woman with a muff, but she is more squat. By lengthening her figure, Bernard created a more elegant pose[3]. In a watercolor also related to the print (illus. 9), Bernard depicted a well-dressed Parisian prostitute with a similar hat, coat, and muff walking past a tree, with a man and carriage in the background. Accompanying the drawing is a statement loosely translated as: "There are the trees that lose their coats. Nevertheless, it is not the moment to let go of them." He is sarcastically referring not to the leaves on the trees, but to the fur worn by the woman in the foreground[4]. In utilizing this image for his woodcut, Bernard eliminated its anecdotal nature by minimizing the setting and dropping the legend.

The Fondation Doucet owns another state of this print which appears to be a zincograph (illus. 8). Several details of the woman's dress were changed and the figure of a man and background details were added. This leads us to believe that the Doucet impression was made by printing the woodblock with lithographic ink onto a transfer paper. Changes and additions were then made and the image finally transferred to a zinc plate for printing. The advantage of this process would have been that Bernard could have achieved the effect of a woodcut in his main figure, and then added other

details after the image was transferred. Additions on the block, after all, are difficult to do when making a traditional woodblock[5].

The Doucet print is signed in ink and dated 1888. This date is believable because the print resembles Anquetin's works. It must, then, date from early or mid 1888, before Bernard met Gauguin in Pont-Aven during the fall of that year[6].

1. See Bogomila Welsh-Ovcharov, *Vincent Van Gogh and the Birth of Cloisonism,* exhibition catalogue, Art Gallery of Ontario, Toronto, pp. 248–255, for examples of Anquetin's work.

2. *Japanese Prints Collected by Vincent Van Gogh,* Rijksmuseum Vincent Van Gogh, Amsterdam, 1978, pp. 30–32, 70–72.

3. Pictured in *Emile Bernard,* exhibition catalogue, Goteborg Konstmuseum, 1969, no. 113.

4. *"V'la les arbres qui perdent leur p'lure. C'est cependant pas l'moment d'la lacher."* The drawing comes from an album of drawings given to Van Gogh entitled "Au Bordel." Rijksmuseum Vincent Van Gogh, Amsterdam.

5. Pierre Courtin suggested, in conversation with the author, 1986, that the Fondation Doucet's print may be a monotype.

6. Bernard first met Gauguin in Pont-Aven in 1886, but Gauguin's then very impressionistic style had little influence on him.

References: Bremen-Lille, no. 197; Baas, Field, 1984, fig 3, p. 18.

Illustration 8. EMILE BERNARD, *LA DAME AU MANCHON,* (1888, zincograph, 315×105 mm). While Bernard's technical experimentation makes it at times difficult to define the exact technique used for a particular work, it appears that he transferred his woodcut (B.L), with changes and additions to make this zincograph.

Illustration 9. EMILE BERNARD, *LA DAME AU MANCHON,* (1888, gouache and ink, 400×350 mm). This is one of the 12 drawings which the artist entitled *Au Bordel* and dedicated to Vincent van Gogh. He used the image of this fur clad woman again in his woodcut (B.2).

B.3 LA LESSIVE, 1888
(Doing the Laundry)

Zincograph highlighted with canary yellow watercolor

111×395 mm (image)
On thin wove off-white paper: 115×399 mm

Signed in plate, lower left: "Emile Bernard, 1888"[1]

The very medium of this print is questionable — it has been referred to as a woodcut as well as a zincograph (see references below), both of which may be correct. From most impressions seen by this author, it appears that Bernard first cut a woodblock, from which he made impressions on which the relief of the block can be seen. He also used the woodblock to print the image with lithographic ink onto transfer paper, which was then used to make the zincograph. Bernard may have gone to all of this trouble because the harsh line inherent in a woodcut did not produce the softer atmosphere he sought, nor would a woodcut have allowed him the flexibility of making changes.

Each impression of the print seen by the author looks slightly different, while the coloring of each varies radically. The Yale Art Gallery has two prints, representing separately the left and right sides of the present print, but with certain changes and a border added. This can be achieved easily in a zincograph, but is difficult to do with a woodcut.

The simplified shapes of the figures, as well as their distortions, link this work to *Les Bretonneries*, (B.4–8) of early 1889. The rare presence of a date in the plate, enables us, for once, to place one of Bernard's works definitely, that is, late 1888, after Bernard and Gauguin had worked together in Pont-Aven. This print may have been done just prior to *Les Bretonneries,* and was probably also printed in Ancourt's studio.

Common to this print and to the prints in *Les Bretonneries* is a Synthetist emphasis on linear rhythms and repeated forms. The line, which swells and changes as it defines figures, plants, and animal forms, is less confining than in *La Chanteuse* (B.1). Here, it seems only an outline to a full and living form, not a rigid border.

La Lessive's composition spreads horizontally with no single focal point, a characteristic common to Japanese screens and prints of a similar format. The lack of depth further emphasizes the horizontality. Bernard totally relied on line in this work, using none of the tonal variations seen in the lavis of *Les Bretonneries*.

The lines created by gouging the wood offer little definition of modeling and simply add texture. As Field points out, they reflect the mind of a sculptor more than a printmaker in their rudimentary hatching[2].

A comparison of this work with Bernard's painting of *Bretonnes dans la Prairie* (illus. 11), done at approximately the same time, reveals a similar discrepancy in the scale of the figures. The painting's central figure, with her hands on her hips, juxtaposed with a figure seen from the rear, relates to the two figures at the extreme right of the print. The figures have similar distortions, including curious, slanted, almond-shaped eyes. Bernard's undulating, lively line characterizes both works and gives life and interest to the figures.

A feeling of relaxation and familiarity is present in both the painting and the print as the figures chat and work together. Placing Breton figures alongside outsiders in the painting suggests a story or event of particular significance, such as a Breton Pardon, which always attracts tourists. The print, in contrast, appears to be simply a charming scene of laundresses working in a field amongst a flock of geese, although Breton women actually did not wear their large, starched coiffes and collars while hanging laundry! For everyday work, they wore a simple cylindrical cap. Bernard, therefore, invented his scene, using Bretons dressed for church or a festival as models. This fact, combined with the decorative nature of the print implies that it may have been done in Paris, far from the Breton site that inspired it.

1. A state of this print which is not signed in the plate, belongs to the Yale Art Gallery, New Haven, Connecticut.

2. Baas, Field, 1984, p. 67.

References: Quimper, 1958, no. 105; Bremen-Lille, no. 195 (as zincograph); Robert Schmutzler, *Art Nouveau*, New York, 1978, no. 65 and pg. 65 (as woodcut); London, 1980, no. 2 (entitled "Cinq Femmes étendent du linge" as woodcut); Baas, Field, 1984, no. 31 (as woodcut).

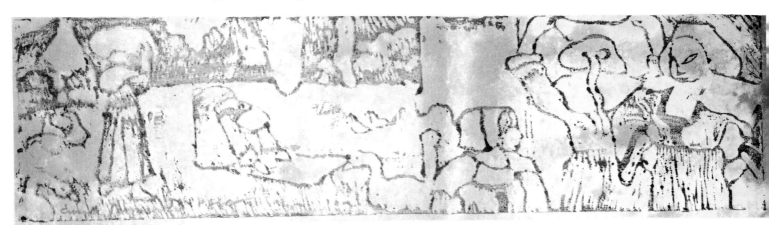

LES BRETONNERIES
1889
Zincographs for the Volpini Show

BERNARD

B.4 BRETONS DANS UNE BARQUE
(Bretons in a Ferryboat)

Colored with gouache

317×247 mm (image)
On thin cream wove paper: 327×251mm

Signed in ink in lower left-hand corner: "Emile Bernard"

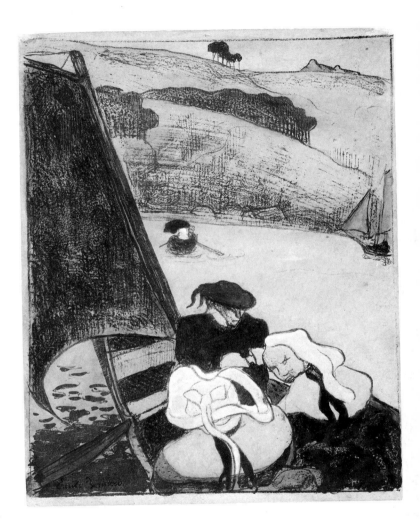

In this boldly colored print, two women of Pont-Aven, wearing formal coiffes and collars, are pictured being rowed and sailed across the Aven river. Small rowboats equiped with sails provided regular ferry service in the 1890s between the villages along the river. The river, after all, is long and has few bridges, so ferry boats, in addition to the fishing and freight boats, added to the bustle. The topography of the area between Pont-Aven and the village of Port Manech to the south, is exactly as Bernard pictured it: clusters of dense, windblown trees upon high rolling hills curving smoothly to the rocks and water below. Gentle curves predominate, with few jagged, irregular shapes.

Bernard used the composition of this print again in his painting of *Marin Breton* (Luthi 189) of the same year. The strong diagonal of the boat and three figures are Japanese in inspiration, as is the dramatic separation of foreground and background[1].

Bernard balanced the strong compositional element created by the large right-angled triangle of the three figures and the sail with the gentle slope of the background hills. The lines of these hills and their vegetation slope right to the orange sails of the boat on the right-hand margin. The pointed triangle of the sail then sends the eye back into the image.

The colors are brilliant and varied. The bright blue hat of the man rowing provides a focal point, while the repeated orange color ties the foreground and background together, as do the repeated greens and blues. Bernard also made small, regular scratches through many of the black lines in the print in order to soften their harshness.

In the nineteenth century, it was common for artists to make their own gouache as needed. By varying the proportions of pigment to binder, various densities and textures could be achieved, sometimes giving the appearance of watercolor and at other times, as here in the blue of the man's hat and the woman's dress, that of pure pastel.

1. See prints from Hiroshige's *100 Views of Edo,* for example.

References: Quimper, 1958, no. 100; Bremen-Lille, no. 199; London, 1966, no. 119; Quimper, 1978, no. 16.

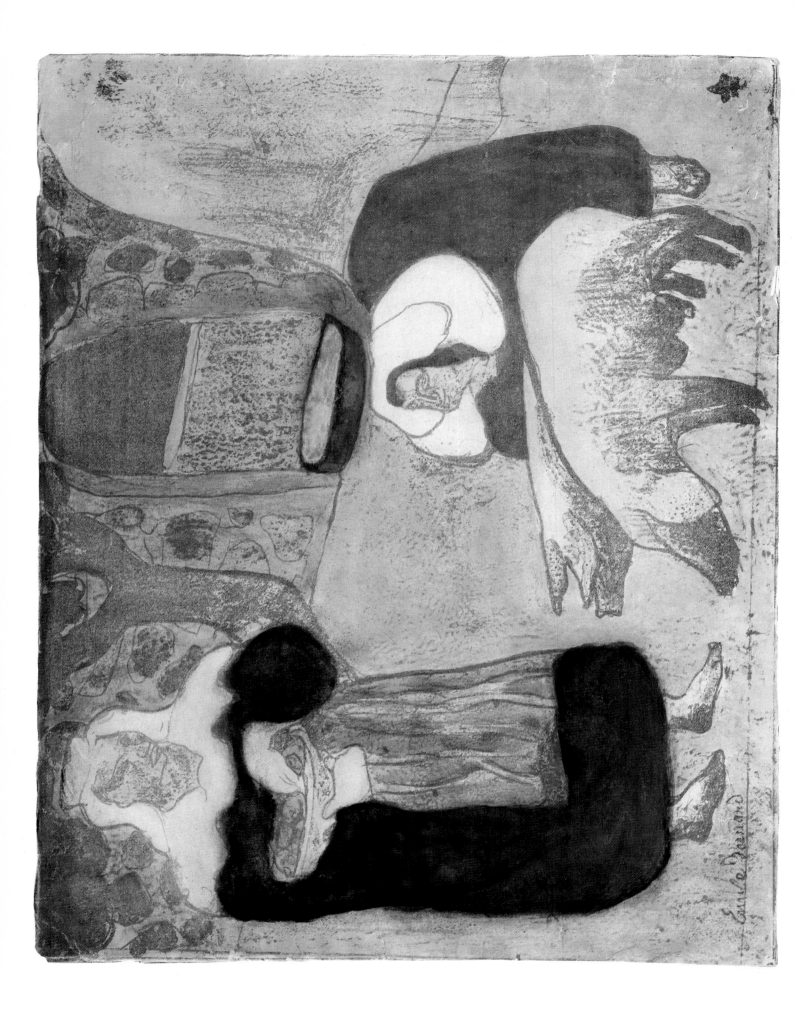

B.5 FEMMES AU PORCS
(Women with Pigs)

Colored with watercolor

248×313 mm (image)
On cream wove paper: c. 251×313 mm

Signed in plate with leaf symbol, lower right
Signed in black, lower left: "Emile Bernard"

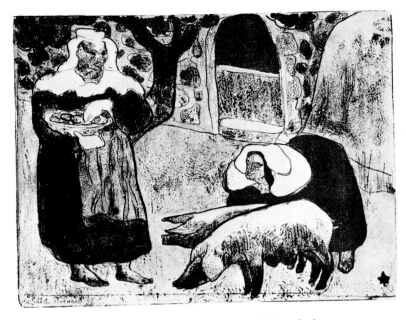

Bernard did not see his Breton peasants as individuals but as formal elements in his compositions. Here, for example, the figure of the woman to the right merges with those of the animals to create a unified curvilinear shape. The shallowness of the space depicted, lack of horizon, flatness of the figures, and the use of the white of the paper as a compositional factor, are all elements common to Japanese prints and contribute to the attractive, two-dimensional effect of the image.

Typical of Bernard are the supple, flowing lines that swell to form figural elements, suggesting natural forms, but not defining them with anatomical exactitude. Figures and landscape elements are outlined flat shapes, leading the eye from one form to the next. Between the initial drawing and the final design, Bernard obviously changed some of the lines in order to enhance the linear flow, such as the curved back of the bending woman. The repetition of the textures created by the lavis as well as the gamut of colors helps to flatten the picture into a two-dimensional composition of smooth shapes and flowing lines.

Bernard used watercolor extensively in this work, leaving the cream colored paper visible only in the womens' coiffes and hands and the bowl of food held by the woman on the left. A turquoise wash on the house in the background brings this area forward, making it flow into the blue colored ground. Over the blue, a very pale green wash was laid, increasing in intensity towards the lower left until that corner became primarily green. An orange wash, with an overlay of light yellow, colors the pile of hay to the left. The orange was repeated in the stripes of the apron on the woman to the left, linking these two foreground objects with those in the background. The same two colors are seen in the pigs and in the faces of the two women. Orange was also used over the blue wash of the ground around the pigs. The intense turquoise color of the house and the fact that it is cut off so that neither roof nor sky shows, create a very tight, closed space which does not permit the eye to escape from the composition.

The rhythm created by Bernard's repeated colors and curvilinear forms carries the eye smoothly in a circle. It focuses on the bright orange haystack and then is carried by its left-hand outline to the bending woman.

From there, the eye moves along the top of the pigs' backs to the angled feet of the woman on the left, then following the apron stripes, up to her head, hands, and bowl. It then moves to the doorway of the house via the tree trunk and back to the hay stack. Bernard carefully planned these rhythmic progressions, which became the primary focus of the work, more important than the subject matter itself.

In another impression of this print, Bernard added gouache and watercolor, using a totally different color scheme (illus. 10). Here the colors are even more saturated, which flattens the space still further. The addition of blue and burgundy colored gouaches on top of the black dresses of the two women causes their shapes to be emphasized even more than when they were left black.

A scene of peasant women and their animals was, of course, a common one in the area. Bernard and the other artists of the Circle of Pont-Aven enjoyed wandering through the fields and farmyards which ring the village. They seem to have preferred these farm scenes to the hustle-bustle of the port or the commercial buzz of the town's mills, subjects rarely seen in any of their works. The smooth forms of farm animals, trees, fields, stone houses, and plump, rough peasants were more in keeping with the painters' formal concerns than were the linear angularities of the boats or the frenzied movement of the mills and their workers.

References: Quimper, 1958, no. 10l; Bremen-Lille, no. 204; Quimper, 1978, no. 14; London, 1980, no. 1b.

Illustration 10. EMILE BERNARD, *FEMMES AUX PORCS,* (1889, zincograph with watercolor, 248×313 mm). Bernard experimented widely with the colors of his series *Les Bretonneries* to which this print belongs. The intense blues used here make the figures seem even flatter than in the exhibited impression (B.5) to which the artist applied more subtle, pastel colors.

B.6 FEMMES ETENDANT DU LINGE
(Women Hanging Laundry)

Colored with watercolor and gouache

248×316 mm (image)
On pale cream wove paper: 249×327 mm

Signed in plate with leaf symbol, lower right.
Stamped with initials in grey, lower right: "EB"

The composition of this print is reminiscent of Gauguin's *Vision après le Sermon* (W 245, National Gallery of Scotland, Edinburgh) in the use of the sharply diagonal tree in the middle-ground, the large scale, partially cut-off coiffed Breton woman in the foreground in profile, and the background cut off by a line of foliage across the top of the picture[1]. Gauguin's work was painted after he saw Bernard's *Breton Women in a Prairie* (illus. 11) while the two were painting together in Pont-Aven in the late summer of 1888, and thus was well known to Bernard. The forms are smoother and

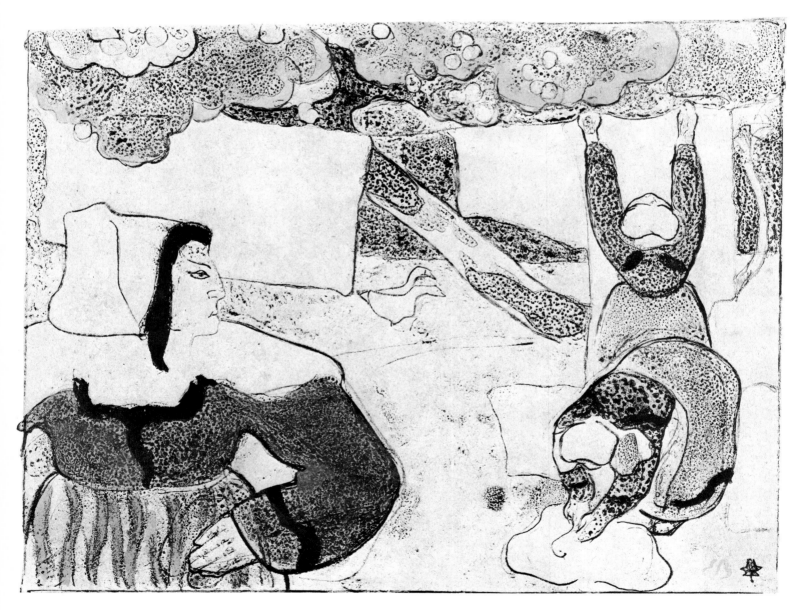

the curves simpler in this work than in the *Femmes au Porcs* (B.5), especially the two figures to the right, whose inverted curves form a harmonious unit. In order to reinforce the patterns created by his lavis, Bernard added dots and circles to these figures with a pen and lithographic ink.

In contrast to the *Femmes au Porcs*, this impression is very lightly watercolored. Bernard only put blue in the blouse, yellow stripes on the apron of the woman to the left and a pale orange wash on the apple trees along the top of the image. The forcefulness of the color on the woman in the foreground makes her stand out and her gaze then carries the viewer into the picture. This use of a large head in the foreground corner to lead the eye into the composition is seen several times in Bernard's paintings of this period[2] and was used in another print from *Les Bretonneries*, (*La Fête Bretonne*, illus. 12).

Les Femmes Etendant du Linge is very close in feeling to Bernard's *La Lessive* (B.3), executed around the same time. The subject matter is the same, as are such stylistic characteristics as the emphasis on linear rhythms linking the flat shapes. The *Femmes Etendant du Linge*, however, is simpler and the lines more fluid, as if Bernard had more fully absorbed the ideas of Synthetism in the short interval between the two prints.

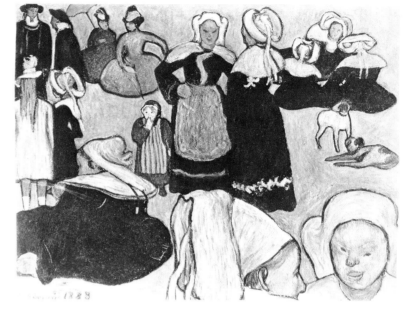

Illustration 11. EMILE BERNARD, *LES BRETONNES DANS LA PRAIRIE,* (1888, Luthi 114, oil on canvas, 74×92 cm). With its limited palette, cut-off forms, outlined flat shapes, and arbitrary use of space, Bernard's painting represents a summation of his Cloisonist and Synthetist ideals of the time.

1. François Bergot, "Une saison à Pont-Aven," *Bulletin des Amis du Musée de Rennes,* 1978, p. 44.

2. see *Le Pouldu,* Luthi 17; *Les Bretonnes dans le Prairie,* 1888, Luthi 114; Collection Maurice Denis Family; and *Le Blé Noir,* 1888, Luthi 123.

References: Quimper, 1958, no. 103; Bremen-Lille, no. 203; Quimper, 1978, no. 13.

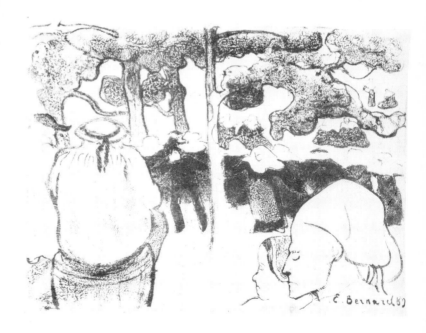

Illustration 12. EMILE BERNARD, *FETE BRETONNE,* (1889, zincograph, 232×290 mm). This print from *Les Bretonneries* depicts Bretons at a celebration dressed in their picturesque festival attires. The artist exploited here the fluidity of the tusche to create a painterly image, whose composition uses a familiar Bernard device of a large-scale cut-off figure leading the eye into the scene and reminds us of Gauguin's painting of 1888 *Vision après le Sermon* (W245).

B.7a FEMMES FAISANT LES FOINS
(Women making Haystacks)

254×326 mm (image)
On cream wove paper: 274×343 mm

Signed in plate with leaf symbol, lower left

B.7b SAME WORK

Colored with watercolor and gouache

254×326 mm (image)
On white wove paper: 254×330 mm

The black-and-white version of the print before water-coloring allows us to appreciate the rhythms Bernard created by the repetition of lines and shapes. The rhythm is not a simple circle, as seen in the previous two prints, but a complicated series of arabesques which zig-zag up and down the picture plane.

The extensive addition of watercolor amd gouache adds depth to the print and serves to highlight the three figures who, in the black-and-white version, almost merge with the piles of hay around them. As in the *Bretons Dans une Barque* (B.4), Bernard utililized a brilliant blue gouache that looks like pastel. Its hue is so startling that one sees the shapes it colors as flat, abstract forms and not as parts of specific figures.

In order to diminish the contrast between some of the black lines and the white background in this print, Bernard scratched through the ink with a fine, pointed instrument, creating tiny white lines. This softened the black outlines around some of the trees, bushes, and the background figures and helped model the face of the woman in the lower left corner and the depression in the rock behind her head.

The artist obviously delighted in the smooth, conical shapes of the trees, clouds, and haystacks, which are so typical of the landscape around Pont-Aven. The alternating horizontal bands of light and dark carry the eye up the picture plane, flattening the space, and denying the distance suggested by the sky and background trees.

References. Quimper, 1958, no. 99; Bremen-Lille, no. 220; London, 1966, no. 118; Quimper, 1978. no. 15.

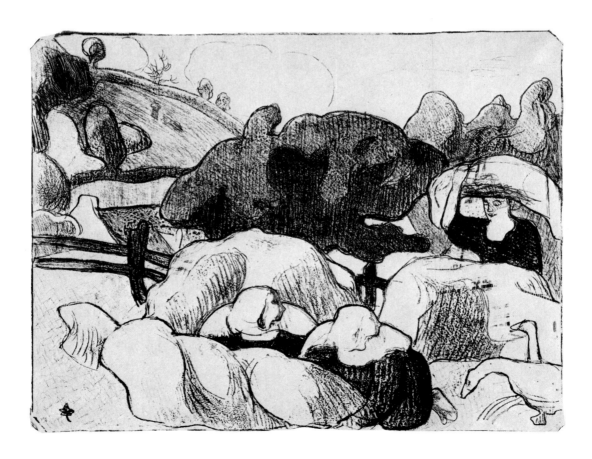

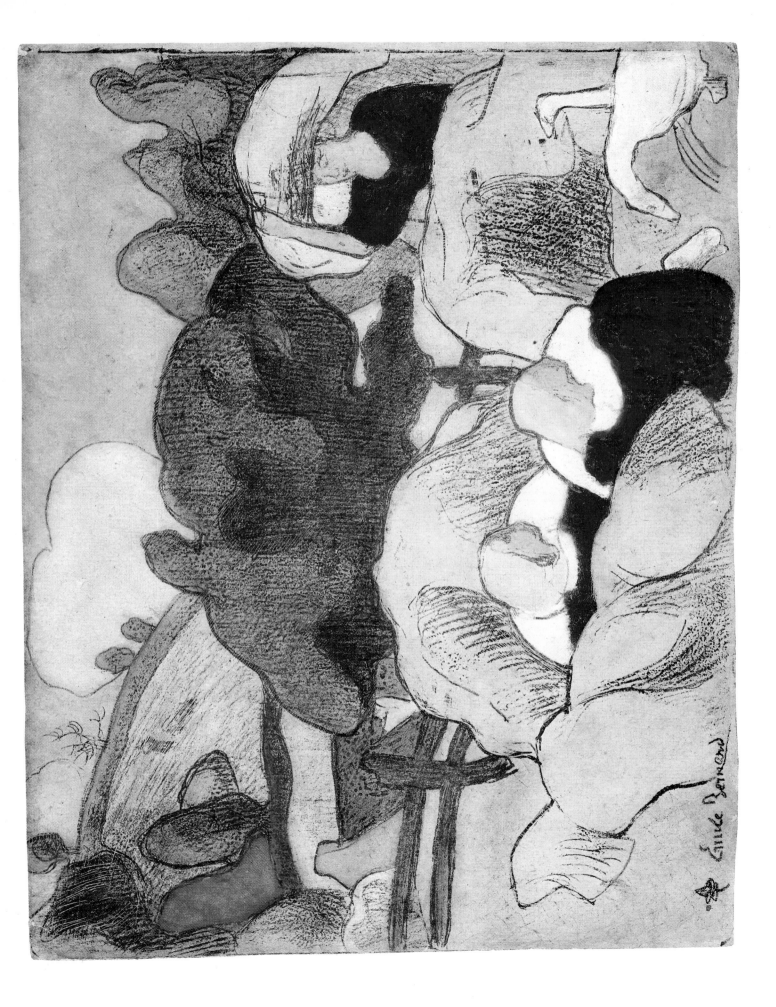

B.8 LES MOISSONNEURS
(The Harvesters)

Colored with watercolor

237×295 mm (image)
On cream wove paper: c.237×295 mm. Angled corners.

Bernard drew his composition from his 1888 painting entitled *La Moisson* (Luthi 121, Musée d'Art Moderne, Paris). In both works, a Breton woman in the foreground faces diagonally towards the viewer, while workers cut grain behind her. The man leaning over his scythe is taken directly from the painting, but was brought closer to the woman, thus shortening the middle-ground of the print.

As in two other prints from *Les Bretonneries* (*Femmes au Porcs* B.5, and *Femmes etendant du Linge* B.6), the composition is dominated by a single, large scale female figure in the foreground. Common to many of the prints is also the fact that the horizon line crosses the picture plane at approximately the same place, while the background is closed off by a screen of trees or buildings.

Bernard created two curious round white shapes when he added blue watercolor to the sky in his print. These must derive from clouds. Yet their smooth contours and unrelieved flatness make of them solid shapes somewhat reminiscent of some of Roderic O'Conor's etched clouds of 1893 (O.1,13).

Reference: Bremen-Lille, no. 201.

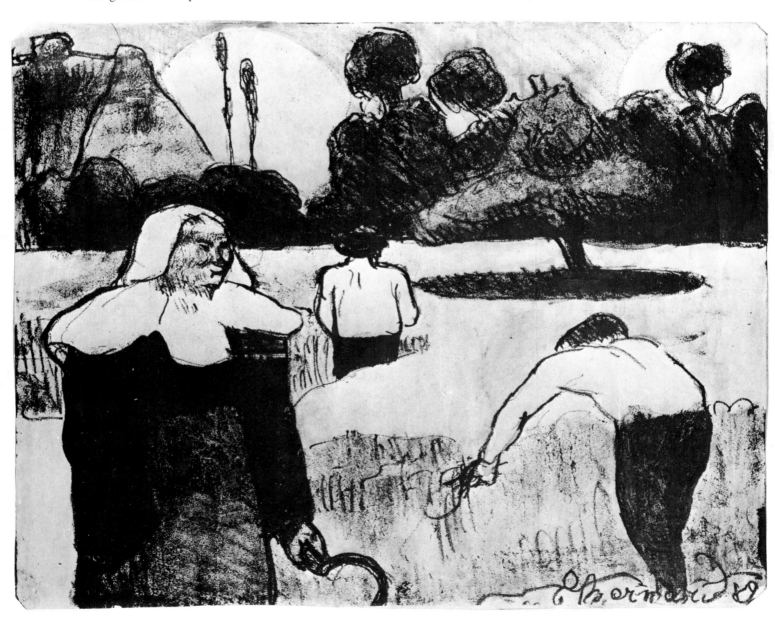

BERNARD

B.9 DEUX BRETONNES, c. 1891
(Two Breton Women)

Woodcut

152×293 mm (image)
On heavy cream laid paper: 210×318 mm (the back of a map or an atlas page)

Soon after executing *Les Bretonneries* (B.4−8), Bernard created several woodcuts in a style drawing upon Gothic prints and French *Images d'Epinal* [1]. While the images of Pont-Aven coiffes and Breton peasants at work are consistent with his earlier zincographs, Bernard's line changed considerably and became more angular and less free-flowing. The same stylistic change is also seen in his contemporary paintings, such as *La Récolte du Blé Noir au bord de la Mer (Luthi 289, Coll. J.)*, where the figures are similarly block-like and squared off.

The angled lines in this woodcut's figures make them appear flat and weightless, in contrast to the more supple lines of the figures in *Les Bretonneries,* whose curves imply the outer limits of forms that have weight of their own.

The uneven intensity of the blacks the use of a piece of paper already printed on one side, and the appearance in the print of faults in the grain of the woodblock suggest that Bernard probably printed this work himself. His aim was not to create an impeccably printed, sharp, clear image, but rather one that evoked the charm of early medieval woodcuts. His lines, nonetheless, are more in keeping with Synthetism than with medieval precedents. The hatchings, for example, were not used to model forms, but to create flat shapes. Note how the figure of the seated woman appears to be carved of flat, broad planes in an almost Cubist manner. Thus Bernard fused older drawing techniques and crude execution with a sophisticated Synthetist definition of form.

1. For more on Bernard's woodcuts of this period, see Jacquelynn Bass, Richard Field, "Towards a Definitive Dating of Emile Bernard's 'Adoration of the Shepherds'", *The Art Bulletin,* June, 1984, vol. LXVI.

2. Luthi no. 289.

65

LES CANTILENES SERIES
1892
Zincographs

BERNARD

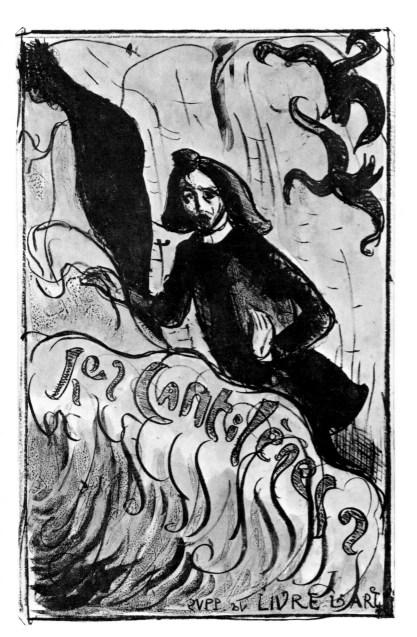

B.10 COUVERTURE: *LES CANTILENES*
(Cover for *Les Cantilènes*)

Colored with watercolor

330×200 mm (plate mark and image)
On simili japan paper: 387×256 mm

Inscribed in plate, lower right: "supp du Livre d'Art".

For the cover of his series illustrating Jean Moréas's collection of poems, *Les Cantilènes*, Bernard portrayed himself, plunging fully clothed into the sea below tall cliffs. The threatening, crow-like forms behind him probably refer to the *alcyon*[1], who share the poet's sadness in the poem:

> *"Je viendrai déposer, ô mer maternelle*
> *Parmi les varechs et parmi des épaves,*
> *Mes rêves et mon orgeuil, mornes épaves,*
> *Pour que tu les berces, ô mer maternelle.*
> *Et j'écouterai les cris des alcyons*
> *Dans les cieux plombés et noirs comme un remords*
> *Leurs cris dans le vent aigu comme un remords."*[2]

The sombre theme of the print sets the mood for the rest of the illustrations in the series. The word, "Cantilène", after all, means a melancholy, non-religious chant.

Vivid green and purple areas alternate with washes made up of both colors, creating a sombre yet intense atmosphere. The inscription in the lower right hand corner, with its inverted "s", indicates that Bernard drew his design directly onto the zinc plate and did not go through the intermediary of transfer paper.

1. the word is translated either as "alcyonarian", a coral-like form, or, more likely, "halcyon", a mythical bird said to be able to charm the winds and waves into calmness.
2. Jean Moréas, *Les Cantilènes,* Paris, 1886, p.28—29. Freely translated by the author as:
 I will come and place, oh Mother sea amongst the seaweed and shipwrecks,
 My dreams, my pride, mournful wreckage for you to rock, oh Mother sea
 And I will listen to the cries of the halcyons in the leaden skies, black with remorse
 Their cries in the wind, piercing as remorse

B.11 DANS LE JARDIN TAILLE
(In the Formal Garden)

Colored with watercolor

323×195 mm (image), 330×200 mm (plate mark)
On thin beige wove paper: 464×298 mm

Stamp in grey, lower right: "EB"

In Moréas's poem, *"Dans le Jardin Taillé,"*[1] a sad young man stands in a garden reminiscing about his lost love. The water in the fountain seems to him like tears, reminding him of a brief, joyful, but now finished moment of love.

The sadness of the man and the theme of lost love are common themes in Moréas's poems in *Les Cantilènes*. Bernard, who also wrote poetry, was equally absorbed by medieval notions of chivalry, fidelity, and chaste love. He was only 24 years old when he did these prints and still smarting from his recent failure to earn a living as a commercial artist in order to marry his young love. The father of his beloved had demanded that Bernard be able to support his daughter before he would allow them to marry. As a result, Bernard went to Lille in a futile effort to become an industrial designer. His letters and later reminiscences of this painful period show him to have been a sentimental, melancholy young man, prone to romantic excesses of feeling. The young lover in this print could well have been himself.

Although the curved shapes in the foliage may be reminiscent of Bernard's 1889 zincographs, the lines of the face and in the water have none of the variation of thickness or suggestion of weight seen in earlier works. Instead, they appear as flat boundaries around flat, weightless forms. The different tusche applications create a marvelous play of textures, unifying the design and forming a lively surface rhythm.

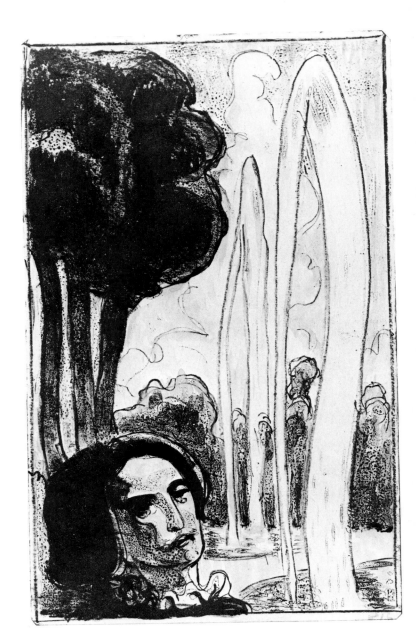

1. Jean Moréas, *Les Cantilènes*, Paris, 1886, pp. 15–16.

Reference: Bremen-Lille, no. 207.

B.12a LA FILEUSE
(The Spinner)

189×316 mm (image), 220×331 mm (plate mark)
On heavy cream wove paper (simili Japan): 307×460 mm

Signed in plate, lower right with leaf symbol and
"92" in reverse

B.12b SAME WORK

Colored with watercolor

189×316 mm (image), 220×331 mm (plate mark)
On heavy, cream, wove paper: 212×333 mm

In Moréas's poem, *Maryo*, a young girl of that name patiently weaves while she waits for her intended husband to return from his adventures. Despite warnings to her of his unfaithfulness, their wedding has been planned and he promises life-long fidelity upon his return. Such medieval standards of honor are a common thread to all of the Moréas poems, themes admired by Bernard and seized upon in many of his medievalizing prints of the 1890s.

Bernard took liberties with the setting of the poem, moving Maryo outside into a landscape reminiscent of his Pont-Aven works, such as *Femmes faisant les Foins* (B.7).

Viewing these two prints side by side demonstrates how color can add three-dimensionality, as well as change the visual patterns of the work. Bernard's colors are perhaps too "sweet", possibly chosen to simulate enamel work or stained glass.

References: Chassé, 1921, p. 31; Bremen-Lille, no. 213 (not included as part of *Les Cantilènes).*

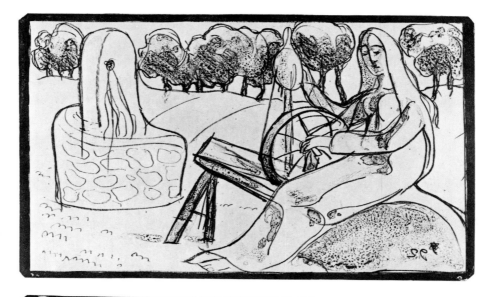

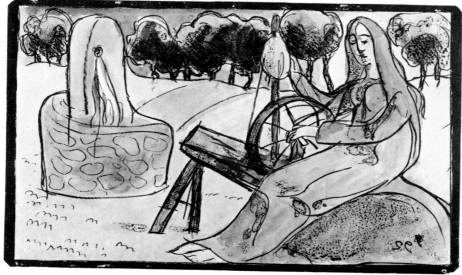

B.13 SOLITUDE
(Solitude)

Colored with watercolor

321×190 mm (image) 329×199 mm (plate mark)
on thin beige wove paper: 466×309 mm

Stamped in grey, lower right: "EB"

This print cannot clearly be seen as an illustration of a specific poem in Moréas's *Les Cantilènes*, although the woman could be the mysterious Mélusine who quietly emerges from a stand of trees and sings in Moréas's poem of the same name[1]. Bernard's own later inscription on an impression in the Foundation Doucet, *Voix qui revenez*, is a stanza from the second poem of Moréas's *Les Funérailles*. She could be listening for the voice that will return to caress and soothe the listener, as described in this poem[2].

In the black-and-white zincograph, the lake appears to be well back in the distance. In the colored print, on the other hand, the veil of colors laid on top of the black negates this feeling of spatial recession. The long, thin, parallel strokes of delicate colors form a transparent, vertical sheet right behind the figure and create a stage-like effect.

The composition of the print is characteristic of most of those in the series: large-scale figure (s) make up the foreground, trees close off the background. The proliferation of dark lavis applied in different patterns, as well as the swirling lines give a great deal of movement and energy to the picture, creating a frenetic rhythm.

This elongated, willowy figure is a curious preview of the works Bernard was soon to paint in Egypt, where he settled in 1893[3].

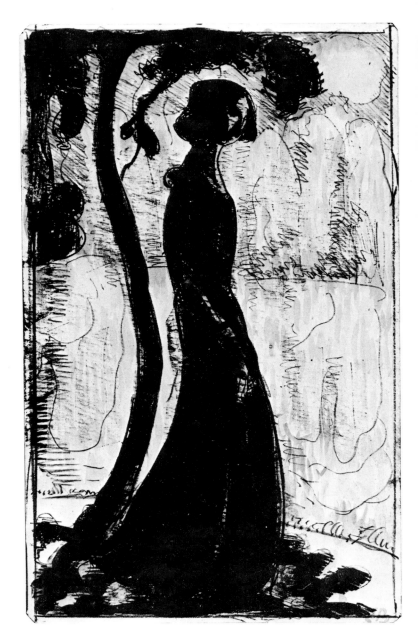

1. Jean Moréas, *Les Cantilènes*, Paris, 1886, p. 118.

2. Moréas, *Les Cantilènes*, pp. 10–11.

3. See for example his *Le Port de Samos*, 1893 (Luthi 406).

Reference: Bremen-Lille, no. 207 (entitled "Dans le Jardin Taillé")

Paul Sérusier

(1864–1927)

Sérusier is best known for his painting *Le Talisman,* done in 1888 under Gauguin's direction in Pont-Aven (Musée d'Orsay). The "lesson" during which it was painted was Sérusier's introduction to the ideas of Gauguin and the Circle of Pont-Aven. He later transmitted these theories to friends in Paris, thus establishing the aesthetic basis for the group of painters who called themselves the Nabis[1]. This group included among others, Pierre Bonnard, Edouard Vuillard, Pierre Ranson, Georges Lacombe, and K.X. Roussel, as well as a number of artists who were also associated with the Circle of Pont-Aven, such as Maurice Denis, Jan Verkade, and Mogens Ballin. Sérusier played the role of theorist for both the Nabis and the Circle of Pont-Aven in the 1890s before turning to religious theory and the School of Beuron for inspiration[2].

Before Gauguin's first departure for the South Seas in 1891, Sérusier was very close to him. Thereafter, Sérusier remained friendly with the other members of the Pont-Aven group during frequent, lengthy stays in Le Pouldu, Pont-Aven, and Huelgoat. In 1894, he finally settled in Châteauneuf-du-Faou, 44 kilometers from Pont-Aven. There he was especially close to Seguin whom he rescued after a suicide attempt in nearby Châteaulin and then brought to his own home, where Seguin lived for many months until his death of tuberculosis in 1903.

Despite the fact that he produced countless drawings, print-making played only a minor role in Sérusier's *oeuvre.* This is most likely explained by the fact that color was Sérusier's main preoccupation [3]. A great many of his drawings were highlighted with color and most of his few prints also attempt to incorporate color, if only in the use of colored paper or a single colored ink. The new technique and complicated processes of color lithography held no interest for him. During his winters in Paris, however, he was exposed to the prolific printmaking of his Nabi contemporaries, especially Paul Bonnard and Edouard Vuillard, which led him to try his hand at the medium a few times.

Sérusier's graphic work can be divided into two categories: Breton scenes (illus. 13, S. 1, 2, 3), usually done for various Paris publications, and theater programs for Symbolist theater productions (illus. 14), especially those at the Théâtre de l'Oeuvre. All of the Nabis, including Sérusier, were very involved in Symbolist theater efforts in the mid 1890s, working on sets, costumes, posters and programs[4].

In addition to acting in quite a few productions, Sérusier designed several programs in a linear and illustrative style.

All of Sérusier's lithographs of Breton subjects date from 1892–95, the period of most intense printmaking activity for all the artists in this study, except Gauguin, who only returned from the South Pacific in August, 1893. While Sérusier's themes of Brittany may have been sketched there, they were probably printed in Paris, where the designs were drawn by him directly on the stones or zinc plates[5].

In his prints, Sérusier did not reuse figures and whole elements from his paintings as did Gauguin. His prints were a creative activity parallel to his paintings, with similar themes and styles. While the lines seen in his prints are as wonderfully supple and expressive as those of his drawings, there is little exploitation of the technical possibilities unique to printmaking.

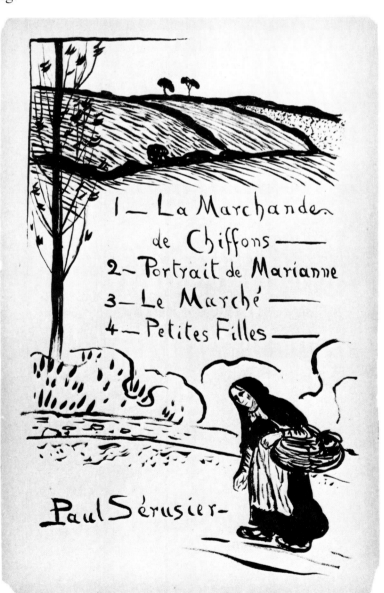

Illustration 13. PAUL SERUSIER, *LA VIEILLE AU PANIER,* (1893, lithograph, 141×229 mm). For the fifth exhibition of avant garde artists in his gallery, Le Barc de Boutteville published a catalogue in 1893. It consisted of one original lithograph by each artist in the show: Maurice Denis, Henri Ibels, Marc Mouclier, Paul Ranson, K.X. Roussel, Félix Vallotton, Edouard Vuillard and the one by Paul Sérusier reproduced here. This set of eight sheets, published in a very small edition on sulphite pulp paper, has by now become extremely rare.

All of Sérusier's Breton prints, as well as many of his paintings, explore the theme of the difficult life of Breton peasants and their unity with the rugged land they tilled. The harshness of their life is emphasized through facial expressions (SR.3), poses (SR.2), or in the landscape itself (SR.1). Synthetist vocabulary emhasizes the peasant's oneness with the earth; rhythmic curves, flowing forms, and harmonious shapes unite the figures with landscape elements and make the two inseparable. Unlike the more decorative *Les Bretonneries* of Bernard, Sérusier's prints express a feeling of melancholy, yet they still do not achieve the intense feeling of mystery so present in Gauguin's Volpini series.

1. See Caroline Boyle-Turner, "Paul Sérusier's 'Talisman'," *Gazette des Beaux Arts*, May-June, 1985. *Les Nabis* was a group of young Parisian painters active from 1888 – c.1893. They pursued many aesthetic ideas of the Circle of Pont-Aven, especially those concerning the abstract notions of line, color, and form. The Nabis were very consciously a *group,* with invitations, meetings, and joint projects. They also sought to publicize their aesthetic efforts whose philosophies and formal innovations brought the artists to the brink of abstraction in their art before they finally dissolved as a group and went their separate ways.
The Nabis were interested in all means of creative expression, including painting, stained glass, and interior design. Printmaking attracted many of them, most notably Bonnard, Vuillard, Denis, Roussel, and Ranson. For more information on the Nabis, see George Mauner, *The Nabis, Their History and Their Art, 1888–1896,* New York, 1978 and Charles Chassé, *The Nabis and their Period,* translated by Michael Bullock, New York, 1969.

2. See Caroline Boyle-Turner, *Paul Sérusier,* Ann Arbor, 1981; and Marcel Guicheteau, *Paul Sérusier,* Paris, 1978.

3. See Paul Sérusier, *ABC de la Peinture,* Paris, 1942.

4. See George Mauner, *The Nabis, Their History and Their Art, 1888–1896,* chapter VI.

5. While it is not always easy to tell a zincograph from a lithograph, the uniformly fine texture seen in Sérusier's Breton prints suggest that they were done on stone. There appear to be no posthumous printings of his prints and the stones or zincs may well have been effaced.

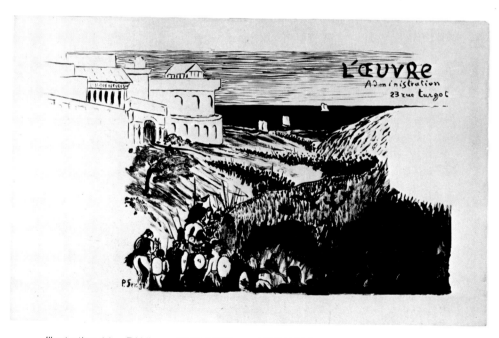

Illustration 14. PAUL SERUSIER, *HERAKLEA,* (1896, zincograph, 300×485 mm. First state, before the letter). This program for the production of Auguste Villeroy's play at the *Théâtre de l'Œuvre,* Paris is quite different from Sérusier's simpler, more Synthetist prints of Breton subjects. Its crowded composition and linear emphasis illustrate a story rather than evoking a mood, as do his Breton prints.

SR.1 LA TERRE BRETONNE, 1892–93
(The Soil of Brittany)

Lithograph

230×217 mm (image)
On cream wove paper: 380×281 mm
In grey/blue

Signed in stone, lower right: "P Sérusier"

Edition of 215 (200 in an "édition ordinaire" and 15 "édition de grande luxe" on japon impériale and chine)

This very Synthetist work stresses the rhythmic flow of softly curving landscape elements. The composition is typical of Sérusier's landscapes of this period in that it has a wide, nearly empty foreground, rolling hills and small figures in the middle-ground, trees silhouetted on the horizon, and a small area of empty sky. It appears to be the Le Pouldu area, where Sérusier spent time during the summers of 1889–92. The figures' shapes reflect the soft curves of the rocks, and the figures themselves blend into the field, reflecting Sérusier's philosophical interest in the unity of the Breton peasant with his environment[1].

Instead of a harsh black and white contrast between ink and paper, Sérusier chose a softer one by using an unusual grey/blue colored ink printed on a cream-colored paper, giving the work a grey, misty cast, typical of Breton coastal areas.

1. Sérusier was a Theosophist and concerned with the interrelationships between any and all living and non-living objects and concepts. See Caroline Boyle-Turner, *Paul Sérusier,* Ann Arbor, 1981, chapter 8.

References: Published in *l'Epreuve,* vol. 4. March, 1895; Paris, 1971, no. 96; Marcel Guicheteau, *Paul Sérusier,* Paris, 1978, no. 73 (sketch, erroneously titled *La Fin du Jour.*)

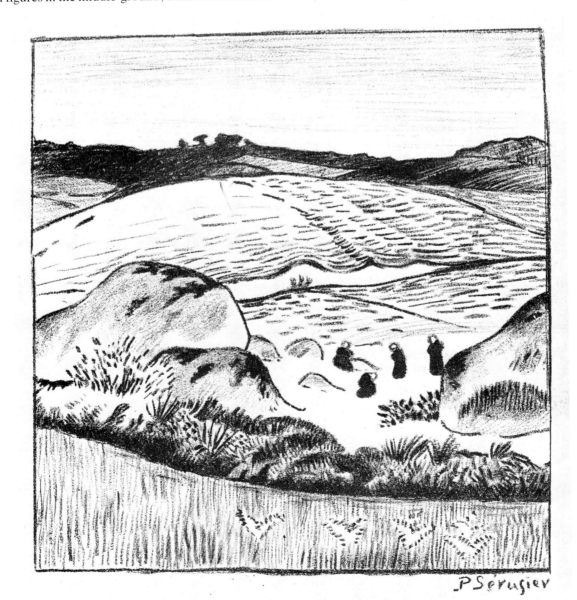

P Sérusier

SERUSIER

SR.2a LA FIN DU JOUR, 1893
(The End of the Day)

Trial proof. Lithograph

230×300 mm (image)
On canary yellow wove paper, 324×500 mm
In brown and green

Signed in plate, lower right: "P Sér"
Artist's "bon à tirer" and notations in artist's hand, right hand margin: *"vermillion, garance, bleu d'or, noir, blanc / vert jaune / bon à tirer, vert plus léger"*[1]

SR.2b SAME WORK

Brown plate

On canary yellow wove paper: 410×510 mm

SR.2c SAME WORK

Final version
On canary yellow wove paper: 418×570 mm
In brown and green

As published in *l'Estampe Originale,* no. 2, April, 1983.
Edition of 100

After a day of tilling a field bordered by leafless apple trees and a cemetery wall, a man slumped with fatigue and despair has thrown down or dropped his hoe. The luminous, warm colors of the paper and ink contrast with this bleak, humble scene. Gauguin's Volpini series is the obvious source for the use of the paper.[2]

The green in the ground and sky hints at the promise of spring and renewal, as Sérusier continued his interest in peasants and their life of ceaseless, seasonal toil. The repetition of the same green color in the sky and foreground, as well as in the emphasized boundaries of the fields, creates two-dimensional patterns that are all part of the Synthetist vocabulary favored by the Pont-Aven artists during the 1890s.

The color separation demonstrates how lithographs printed in color are made, with each color printed by a different stone onto the same paper, one after the other. In the trial proof, Sérusier decided that the green was too intense and created too high a contrast with the yellow and brown colors. His handwritten instructions to the printer, written on the proof itself, call for a lighter green. These were followed in the final edition, which was published in *l'Estampe Originale,* where a lighter, more yellow green was employed. Sérusier's color changes and instructions to the printer indicate

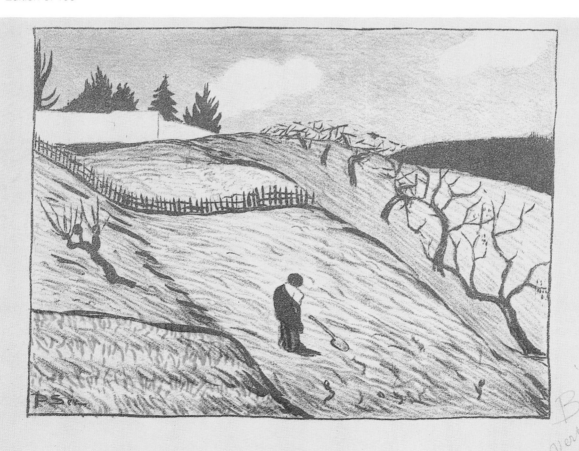

his concern for color and his attentiveness to the possible nuances of paper and ink in order to achieve the effect he wanted.

1. Translated as: "vermillion, madder, gold-blue, black, white, yellow green. Alright to print, lighter green." An early color

separation for the green shows a color with more turquoise than in the final state. Coll. J.

2. The yellow papers used by Gauguin and Sérusier are exactly the same color. Gauguin's paper, however, has a grainier texture and is slightly thicker than that used by Sérusier.

Reference: Caroline Boyle-Turner, *Paul Sérusier*, Ann Arbor, 1981, no. 26.

SERUSIER

SR.3 LA MARCHANDE AMBULANTE, 1895
(The Street Vendor)
(frequently called *La Marchande de Bonbons* – The Candy Seller)

Lithograph

223×135 mm (image)
On thin beige wove paper: 320×246 mm
In light beige and black

Initialed in stone: "P Ser."
Published *hors texte* in *La Petite Suite de la Revue Blanche*, Edition of 100

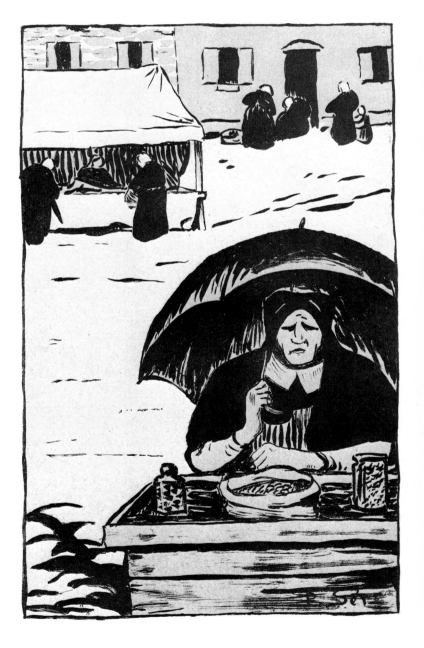

Sérusier depicts a rather sour-looking candy seller at her temporary stand in the open-air market of the central Brittany village of Huelgoat which he discovered in 1891. He spent several summers there and finally settled in the nearby village of Chateauneuf-du-Faou. The woman's expression is calculated to reflect the harshness of her life and contrasts humorously with the candy she is selling. In his work of 1893–95[1], Sérusier often exaggerated unhappy expressions of his female models as he explored their narrow lives bounded by poverty, superstition, religion, and daily toil.

The beige color used in this print is extremely sensitive to light. As a result, most impressions that one sees appear to be printed in black and white with the beige completely faded. The problem of fading inks and discolored paper is a common one in late nineteenth century prints. Printmakers were not yet aware of the instability of the sulphite papers or the newly discovered synthetic dyes and pigments they used.

1. See, for example, the *Marchande d'Etoffes*, Petit Palais, Geneva.

Reference: Marcel Guicheteau, *Paul Sérusier*, Paris, 1978 no. 97.

Henri Delavallée

(1862-1943)

Delavallée spent time in Pont-Aven from 1886 to 1888 and possibly later until 1893, when he left France for nine years in the Middle East. He knew at least Seguin, Bernard and Gauguin and met several other artists of the Pont-Aven Circle in Paris, where he maintained a studio. Until 1890, his stylistic affinities leaned more towards Pointillism than Synthetism. His subjects, nonetheless, were often Breton.

Delavallée began printmaking in 1889, producing very highly finished, beautifully executed etchings. His vocabulary of small, tight lines, carefully modeled forms, detailed landscapes, and spatial recession links him to traditional nineteenth century etching. Despite occasional Synthetist passages in his works, such as the background tree in *Bretonne Assise* (D.3), Delavallée's prints are closer in feeling to those of Millet and even Pissarro than to those of Gauguin. His quiet, idealized peasants and picturesque farms have little in common with the harsh figures and Synthetist distortions seen in some works of Gauguin, Bernard, and other members of the Circle of Pont-Aven. Rather, Delavallée belongs to a long line of nineteenth-century Romantic artists who glorified the virtues of simple country life.

As a technician, Delavallée was superb; his prints are remarkable displays of the techniques of aquatint and soft ground etching in particular. They also offer an interesting juxtaposition with works by other artists in this study. Despite similarities in style and subject matter, the mood created in Delavallée's prints is different from that of the Pont-Aven artists and clarifies why he is often not considered a member of the group. He was, however, important to the Circle of Pont-Aven, and is included in this study because he probably taught Seguin to etch in 1891. This technical training becomes very evident in Seguin's early prints.

D.1 FERME A PONT-AVEN, c. 1889
(Farm in Pont-Aven)

Etching, roulette, drypoint, aquatint, and soft-ground

202×283 mm (image), 211×293 mm (plate mark)
On simili Japan laid paper: 287×456 mm

Signed in pencil, lower left: "Ferme à Pont-Aven, no. 1"
Signed in pencil, lower right: "1886 H. Delavallée, no. 6"

This print is a *tour de force* of different techniques, each expertly rendered, although a bit awkward in juxtaposition. The foreground details of rocks, plants, and earth give way to a vague middle ground and a misty, undefined background, all of which create a convincing recession from front to back, not bottom to top, through superimposed horizontal bands as is often seen in the prints of the Circle of Pont-Aven.

References: Charles-Guy le Paul, *l'Impressionisme dans l'Ecole de Pont-Aven*, Paris, 1983, p. 237

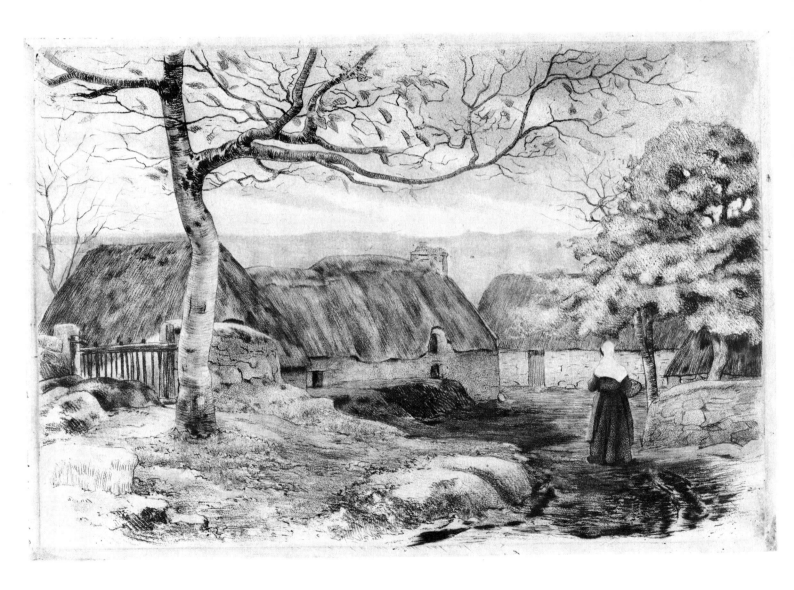

D.2 CHENES TETARDS, c. 1892
(Pruned Oak Trees)

Etching, soft-ground etching, and aquatint

184×286 mm (image), 193×295 mm (plate mark)
On medium-weight laid white paper: 244×375 mm

Signed in pencil, lower right: "H. Delavallée"
Edition of 50[1]

The thrashing, twirling movement of the trees, defined by jagged silhouettes and convoluted lines, are reminiscent in feeling and execution of O'Conor's contemporary prints, especially *Maisons et Arbres*, (0.9) and *Les Grands Arbres* (0.2), both of 1893.

The contemporary work of Charles Dulac may have been another source of inspiration for Delavallée[2]. Indeed, the reliance on mass and three-dimensional modeling of the trees in light and dark is different from Seguin and O'Conor, and closer to Dulac. The soft-ground etching technique creates the effect of a crayon sketch and permitted the artist a wide variety of modeling and atmospheric effects.

1. The Bibliothèque Nationale in Paris has an impression signed in pencil, lower right, "H. Delavallée" and numbered 2/50.
2. See his *Suite de Paysages,* published during the winter of 1892−93.

D.3 BRETONNE ASSISE, c. 1893
(Seated Breton Woman)

Proof before steel facing. Etching, aquatint and soft-ground etching

249×179 mm (image and plate mark)
On simili Japan paper: 366×278 mm

Signed and dedicated in pencil, lower right: *"à mon ami E.F. Robertson cordialement, H. Delavallée"*

Luminosity, an elegant use of aquatint, and Breton charm all characterize this print. The carefully modeled figure wears the coiffe of Pont-Aven. Her calm pose, graceful clothes, and contemplative demeanor are as far from the coarse figures of Gauguin's and Sérusier's peasants as they are from the poor, though picturesque, farmers of Millet. In fact, she shares a greater affinity with Camille Pissarro's and Jules Breton's peasants, who often convey purity and pastoral bliss[1]. The silk-like simili Japan paper conveys luster to the print, further adding to the exquisite effect[2].

Delavallée's mastery of intaglio techniques is obvious in this painstakingly executed work. He carefully burnished areas of the aquatint around the face, in the clouds, and the woman's collar. At first glance, the patterns in her apron and dress appear to have been created also by aquatint, but upon careful examination, the time-consuming process of drawing each little squiggle into a soft-ground is revealed. The darkly inked border was intended to imitate a photograph, a popular convention in the 1870s[3].

The print's only stylistically jarring note is the tree to the left. Its convoluted lines and swirling movement hint that Delavallée was well aware of O'Conor's and Seguin's prints of 1893. He preferred, however, to use carefully drawn, parallel strokes to generate a feeling of energy and movement, rather than the freer lines employed by the other two artists.

Eric Forbes-Robertson, to whom the print is dedicated, was an English artist who was in Pont-Aven at various times between 1890 and 1894[4]. He became friends with Gauguin, Maufra, Seguin, Bevan, and O'Conor, whose influences are seen in his contemporary drawings[5].

1. See Richard and Caroline Bretell, *Painters and Peasants in the 19th century,* Geneva and New York, 1983, p. 49.

2. Many posthumous proofs of this print exist. They are usually printed on heavy white wove paper. The aquatint is worn on these restrikes which at times bear fake signatures.

3. Information from Pierre Courtin in a conversation with the author, 1986.

4. Seguin also dedicated one of his prints, *Le Pêcheur* (1891), to Forbes-Robertson, Coll. J.

5. Denys Sutton, "Echoes from Pont-Aven," *Apollo,* May, 1964, pp. 403−406.

References: Quimper, 1958, no. 106; Charles-Guy Le Paul, *L'Impressionisme dans l'Ecole de Pont-Aven,* Paris, 1983, p. 240.

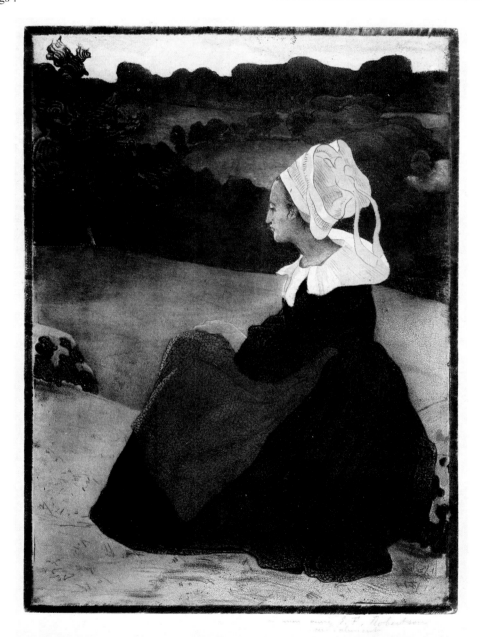

Armand Seguin

(1869–1903)

Printmaking and its technical possibilities occupied a larger place in Seguin's career than in that of any of the other Pont-Aven artists. In 1896, he staunchly defended the expressive potential of the medium, while deploring the fact that most modern printmakers had descended to mere reproduction in their work[1]. Although he executed more than ninety different prints, and fewer than twelve paintings by him are known, Seguin always considered himself a painter rather than a printmaker and suffered greatly from his lack of success in that medium. Nevertheless, his prints of 1893, in particular, were far ahead of their time in their exploration of abstract design principles.

Little is known about Seguin's training or early career. This Breton by birth may have come to Paris to attend the Academie Julian[2] and the Ecole des Arts Décoratifs[3] in the late 1880s. His exposure to Gauguin's work occured in 1889 at the Volpini exhibition[4] and he was also mentioned during that year in a letter by Sérusier[5]. The first concrete evidence of his association with Pont-Aven is a portrait sketch of Forbes-Robertson inscribed "Pont-Aven, April, 1891"[6], a time when Sérusier and the Dutch artist Jan Verkade were also in residence[7]. Gauguin, of course, had left for the South Seas in February.

During 1891, Seguin took up printmaking with great enthusiasm. He wrote to Forbes-Robertson, "I have never been so wrapped up in etching, from night until morning and morning until night"[8]. In the same letter, he mentioned Delavallée, who probably taught him the etching process and whose influence can be seen in Seguin's two earliest works, *La Ronde de Pont-Aven* (S.1) and *Le Pêcheur* (Field, 3). Both etchings are technically complicated, employing subtle aquatints, roulette, lavis, and dense layers of etching[9]. They do not, however, appear to have been professionally printed. In fact, Seguin probably printed most of his works himself, for they lack the clean, evenly inked, fine finish of professionally printed works. Obviously not intended for large editions and mass distribution, they were primarily experimental.

A distinct difference in style exists between Seguin's prints of Paris themes and his Breton subjects. Gauguin remarked on this in his 1895 preface to an exhibition of Seguin's works (illus. 15)[10], noting that the Paris works were too much like posters or caricatures. The long, sweeping lines, facial expressions, and themes of

cafés and nudes are strongly reminiscent of Toulouse-Lautrec and Anquetin, both of whom Seguin may have known through Bernard. In turn, Bernard stated that he worked with Seguin in 1892–93[11] and that they spent time together in Pont-Aven[12]. Many of the Breton works suggest both Bernard's and O'Conor's influence. Distinctly Synthetist in style, they emphasize decorative surfaces but do not incorporate the psychological sensitivity characteristic of Gauguin. As with Bernard, formal concerns predominate.

Seguin's artistic career, as analyzed by Field, Strauss, and Wagstaff in the only major study of this artist's prints, suffered from a lack of consistency and "inner vision."[13] An explanation of his uneven development might be that he spent the 1890s searching for and absorbing the influences surrounding him. The 1890s were, after all, years of challenging aesthetic concepts, and Seguin, a timid man, chose to surround himself with very strong, opinionated artists, such as Gauguin and Sérusier. He never acquired the deep philosophical convictions of some of his contemporaries, such as Sérusier, Verkade, and Denis[14], but rather seemed awed by their intellectual achievements[15]. His illustrations for *Gaspard de la Nuit* (1900–03) also demonstrate an awareness of the old masters.

Seguin did possess, however, a strong sense of design, which was a useful talent for exploring the decorative possibilities of the Pont-Aven style. Overshadowed by the philosophical talents of the strong personalities around him, he grafted various styles upon the Breton imagery that they all explored. Never content, he kept searching. If he had lived beyond the age of thirty-four, he might have settled upon a more independent and consistent style.

Illustration 15. LE BARC DE BOUTTEVILLE GALLERY CATALOGUE FOR THE EXHIBITION OF PRINTS BY ARMAND SEGUIN – Cover and Frontispiece, (1895, Letterpress on light mauve Ingres paper, unevenly folded and stitched, approx. 18½×20 cm., 24 pages plus covers). Seguin carved two special letrines on wood (not in Field) for this catalogue, which includes a preface by Gauguin, with not entirely unmitigated praise for the artist.

The earliest of Seguin's prints that can readily be called "Pont-Aven" in style date from 1893. That he had already been influenced by the works of Bernard and Sérusier is evident in the swelling lines and the emphasis on surface rhythm. Seguin's lines reflect Bernard's Cloisonism in their thick outlining, but the shapes inside the outlines are rarely as flat[16]. The prints of 1893 manage to convey three-dimensional solidity as well as two-dimensional patterns. Subtle distortion of forms, such as in trees and bushes, harmonize shapes within the overall rhythm of the work.

Sérusier's influence can be seen in the way Seguin approached a landscape. Both men allowed the natural patterns of stone fences, trees, or fields to dictate the lines of the composition and create a two-dimensional surface design.

Unlike Sérusier and Bernard, Seguin does not seem to have been interested in the study of Breton peasants and their relationship to their environment. His interest lay more in the abstract potential of lines.

Seguin was further encouraged in the use of strong, lively lines by the Irish artist, Roderic O'Conor, whose painted, drawn, and etched lines convey a great sense of movement and vigor. O'Conor arrived in Le Pouldu during the summer of 1893, when Seguin was living in St. Julien, an area of the village up the hill from the sheltered harbor. He occupied a large house that had once been a hostel for pilgrims travelling from England and Brittany to Spain.

The two men spent the summer tramping around the nearby fields and dunes, delighting in the steep cliffs, isolated farm houses, vast, cloudy skies, and wind-swept coast. During this time together, they launched an intensive etching effort, consisting mostly of landscapes, although Seguin did a large number of figure studies as well. In an earlier letter to O'Conor, Seguin stated his definite preference for the human figure[17], so the predominance of landscapes in this summer's campaign was presumably due to O'Conor's influence.

Seguin's and O'Conor's prints of 1893 were probably printed in Le Pouldu on a small proofing press[18]. No solid evidence of this press exists, but the nature of the prints and the relatively large number of works strongly suggest that it was at hand. Seguin also sent some of his plates to Paris with instructions to Delâtre on how to print them[19].

The limitations of the printing and studio facilities called for a simplification of technique: complicated aquatints are absent from these prints, and only one or two acid baths were used in producing them. In fact, most of Seguin's prints of that summer lack the tonal qualities of aquatints or the complicated plate wipings found in some of his earlier works, which he also probably printed himself in a well-equiped Paris printing studio. The numerous scratch and pit marks on many of the works suggest that they were printed from poorly prepared plates.

Seguin's prints of 1893 were wiped relatively clean before printing and thus totally rely on the power of line for their strong effect. These simply executed prints were highly experimental for Seguin. The limited number of proofs from each plate and the lack of professional finish further suggest their experimental nature. These works rank among his most striking and successful prints.

O'Conor may have led Seguin to adopt a more direct printing technique, one which relied on line and not on tonal effects. The rhythmic, swirling lines in O'Conor's works were derived from Van Gogh and adopted by Seguin (S.15,18). Thus an attempt was made to graft the energy of Van Gogh's line onto the rhythmic, decorative, surface requirements of the Pont-Aven style. Seguin also began to use shorter lines, combined into dense individual units rather than the long arabesques of his Paris works[20].

Unlike O'Conor, who was fascinated by the windswept coast just south of Le Pouldu, Seguin preferred the quieter area where the Laita River empties into the sea in a large, protected bay opposite the village. His interest in these landscapes may have been purely formal, for he was concerned with the linear patterns created by the landscape elements, not in the life of the people inhabiting these areas.

Seguin might have continued to explore the potential of his expressive lines had Gauguin not returned to Brittany in 1894, when Seguin met him for the first time. Overwhelmed by several months of close contact, Seguin's art changed radically: his lines became more convoluted and varied, and he attempted to introduce an element of mystery into some of his works, as in the two *Decorations de Bretagne* (S.24, S.25). Under Gauguin's influence, he also experimented with the potentially rough and primitive qualities of the woodcut, even trying to imitate those qualities in etching[21].

The problem of earning a living was added to the pressure provided by Gauguin's powerful influence. Seguin had to devote some of his time to commercial ventures, such as producing fans (S.30) or creating works acceptable to publishers, for example, *La Primavère* (S.26). His only exhibition, held at the gallery of Le Barc de Boutteville in February 1895, must have presented a confusing mixture of styles. Gauguin, who wrote the introduction to the Catalogue (illus. 15), noted the as yet unfulfilled potential of his friend and encouraged him to pursue his Breton studies[22]. Unfortunately, Seguin did not live long enough to fulfill these expectations. His sporadic prints of 1896—1903 were primarily book illustrations, none of which pursued the discoveries of his 1893—95 works. He finally attempted suicide in 1903, was rescued by Sérusier, but died later that year of tuberculosis[23].

1. Armand Seguin, "Préface" to the *12e Exposition des Peintres Impressionnistes et Symbolistes*, Le Barc de Boutteville Gallery, Paris, 1896, p. 4.

2. Jaworska, p. 139.

3. Field, p. 8.

4. Armand Seguin, "Paul Gauguin," *Occident*, March, 1903, p. 166.

5. Paul Sérusier, "Correspondance" in *ABC de la Peinture suivi d'une Correspndance inédite receuillie par Mme Paul Sérusier et annotée par Mlle Henriette Boutaric*, Paris, 1950, p. 40.

6. Eric Forbes-Robertson sketchbooks, Victoria and Albert Museum, London.

7. Verkade was a Nabi in 1891—93 before taking his vows as a Catholic monk. He was very close to Sérusier and Ballin, and his works of that period reflect that influence.

8. Letter reprinted by Denys Sutton in "Echoes from Pont-Aven," *Apollo*, May 1964, p. 405.

9. Field, p. 9.

10. Paul Gauguin "Préface," *Armand Seguin*, Le Barc de Boutteville Gallery, exhibition catalogue, Paris, 1895, p. 10.

11. Emile Bernard, *Souvenirs Inédits*, Paris, 1939, p. 19.

12. Emile Bernard, "L'Aventure de ma Vie," Unpublished manuscript, Bibliothèque du Louvre, p. 95.

13. Field, p. 5.

14. Another member of the Nabis, Denis was deeply religious. His Catholicism strongly affected the subject matter and style of his works.

15. See his comments on Sérusier in "Paul Gauguin," *Occident*, pp. 232ff.

16. Seguin admitted his stylistic debt to Bernard in his article "Paul Gauguin," *Occident*, March 1903, p. 165.

17. Cited in Jaworska, p. 222.

18. We know that Seguin had access to a press in Pont Aven in 1895 (letter from Seguin to Delâtre, 1895, Coll. J).

19. Unpublished letter from Seguin to Delâtre, (Coll. J).

20. Field, p. 7.

21. See *Bretonne*, (S. 27).

22. Gauguin, "Préface," *Armand Seguin*.

23. Twenty-four of Seguin's plates were reprinted by Maurice Malingue in 1964. These prints and their catalogue numbers in Field are: *Jeune Femme Couchée*, 19; *Nue*, 20; *Nue avec Chignon*, 21; *Arbres au bord d'une Rivière*, 24; *Saint Maurice*, 25; *Petit Paysage*, 28; *Paysage Rayé*, 34; *Paysage de Pont-Aven*, 35; *Bretonne*, 44; *Deux Bretonnes assises*, 45; *Paysanne en Coiffe de travail*, 48; *Femme en Coiffe, de dos*, 49; *Femme en Coiffe, de dos*, 50; *Jeune Paysanne assise, de Profil*, 51; *Femme assise*, 52; *Femme assise*, 54; *Bretonne*, 55; *Femme assise*, 56; *Femme assise*, 57; *Bretonne au Travail*, 60; *Bretonne au Travail*, 61; *Etude Bretonne*, 63; *Nue*, 75; *Figure decorative* (*Bretonne*), 82. While it is unknown how large this edition of reprints was, one series was numbered 1-35 and bears an "ES" stamp. Many others are not numbered or bear different stamps. They can be distinguished by the clean Arches paper upon which they were printed and by an unsympathetic printing. In addition, some of the scratch marks do not show in the reprints, and there is an even plate tone. Another edition on thinner Japan paper exists, usually with a yellow "ES" stamp.

S.1 LA RONDE DE PONT-AVEN, 1891
(The Dance of Pont-Aven).

Field, 2. Etching, drypoint, aquatint

105×185 mm (image and plate mark)
On medium-weight cream laid Arches paper: 176×270 mm

Signed in plate, lower left: "AS Pont-Aven 1891"
Planned edition of 15[1]

This very delicate etching is one of Seguin's earliest prints. Its fine lines, subtle aquatint, and mastery of texture reflect his training with Delavallée. Seguin's later works do not have settings or costumes rendered in such detail, or as fine a line.

The etching is immediately reminiscent of Gauguin's painting *La Dance des Quatre Bretonnes* of 1886 (W 201, Bayrische Staatsgemäldesammlungen, Munich). The subject matter and compositions of both works are strikingly similiar, especially when one remembers that an image drawn upon a plate is reversed in the printing process. The figures' apparent clumsiness and the rough rhythms created by the composition's lines are also common to both works.

Field sees Sérusier's influence in the stiffness of the figures and the awkward flow of lines and rhythms[2]. These characteristics are indeed found in several of Sérusier's paintings of 1891, in which he explored the theme of Breton peasant women trapped by their harsh environment[3].

Even though Seguin inscribed "Pont-Aven" onto the image, the scene is not, in fact, Pont-Aven, but rather a combination of individual Pont-Aven characteristics, such as the church spire and steep hillside, with a view of the sea and boats. The sea however, actually cannot be seen from the town. This suggests that the print was drawn elsewhere, probably in Paris. It must have been printed by Seguin himself, who pulled it from left to right. A professional such as Delâtre would have pulled it from top to bottom and cleaned the plate before printing[4].

1. The edition notations for Seguin's prints are based on the number of prints of each title he listed in the catalogue of his 1895 exhibition at the Barc de Boutteville Gallery. In most cases, the entire edition may never have been printed. This would explain the rarity of the impressions of these works. For instance, of the planned edition of fifteen of this work, only two impressions have been discovered to date; the one listed by Field, dedicated to the art dealer and painter Georges Chaudet; and the impression described here.

2. Field, p. 9.

3. See, for example, his *Jeunes Lavandières Remontant de la Rivière*, 1891, Bayrische Staatsgemalddessammlungen, Munich, and *Quatre Bretonnes dans la Forêt*, 1891, location unknown.

4. Information from Pierre Courtin, in a conversation with the author, 1986.

References: Le Barc de Bouteville, 1895, no. 36; Pont Aven, 1961, no. 154.

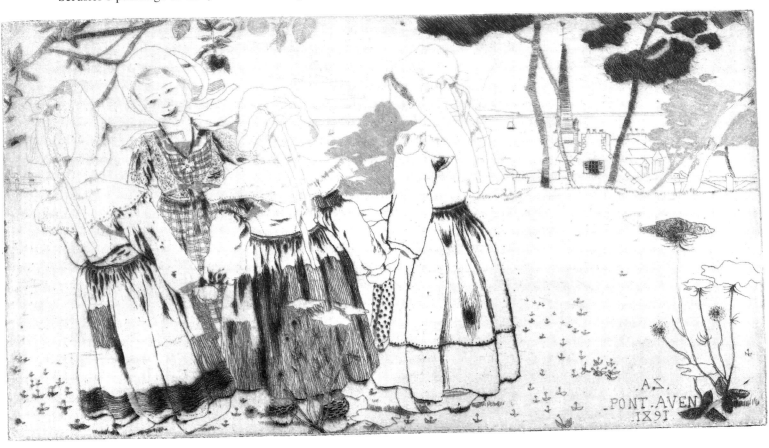

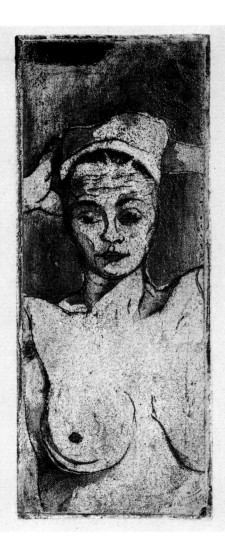

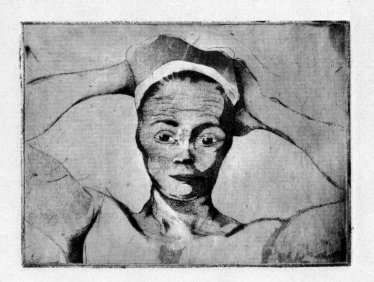

SEGUIN

S.2a NUE AVEC LES MAINS DERRIERRE LA TETE, VERTICALE, 1892
(Nude with Hands behind her Head, vertical)

Field, 75. Etching and open bite aquatint

160×62 mm (image and plate mark)

S.2b NUE AVEC LES MAINS DERRIERES LA TETE, HORIZONTALE, 1892
(Nude with Hands behind her Head, horizontal)

Field, 76. Etching and aquatint

82×105 mm (image and plate mark)
Published in *l'Ymagier*, no. 3, April, 1895.

Both 2a and 2b are printed together on a single sheet of cream laid Arches paper: 224×304 mm

Inscribed in pencil, lower right: *"à l'ami Chaudet A Seguin 92"*[1]

Seguin was obviously intrigued with these two images, for several impressions of each exist in different states, printed on separate sheets of paper[2]. Although the image on the right was not published in *Ymagier* until 1895, it was etched in 1892, as the inscription on this impression proves. For both stylistic and technical reasons, the date of 1892 is, in any case, more believeable than 1895, when Seguin was no longer interested in either the subtlety of aquatint, or in the fine modeling that characterizes this print (See S.27).

Seguin's two images create an intriguing contrast of techniques. The right hand figure is very refined and close in feeling to Seguin's works that were inspired by Delavallée, such as *La Ronde de Pont-Aven* (S-1)[3]. Seguin, in fact, may have gone to Brittany with Delavallée during the summer of 1892. This would explain the thin, elegant lines, exquisite aquatint, delicate tonal modeling, and careful plate wiping here that also characterize many of the latter's prints. According to Field, Seguin was, at that time, attempting to incorporate the technical skills he had learned from Delavallée into "a style of elegance, sophistication, and

surface decoration." In this print, he certainly succeeded. The left-hand image, on the other hand, is characterized by a coarse aquatint that gives the print a rough, splotchy appearance. Seguin laid the aquatint down first and then delineated the face with etched lines of various thickness.

In the two nudes, Seguin skillfully utilized a variety of techniques to create both a traditionally modeled nude and one that incorporates a more purely Synthetist vocabulary of large, relatively flat areas of aquatint with thick lines that vaguely delineate certain features.

The subject is highly unusual. The model's hat suggests a Breton cap, the kind worn under a coiffe, but modeling in the nude was disapproved of amongst the Bretons and consequently is rarely seen in works that depict the people of the region.

1. Georges Chaudet was a Paris-based painter and dealer who tried to sell works by both Seguin and Gauguin.

2. Coll. J. and Field, nos. 75, 76.

3. Compare the careful use of aquatint here to that seen in Seguin's *Le Pêcheur* of 1891 (Field 3, Coll J). Both prints show a mastery of subtle aquatint application.

References: *Nue* (vertical), Pont-Aven, 1961, no. 177; *Nue* (horizontal), London, 1966, no. 180.

SEGUIN

S.3 SAPINS AU DESSUS DE LA RIVIERE, c. 1892 (Fir Trees above the River)

Field 12. Etching, open-bite

160×197 mm (image and plate mark)
On medium-weight cream laid paper: 262×362 mm

Inscribed with a flower in yellow/brown crayon, lower left.[1]
Pencil inscription, lower left: "Seguin" over previous inscription of "Gauguin," not in artist's hand.[2]

The jagged, irregular silhouettes of the foreground trees, the panorama, and the high vantage point are all influenced by Japanese art. When compared to a companion print, *Tree above the River* (Field, 11), this debt appears even more obvious.

The tight webs of parallel lines, flattened by the open-bite take on the abstract, planar qualities seen in many Japanese woodblock prints. Maufra also used the same technique in his print *Le Cimetière, Plougasnou* of 1894 (Morane, 20).

1. The same image is seen on examples of *Les Bretonnes* (S.23).

2. At various times, hopeful collectors or dealers have signed works by members of the Circle of Pont-Aven or unknown artists with Gauguin's name. In one of Seguin's paintings, *Les Fleurs de Mal* (Coll. J.), for example, the signature "P. Gauguin" was added by carefully changing the "A.S" of Seguin into a "P.G" and adding the fictitious date of 1889.

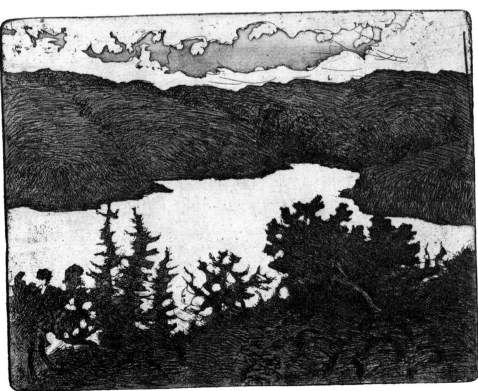

SEGUIN

S.4 LE CAFE, 1893
(The Café)

Field, 23. Etching, roulette and open bite

393×230 mm (image and plate mark)
On cream laid monogrammed paper: 540×364 mm
In dark brown

Signed in plate in reverse, upper right: "A Seguin 93"
Ochre stamp in lower right: "AS"
Red stamp in upper right: "AS"

Planned edition of 25

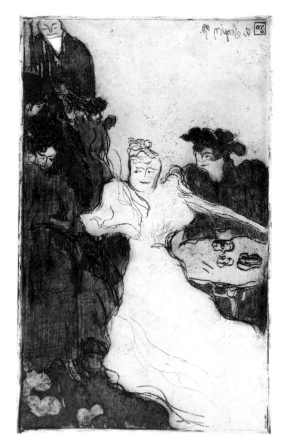

Patterns, lines, textures, and subject matter relate these two prints to Seguin's highly successful painted screen *The Delights of Life* of 1892—93 (illus. 16). All three café scenes are rich in atmosphere, but while the screen is light and gay, the prints are slightly sinister. Their compositions are characterized by flat patterns silhouetted against each other to create convoluted, wiry lines whose agitated curves together with the caricatural features of the figures are reminiscent of works by Toulouse Lautrec, as is the compositional device of silhouetting flat figures against a background of opposite tonality [1].

In both prints, Seguin employed various etching techniqes to produce rich, painterly patterns. Each figure was conceived as a flat shape, one behind the other, receding back and up the picture plane. Seguin carefully wiped his plates so that entire figures and isolated forms would create lively, abstract shapes over the picture's surface. He even used a matchstick to wipe off some of the ink in certain places, such as the white dress on the woman in the foreground of *Le Bar*. Thumb prints, ragged edges, and uneven inking attest to Seguin's own printing of the works.

The two prints complement each other compositionally. In each, figures of the same scale are grouped in a roughly right-angled triangle of the same dimension. The two prints may have been created as a pair, although each of them stands by itself.

Few of Seguin's prints have a narrative theme, and any suspicion of emotional content behind their bold formal elements is very rare. Here, however, he presents both a highly decorative surface and an emotional atmosphere with several potential interpretations. The dark figures are vaguely menacing, and the flirtatious, mocking expression on the faces of some of the women have many different possible explanations.

While all of the Pont-Aven artists loved the isolation of Brittany, they also seemed to revel in the intellectual and social life of Paris. They visited galleries and museums, attended concerts and plays, and gathered in the cafés frequented by other artists, playwrights, poets, and philosophers. Few of the young artists had steady, romantic liaisons at the time. Women, like the ones pictured here, were objects for study, for chance encounters, and for flirtations, but not for inspiration or romantic longing. Seguin, had a female companion when he visited Pont-Aven in 1892, but whether or not she was the subject of any of his prints must await further evidence.

This impression of *Le Bar* is a unique proof of an early state before aquatint was added in the face and coat of the man, as well as in the dresses of the women sitting at the table. In the later state of a planned edition of twenty-five described by Field, Seguin also burnished out the right arm of the woman facing us and more clearly defined the face and hair of the woman in the right corner.

1. See Toulouse-Lautrec's "Une spectatrice pendant la chanson de Polin," lithograph from the *Café Concert* series of 1893 (Loys Delteil, "Henri de Toulouse-Lautrec," *Le Peintregraveur Illustré,* vols X-XI, Paris, 1920, no. 37) or "Au Moulin Rouge, un Rude, un vrai Rude," lithograph reproduced in *L'Escarmouche,* 10 December, 1893.(Oelteil no. 45.)

References: Le Barc de Boutteville, 1895, no. 23 or 24; (*Le Café*) Pont-Aven, 1961, no. 168; London, 1966, no. 171; Mannheim, 1963, no. 241; Paris, 1971, no. 90.

Illustration 16. ARMAND SEGUIN, *THE DELIGHTS OF LIFE,* (1892–93, four panel screen, oil on canvas, with painted frames, overall 159×256 cm). This screen reminds us of the artist's 1893 prints of Parisian café scenes and reflects his admiration of Toulouse-Lautrec and Anquetin.

SEGUIN

S.5 LE BAR, 1893
 (The Bar)

Field, 22. Early state not described by Field. Etching, aquatint, open-bite, roulette, soft-ground etching

386×220 mm (image), 400×231 mm (plate mark)
On white laid paper: 445×310 mm

In brownish black
Maroon stamp in upper, left corner of image: "AS"
Green stamp, botton right corner of image: "AS"

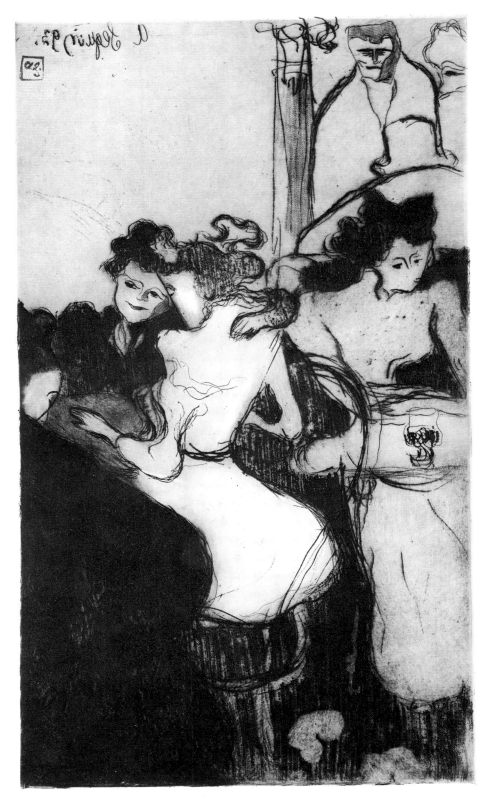

S.6a FEMME ASSISE AVEC CHAPEAU A PLUMES,
c. 1893
(Seated Woman with Feathered Hat)

Field, 6. Early state. Etching

217×110 mm (image and plate mark)
On medium-weight cream laid Arches paper: 308×218 mm

Green stamp, lower right: "AS"
Signed in pencil, lower right: "A Seguin"

S.6b SAME WORK

Field, 6. Final state. Etching, drypoint, stipple

220×110 mm (plate mark)[1]
On simili japan paper, slightly green in color: 394×240 mm

Green stamp. lower right, "AS"

The distinctly non-peasant subject, flowing lines, and stylized figure mark this as one of Seguin's "Paris works." The early state shows a fascination with a sinuous linear structure; its curves are beautifully contrasted by the smooth sweeps of the heavier lines of the left arm. Although an early state, the work is an elegant finished image.

The final state displays an almost Vuillard-like preoccupation with pattern[2]. Each textured area stands alone as a flat, decorative shape. The woman's face and hands and each flower on her skirt were carefully wiped clean of ink before printing, whereas in the first state, only the face was wiped clean.

1. Shrinkage in the different papers used accounts for the different plate mark dimensions for the same print.
2. Edouard Vuillard was a member of the Nabis whose early works often contain marvellous varieties of texture and pattern.

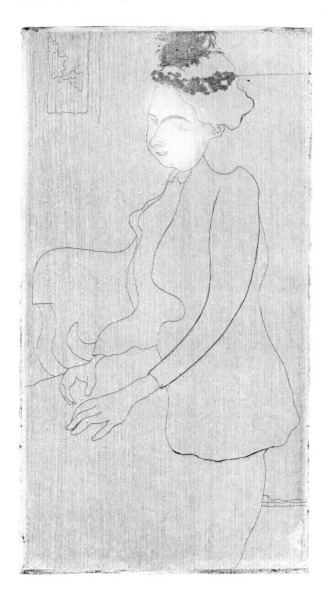

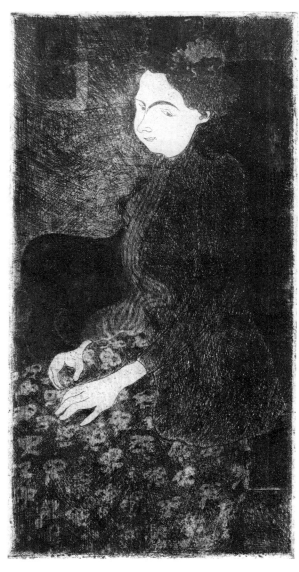

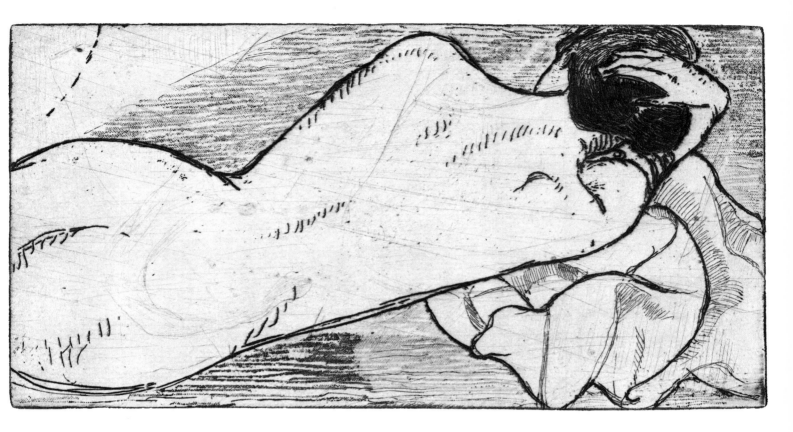

S.7 NUE AVEC CHIGNON, c. 1893
(Nude with Chignon)

Field, 21. Etching, roulette and open bite

114x 217 mm (image and plate mark)
On cream laid paper (Hollande) watermarked with a
monogram: 274×364 mm

One of three Synthetist nudes etched by Seguin, this
may have been done in Paris after he spent the summer
of 1893 with O'Conor in Brittany[1]. If it was made later
in that year, and if *The Café* (S.4) and *Le Bar* (S.5) date
from early 1893 before his trip to Brittany when his
Pont-Aven style coalesced, the radical difference in
style between the two works would be explained.

Bernard claims that he worked with Seguin during
the winter of 1892−93[2]. This collaboration may have
led to Seguin's preoccupation with Cloisonist outlines
in this and other works from the summer of 1893. A
thick, black, Cloisonist line which defines the figure

comes alive in its own right as a purely decorative
shape. Even the cloth upon which the woman rests is
depicted in clearly defined flat areas, in Cézannesque
fashion. Modeling is minimal, accomplished with just a
few short strokes.

The plate used for the print had obviously been used
before for a previous image; a woman's head can still be
seen on the torso of the nude. Nonetheless, Seguin
must have thought highly of the print since he chose a
fine hand-woven paper for it.

1. The others are *Jeune Femme Couchée*, Field 19, and *Nue*,
Field 20. It seems that none of the artists of the Circle of Pont-
Aven used nude female models while painting in Brittany.
When Charles Filiger, a member of the group, painted nude
boys, it caused a local scandal.

2. Emile Bernard, *Souvenirs Inédits*, Paris, 1939, p. 19.

Reference: Pont-Aven, 1961, no. 182.

S.8 LA GARE DE VALMONDOIS, 1893
(The Train Station at Valmondois)

Etching and roulette

180×299 mm (image)
On medium-weight laid cream Arches paper: 305×447 mm

Monogram stamp in green/gold, lower right
Dark red stamp in lower right: "AS"
Planned edition of 5

In 1893, Seguin made a series of four etchings of Valmondois, a town north of Paris in the Val d'Oise (Field, 16, 17, 18). This one, not listed by Field, is noted in the catalogue for Seguin's 1895 exhibition at the gallery of Le Barc de Boutteville. An Impressionist concern for luminosity pervades all four works. The shimmering quality of the light and the fine, sketchy line apparent here clearly relate to the works of Pissarro, Daubigny, and Corot, as pointed out by Field in discussing the three other prints[1].

It is interesting to note that Valmondois is not far from Eragny-sur-Epte, where Pissarro lived then. Could Seguin have been influenced by the older Impressionist and friend of Gauguin in his choice of subject matter and concern with light? While there is no proof to date that Seguin and Pissarro knew each other, a stylistic rapprochement is suggested in these Valmondois etchings.

The subject matter of a railroad yard, pulleys, electric cables, and lights is uncharacteristically modern for Seguin. He normally shunned such industrial features in favor of the more timeless themes of peasants and landscapes.

1. Field, p. 12.

Reference: Le Barc de Boutteville, no. 69.

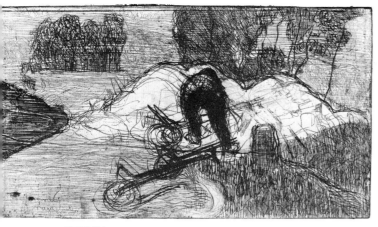

SEGUIN

S.9a LE DEBARDEUR, 1893
(The Stevedore)

Field, 16. Early state. Etching

161×289 mm (image and plate mark)
On medium-weight cream laid paper: 309×447 mm
In dark brown

Green stamp in lower right corner: AS

S.9b SAME WORK

Experimental proof. Etching

161×267 mm (image), 161×280 mm (plate mark)
On medium-weight cream laid paper: 217×368 mm

A concern for light, as well as the prevalence of webs of fine lines, place this print in Seguin's *Valmondois* series. The outlined forms and flatness of the groups of trees, for example, are obvious references to Synthetism, but the sheer number of fine lines almost obscures the simple shapes they define.

In the later proof (S.9b), Seguin evidently decided that his print was too long and wide. He masked the left-hand edge by ten millimeters and tried to mask three millimeters at the top, probably with pieces of paper. By the time he printed this impression, however, the paper had dried too much, resulting in the uneven greys and a washed-out effect[1]. The surprising atmospheric effect created by the dry paper obviously pleased him enough to stamp it with his monogram.

1. Analysis by P. Courtin in a conversation with the author, 1986.

SEGUIN

S.10 LA PECHE, 1893
(Fishing)

Field, 27. Early state. Etching and roulette

Irregular size, c. 177×301 mm (image and plate mark)
On medium-weight cream laid Arches paper: 325×484 mm

Inscribed in plate in reverse, lower left: "AS juillet 93"
Ochre stamp: "AS", maroon stamp: "EAS" in lower right[1]
Inscribed in pencil, lower left: "Seguin," not by the artist.

Planned edition of 15

The irregular edges and the reversed "12" in the upper left corner indicate that Seguin used a flattened tin can for his plate with the maker's name still visible. He did not varnish the back or edges, which allowed them to be badly eaten by acid. A single acid bath led to the uniform linear thickness. In a later state (Coll. J), Seguin cleaned his plate and buffed away many of the dots that are randomly sprinkled across this proof.

This view of the Laita River, with the Chapelle de la Pitié in the background, possesses all the qualities of a quick sketch. Seguin delineated some of the landscape elements and defined their outlines in a manner that he further explored in other prints of the summer of 1893, such as *La Maison du Pendu* (S.11).

1. The "E" probably refers to "Ergastère," the Nabi word for "studio," thus, "Studio of Armand Seguin."

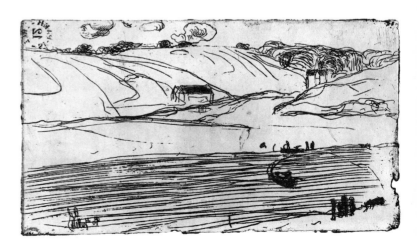

S.11 LA MAISON DU PENDU, 1893
(The House of the Hanged Man)

Field, 42. Etching
182×302 mm (image and plate mark)
On medium-weight laid cream paper: 233×338 mm

Signed in plate in reverse, lower left: "Juillet 93"
Monogram (entertwined A's and S's)[1] stamp in green, lower right

Planned edition of 15.

This house, also painted by Filiger, Gauguin, and Sérusier[2] stood isolated on a tall bluff of treeless sand on the south coast, several kilometers from Le Pouldu. The name of the house may refer to a local suicide or to a misspelling of the Breton word, "pandu," which means "tête noir" or "black head." Seguin emphasized its isolation by silhouetting the house against the sea.

He was interested in the stone fences that snake across the fields, carving the area into irregular patterns. The rippling lines of the fences move the eye smoothly across the scene, from left to right and from foreground to background.

The scratched and pitted plate surface suggests rustic printing conditions, but it may well be that Seguin wanted this defect as part of the finished print. It would have been easy for him to polish and clean the plate, but obviously, he found that the scratches gave the composition an earthy quality that he liked.

1. This stamp was used frequently by Seguin. It is difficult to decipher, but seems to consist of three "A"s, vertically placed, and intertwined with six horizontal "S"s.

2. Filiger, *La Maison du Pendu*, 1890 or 1891; Gauguin, *La Maison Isolée*, 1889 (W 364); *La Perte du Pucelage*, (W 412) and *La Maison du Pendu* (W 395), both of 1890.

References: Le Barc de Boutteville, 1895, no. 33; Pont-Aven, 1961, no. 157; London, 1966, no. 172.

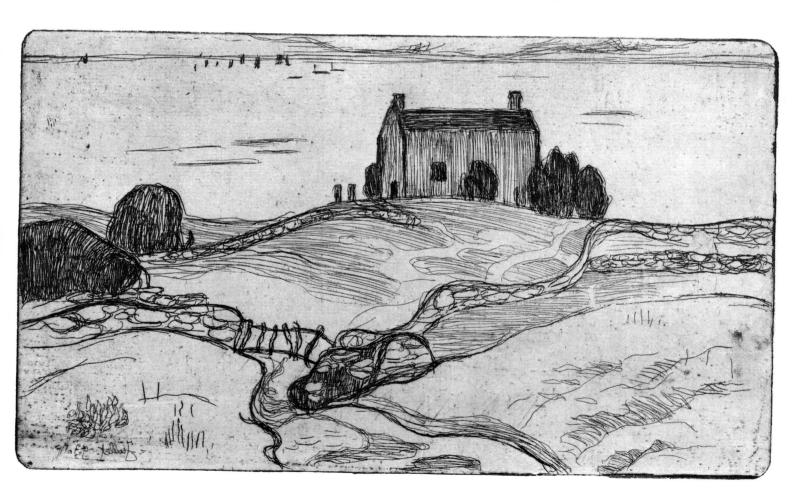

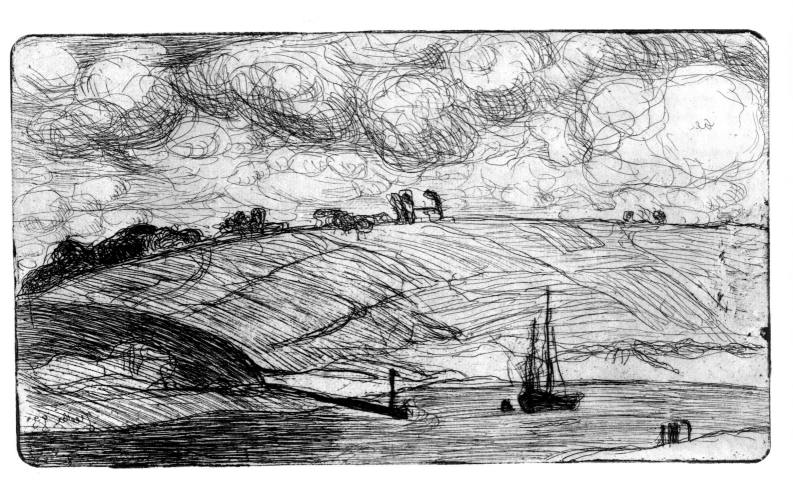

SEGUIN

S.12 L'ENTREE DE LA RIVIERE, 1893
(The Entry of the River)

Field, 30. Etching

181×303 mm (image and plate mark)
On medium-weight white laid Arches paper: 330×508 mm

Inscribed in plate in reverse, lower left: "juillet, 93"
Dark red stamp in lower right: "AS"
Monogram stamp in blue, lower right of entertwined E's and S's.

Planned edition of 15

This view of the Laita River and the fields beyond reflects an Impressionistic concern for atmosphere and light. The grey, misty environment and the sky full of moving clouds, evoke the Breton coastal areas. The print's composition is similar to that of *La Pêche* (S.10), including the four small figures on the shore drawn with a few quick lines. The technique of irregular, thin, short parallel lines and the concern for light recall the *Valmondois* series (S.8, S.9).

References: Le Barc de Boutteville, 1895, no. 38; Pont-Aven, 1961, no. 156; London, 1966, no. 173.

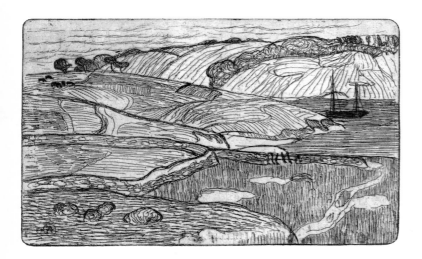

SEGUIN

S.13 PAYSAGE AVEC CHEVAUX ET BATEAUX, 1893
(Landscape with Horses and Boats)

Field, 33. Etching

184×295 mm (image and plate mark)
On medium-weight cream, laid paper: 243×313 mm

Green stamp, lower right: "AS"
Inscribed in pencil, lower right: "AS" (artist's hand?)

Planned edition of 15

In this impression, Seguin used a coarse cloth to wipe the plate after inking so that some of the ink was pulled out of the etched lines. This gives a rich appearance to the lines, similar to the effect of burr on drypoint lines. The overall impression is of a misty, heavily laden, atmosphere.

Another impression of this print was wiped clean of surface ink before printing (Coll. J.). Because of its clean white areas between black lines, the scene there appears to be crisp and fresh as if in full sunshine and the preoccupation with pattern becomes even more evident than in the present impression. The areas are well-defined in a Cloisonist manner and each is characterized by strokes going in different directions.

The spatial complexity in this print is remarkable, considering the narrow depth of field in so many of Seguin's other prints. Each bordered field succeeds the previous one in leading the eye back into space. Yet this almost abstract image conveys the actual appearance of the Breton landscape. After having seen Brittany, one cannot look at the Pont-Aven prints without feeling part of that landscape itself.

Reference: Le Barc de Boutteville, 1895, no. 39?

SEGUIN

S.14 PAYSAGE RAYE, 1893
(Striped Landscape)

Field, 34. Etching

93×192 mm (image and plate mark)
On cream laid monogrammed paper: 223×323 mm

Seguin analyzed this landscape in terms of flat planes, dividing the foreground cliffs and fields into simplified, outlined shapes. As in the previous print, the high skyline emphasizes the use of different patterns. The

bold result demonstrates how far Synthetism led this artist towards pure abstraction. Seguin has been criticized for not carrying through his very personal experimentation into abstract design and for succumbing instead to the influence of other artists due to lack of faith in his own vision[1]. This little print, revolutionary for its time, may well represent the summit of his *oeuvre*. One feels a sense of loss at having been denied further explorations of this bold, planar schematization of nature[2]. Yet this almost abstract study of patterns and shapes still manages to convey a feeling of the landscape of Brittany.

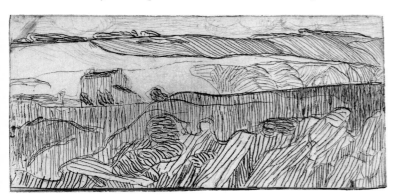

1. Field, p. 5
2. While the plate survives and restrikes have been made by Malingue, the restrikes have lost most of the subtlety of the present impression of this beautiful print, which seems, to date, to be the only surviving lifetime impression.

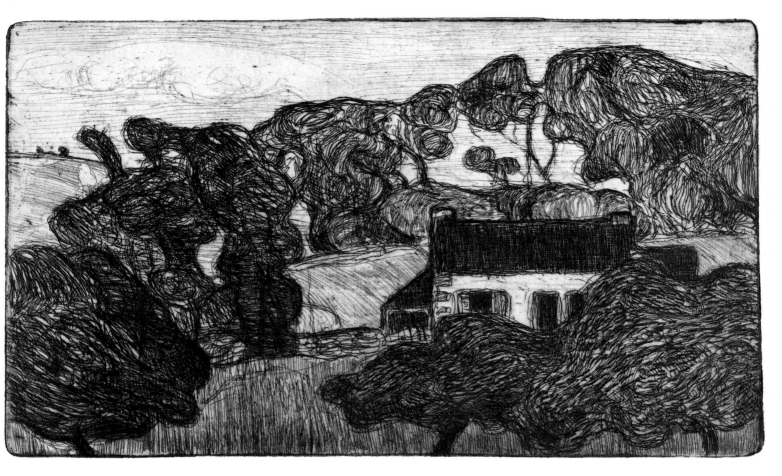

S.15 FERME ENTOUREE D'ARBRES, 1893
(Farmhouse surrounded by Trees)

Field, 38, Etching

182×305 mm (image and plate mark), rounded plate corners
On cream laid Arches paper: 329×506 mm

Tan stamp in lower right: "AS"

The energy and exuberance suggested by the trees in this print are reminiscent of contemporary work by O'Conor (0.6), whose tortuously shaped trees also imply the buffeting they receive from the winds around Le Pouldu. Seguin saw his trees not as individual units but as a group, linked by sinuous lines. Shapes full of energy were his primary concern.

This print relates to Seguin's painting of the same period, *Deux Chaumières, Maisons dans un Paysage* (illus. 17). The two works display similar compositions of houses closely surrounded by dense trees. An identical feeling of turbulance created by the churning lines fills both works. Seguin used webs of lines to suggest energy and movement within each form. On top of these, he used thicker lines to tie the individual forms together, thereby emphasizing the flat shape of the whole unit.

The painting's bright red color adds to the effect, white the black-and-white print suggests the same claustrophobic energy through dense webs of lines.

References: Le Barc de Boutteville, 1895, no. 48 (?); London, 1966, no. 175.

Illustration 17. ARMAND SEGUIN, *DEUX CHAUMIERES, MAISONS DANS UN PAYSAGE,* (1893, oil on canvas, 60×91 cm). Churning lines and saturated colors characterize this painting, whose turbulent image creates an effect similar to some of Seguin's 1893 etchings.

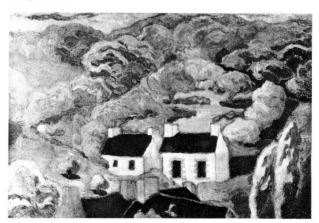

SEGUIN

S.16 LES POMMIERS, 1893
(Apple Trees)

Field, 39. Etching, drypoint, and aquatint

180×297 mm (image and plate mark)
On medium-weight cream laid Arches paper: 305×446 mm

Signed in plate in reverse, lower right: "Pouldu/A Seguin"
Green stamp, lower right: "AS"

Planned edition of 5

S.17 LES SAPINS, 1893
(The Fir Trees)

Field, 40. Etching and roulette

182×302 mm (image and plate mark)
On medium-weight white laid Arches paper: 327×508 mm

Signed in plate in reverse, lower right: "A Seguin 93"
Green stamp, lower right: "AS"
Burgundy monogram stamp: lower right: entertwined
 "E"s and "S"s.

Planned edition of 15

S.18 L'ORAGE, 1893
(The Storm)

Field, 41. Etching and softground etching

181×298 mm (image and plate mark)
On medium-weight cream laid Arches paper: 306×444 mm

Signed in plate in reverse, lower left: "A Seguin 93/Pouldu"
Yellow stamp, lower right: "AS"
Gold stamp, lower right: "EAS"

Planned edition of 15

These three images, in pure Synthetist style, reduce the trees to bold two-dimensional patterns that run horizontally across the picture plane. Seguin relied on three different etching techniques to achieve this effect. In *Les Pommiers* he used etched lines, aquatint, and drypoint to create a wash-like effect that moves across all four of the apple trees, fusing them into one shape. Only slight variations in the aquatints differentiate the trees.

In the stunningly abstract *Les Sapins*, Seguin's flat trees flow sinuously into each other with long looping and curved lines placed on top of vertical roulette patterns. The horizontal stripes between roulette areas

in the central tree emphasize its flatness while the two different plate tones draw attention to the bands that divide the composition.

Finally, in *L'Orage,* Seguin employed a consistent pattern of short, comma-like strokes in the trees to suggest masses of foliage. He also emphasized the flow of these horizontal shapes by defining them with thick outlines. The trees are more three-dimensional than those in the other two prints. Although the fullness of each separate area of foliage is emphasized by short, curving lines, the dark Cloisonist outlines effectively negate this three-dimensionality. The contradiction of flatness and fullness is a common feature of the Pont-Aven style, often causing a visual tension that breaks the tendancy towards surface decoration.

Technically, these works show the wide range of Seguin's abilities. In the *Orage,* for example, he used drypoint over soft-ground in the lower portion of the print to create the dark, round shapes that lead to the trees in the middle ground. The roulette work of *Les Sapins* results in an unusually bold texture in the trees in addition to underscoring their flat, horizontal patterns. The horizontal sweep of the aquatint in *Les Pommiers* serves the same purpose: to stress the two-dimensional qualities of the composition, which should be read as horizontal bands and not as front-to-back spatial recession.

References: (*Les Pommiers*) Le Barc de Boutteville, 1895, no. 43; (*Les Sapins*) Le Barc de Boutteville, 1895, no. 47; Hans Hofstatter, *Jugenstil Drukkunst*, Baden-Baden, 1968, p. 27; (*L'Orage*) Le Barc de Boutteville, 1895, no. 37.

SEGUIN

S.19 LA GLANEUSE, 1893
(The Harvester)

Field, 58. Etching

180×249 mm (image and plate mark), left plate corners rounded
On medium-weight tan laid paper: 263×383 mm

Rust-colored stamp, lower right: "AS"
Blue stamp, lower right: "EAS"
Signed in pencil, lower right: "AS" and
"A Seguin" (artist's hand?)
Inscribed in pencil, lower center: "La Glaneuse/ 1907/
Le Garrec" (not artist's hand)
Collector's mark, lower right: "KW" in circle (Casimir de
Woznicki, Lugt 1652a)

S.20 LA BRETONNE AUX GENOUX, 1893
(Breton Woman Kneeling)

Field, 61. Etching

182×173 mm (image and plate mark), rounded plate corners: right side
On medium-weight white laid monogrammed paper: 324×227 mm

Signed in plate, lower left: "AS 93"

S.21 LES ROUISSEUSES, 1893
(The Flax Gatherers)

Field, 62. Etching

159×229 mm (image and plate mark)
On medium-weight cream laid monogrammed paper: 270×359 mm

Planned edition of 5

In addition to the landscapes executed during the summer of 1893, Seguin completed at least twenty-two figure studies. All depict Breton peasant women at work or at rest, wearing traditional clothing and the coiffe of Pont-Aven. Field suggests that Seguin was considering a large work based on the theme of gathering flax[1]. Indeed, eight of the prints are based on this theme, including the *Les Rouisseuses,* which depicts the drying of linen made from the already gathered flax and not the bundles of flax themselves. *La Glaneuse* (S.19) may have been either a study for this larger project or a separate image.

The technique involved in these two prints is remarkably simple. One acid bath was used to produce a uniformly dense black line, with no aquatints, roulette, or complicated plate wipings. The plates are very scratched and pitted, resulting in an earthy, spontaneous quality. Seguin did not even burnish out mistakes in *Les Rouisseuses,* such as the line of the man's chest, that crosses his arm or the lines of the stacks of grain that overlap the figures in front of them.

The long, thin lines of the figures, combined with the short, vertical, parallel lines defining the settings, are consistent with those in several of Seguin's contemporary landscape prints, such as the *Paysage avec Chevaux et Bateau* (S.13). None of the turbulence seen in certain landscapes of Seguin and O'Conor are seen in these figures, whose elegance may be due to Bernard's influence. Seguin's *Les Rouisseuses* calls to mind Bernard's large canvas, *Le Blé Noir au Bord de la Mer* (Coll. J.), in composition, poses of the figures, and reduction of the figures to smooth, swelling forms and lines.

Field notes how Seguin's flowing, ample forms recall those of Bernard's *Les Bretonneries* (B.4−8), and he criticizes both for failing to translate these figures "into convincing physical action"[2]. Action and believability, however, may not have been Seguin's goals. Rather, his interest in surface patterns and rhythms may have dictated his concentration on the graceful movements of the working women.

Bernard, in *Les Bretonneries,* dramatized the coarseness of the peasants, their oversized feet and hands, and their inelegant poses and features. Seguin, on the other hand, froze his figures in almost ballet-like poses,

dwelling on the long, smooth sweeps of their dresses and extended arms. The few facial features represented are vague, but hardly coarse.

An interpretation of the figures as decorative entities and not as symbols or sociological statements is consistent with Seguin's landscapes of the same summer. Line, rhythm, and pattern remained the predominant concerns. In these figure studies, the two-dimensional rhythms created by the figures and the settings are paramount, with the artist readily distorting natural details in order to meet his decorative needs. Seguin even substituted the elegant coiffe of Pont-Aven for the very simple, close fitting cap usually worn by the women of Le Pouldu. Exactitude was less important to him than were the linear rhythms created by these more elaborate coiffes.

1. Field, p. 16.

2. Field, p. 16.

References: (*Les Rouisseuses*) Le Barc de Boutteville, 1895, no. 61; Charles Chassé, 1921, p. 55.

SEGUIN

S.22 LE SOIR or LA GLANEUSE, 1893 (Evening or The Harvester)

Field, 68. Early state. Etching, roulette, aquatint and lavis

232×228 mm (image and plate mark)
On cream laid paper: 299×325 mm
In dark brown

Light green stamp, lower right: "AS"

This early state of *Le Soir* was probably printed by Seguin himself, unlike the final state which was professionally printed and published in *L'Estampe Originale* (Album 7, July-September, 1894). Selective plate wiping and careful printing of this early state causes the lines to stand out more boldly against the lighter background than they do in the published state. The loss of detail and "presence" in the published edition may be due to steel facing the plate before the edition was printed in order to achieve uniformity in the one hundred prints necessary for the albums of *l'Estampe Originale*.

The trees appear in clear silhouette against the sky in the early state, and some features, such as the fence and foreground stone wall, are more discernible and create a feeling of space. In this early proof, Seguin used plate wiping to heighten interest in the sky area. The heavy burr creates a rich texture in the early state, that is absent in the published version. When the edition for *l'Estampe Originale* was printed, the plate edges were cleaned up and many scratches removed. Seguin also changed the ink to a lighter, more reddish brown.

Seguin's young girl harvesting in the gathering darkness of evening is taken from his print *La Glaneuse* (S.19). In *Le Soir,* he simplified the folds of her dress and changed her coiffe to the little white cap worn by the women of Le Pouldu. Common to both works is a two-dimensional schematization. In *Le Soir,* trees in particular appear as flat silhouettes against the evening sky. The lines of the fences, trees, and swelling in the ground create a lovely, smooth rhythm that carries the eye in waves back and forth across the picture plane.

The site of this print is the same as that painted by Gauguin in *Ferme en Bretagne* (W 372), dated 1889 by Wildenstein but re-dated 1894 by Field based on this print[1]. Gauguin's advice and explanations of his own stylistic development may have led Seguin to emphasize surface rhythms here more than in his earlier works. The curves and sweeps of the two-dimensional lines are smoother and more consistent in *Le Soir.* Comparison with Gauguin's painting of the same scene, however, underscores a fundamental difference between the two artists' works. While Gauguin's painting stresses a two-dimensional rhythm created by flowing lines, the scene, nonetheless, has depth and "shows a mastery of space and articulation of detail"[2]. Its complicated patterns and multitude of color variations, lines and shapes invite prolonged study. Seguin, on the other hand, negated space and avoided details in order to accentuate surface rhythms, which resulted in a more decorative work whose visual elements can be quickly grasped.

1. Field, p. 56, no. 68.

2. Field, p. 17.

References: Le Barc de Boutteville, 1895, no. 50; Galerie Lafitte, "Peintures, pastels, aquarelles et dessins Modernes," Paris, April-May, 1895, no numbers. 10 francs; Vente O'Conor, 1956, no. 66; Pont-Aven, 1961, no. 166; Mannheim, 1963, no. 238; London, 1966, no. 177; Donna M. Stein, Donald H. Karshan, *l'Estampe Originale — a Catalogue Raisonné*, New York, 1970, no. 79; Quimper, 1978, no. 83;

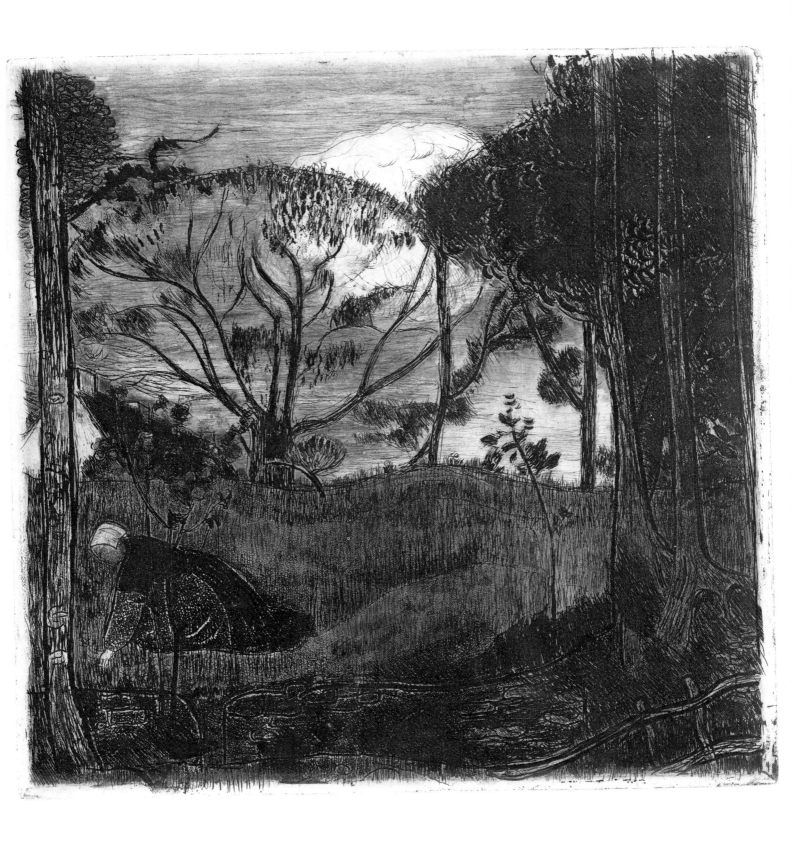

S.23 LES BRETONNES, 1894
(Breton Women)

Field,70. Early state. Woodcut or linoleum cut[1]

220×186 mm (image)
On cream laid paper with watermark of a cock over the letters "Vigilantia": 350×217 mm
In brown

Dedicated to O'Conor by Gauguin in black ink at the bottom: *"taata O. Connor* [sic] *vau hinaaro oe nafeu oe parahi Samoa fenua P. Gauguin"*[2]

Despite the occasional attribution of this work to Bernard, who was in Cairo in 1894 and working in a completely different style, it clearly belongs to Seguin, as indicated in *Ymagier*, in which the second state was published[3]. This confusion has arisen from the apparent initials "EB" in the plate in the later published state. These letters may in fact be an unsuccessfully carved "ES" (Ergastère Seguin), as in *La Pêche*, (S.10). In a woodcut the letters have to be carved in reverse, and mistakes are easily made.

Several of the early states of the present print, including this one, bear dedications by Gauguin. It is inconceivable that in 1894, at a time when he and Bernard were feuding, Gauguin would have written a dedication on a print made by his adversary. The dedication by Gauguin, on the other hand, is evidence of the high esteem in which he held Seguin's works.

During the summer of 1894, Gauguin was laid up in Pont-Aven with a broken ankle, the result of a fight in nearby Concarneau. Seguin, who had been involved in the fracas, spent a great deal of time keeping the invalid company and discussing his work at length with the "master." Their friendship subsequently flourished enough for Gauguin to invite him to the South Seas the following year, an offer Seguin declined.

Seguin's use of the woodcut medium for this print can be directly attributed to Gauguin's influence. The latter was working on woodcut illustrations for his *Noa Noa* series when Seguin's print was probably also executed[4].

The simplicity of Seguin's figures and their setting in *Les Bretonnes,* as well as the textures of the sea and of the clothing, contrast with the spontaneous lines of his etchings. Yet, these lines are reminiscent of those in the 1893 figural etchings (S.19–21) with their smooth linear transitions carrying the eye from one figure to the next.

A poem by Charles Morice that accompanies the print only in the early state praises Gauguin and, curiously, has nothing to do with the print. Why Morice and Gauguin chose this rather than a work by Gauguin himself is uncertain, unless an allusion could be made to Gauguin's projected departure by the three figures on the shore watching a distant boat. Could it represent Gauguin departing for the South Seas with the peasants of Brittany saying good-by[5]? Whatever the reason, Gauguin liked the work sufficiently to dedicate copies of it to several of his friends, including Jean Dolent, Maxime Maufra, Paul Sérusier, and Stéphane Mallarmé[6].

1. The gouged areas in the water in the upper left of Seguin's print have caused some experts to suggest that it might have been cut on a linoleum block. Other areas, however, such as the area to the right of the right foot of the woman on the right, suggest a woodcut. If this is a linoleum cut, then it would be one of the earliest examples of this medium, since linoleum, although invented in 1860, was not extensively used for prints until the early 20th century. (Françoise Woimant and Pierre Courtin, in conversations with the author, 1986.)

2. Translation: "Mr O'Conor, I would like to see you living in Samoa, but when?" Samoa was used as a general word for Polynesia. Information from Gilles Artur, Director of the Musée Gauguin in Tahiti.

3. For a discussion of the mistaken attribution and its re-attribution to Seguin, see Field, pp. 57–58. Note also that the pencil insignia similar to an "EB", but possibly an "ES" with an inverted "S", found on some of the proofs is also found on an impression of Seguin's *Two Swans Flying over the Sea,* 1892 (Field, 8) in the collection of E. Kornfeld, Berne.

4. For a discussion of the *Noa Noa* prints, see Richard Field, "Gauguin's *Noa Noa* Suite," *Burlington Magazine,* September, 1968, pp. 500–511.

5. Gauguin left again in June, 1895.

6. Field, p. 57.

References: Published in *Ymagier,* no. 2, January, 1895, without the poem by Morice; Galerie Lafitte, *Peintures, Pastels, Aquarelles et Dessins Modernes,* Paris, April-May, 1895, no number, sold for 7 francs; Quimper, 1950, no. 28 (as Gauguin); London, 1966, no. 187; Goteborg, 1969 (as Bernard).

A PAUL GAUGUIN *Le 21 Novembre 1894*

Un beau jeune homme nu sous un ciel d'orient *Frère des grandes fleurs, comme elles il adore*
Incline l'innocence et l'orgueil de sa force *Ces dieux du crépuscule et ces dieux de l'aurore :*
Devant l'Idole qui sommeillait sous l'écorce *Le Plaisir la Gaîté la Joie et le Bonheur. —*
De l'Arbre hier debout dans le bois verdoyant.

 — C'est ton âme, Gauguin, ton génie et ton âme
Puis — rite essentiel d'un culte souriant — *Que je vois vivre dans mon rêve et que j'acclame,*
Il se laisse séduire à l'amoureuse amorce *Toi qui sais le Mystère et nous dis sa Splendeur.*
D'une dont l'œil reluit parmi les tresses torses
A l'ombre du bois verdoyant, luxuriant. CHARLES MORICE.

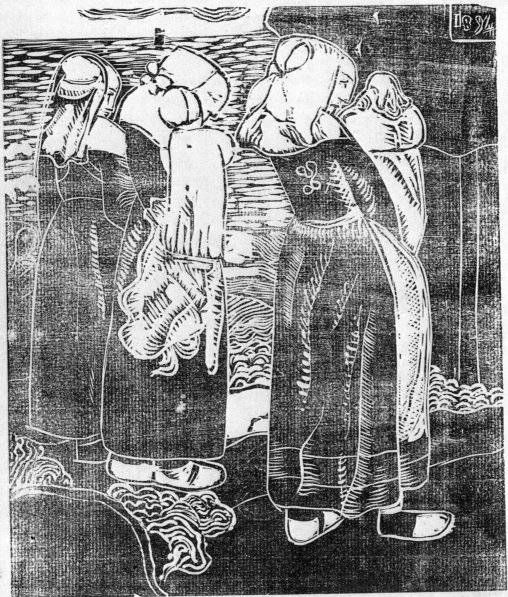

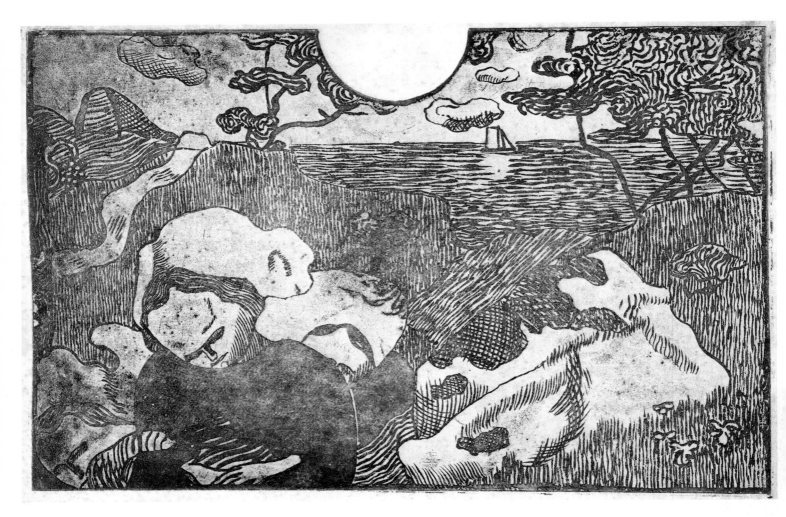

S.24 DECORATION DE BRETAGNE – UN JOUR D'ETE, c. 1894
(Breton Decoration, a Summer's Day)

Field, 72. Sugar lift on zinc[1]

245×378 mm (image)
On thin laid cream Japan paper: 271×387 mm

Planned edition of 10.

S.25 DECORATION DE BRETAGNE – BRETONNES AU BORD DE LA MER, c. 1894
(Breton Decoration, Breton Women by the Sea)

Field, 73. Sugar lift, etching, and aquatint

184×349 mm (image and plate mark)
On heavy cream laid Arches paper: 253×430 mm

Light green stamp, lower right, in image: "AS"
Dark red stamp, lower right: "AS"

Planned edition of 10

During the summer of 1894 when Gauguin and Seguin spent time together, Gauguin experimented with monotypes and woodcuts. The painterly effects, unusual textures, and distorted forms of these two highly experimental works may well have been inspired by Gauguin's woodcuts for *Noa Noa*.

Gauguin had criticized etching as a technique, finding it too delicate or sensitive ("le métier est trop sensible")[2]. He preferred the roughness of the potentially more expressionistic woodcut. Seguin may have been reluctant to abandon etching as a technique, but he met Gauguin's challenge to use more "ingenuity"[3] by experimenting with the technique of sugar lift in order to create a woodcut-like appearance. He even chose a zinc plate for S. 24, shaped like a wooden panel. His etchings done with sugar lift displayed a softer, more subtle effect than a straight woodcut could achieve[4]. He began print S. 25 with aquatint and then improperly applied his varnish with a brush. Despite the pronounced pattern this created, he continued working with the plate, using sugar lift to draw the figures and

106

landscape details. The large brushstrokes of ink visible underneath the image are not altogether satisfying, but they do create texture and a curiously haunting effect.

The lines of varying thicknesses were made with a brush onto poorly polished plates, which Seguin then printed himself. In the *Decoration de Bretagne — Un Jour d'Eté,* he used a paper that was too wet, which caused the greys on the woman's dress in the lower left corner.

In both of Seguin's *Decoration de Bretagne,* the female figures wear brooding expressions. The effect of mystery is enhanced by the somber appearance of the prints. The darkness, especially of *Decoration de Bretagne — Bretonnes au bord de la Mer* is unusual for Seguin and may also reflect the influence of the *Noa Noa* woodcuts, in which Gauguin used darkness to suggest mystery and exotism. Criticized by Gauguin for the shallowness of his works[5], Seguin may have responded by seeking a similar aura of mystery in his own prints.

1. For an explanation of the sugar lift technique, see footnote no. 40, "Introduction," p. 33

2. Gauguin, "Préface," *Seguin,* Le Barc de Boutteville, Paris, 1895, p. 12.

3. Gauguin, "Préface," *Seguin,* p. 12.

4. Bernard had aready tried to achieve this effect in 1888 (B.2).

5. Gauguin, "Preface," *Seguin,* p. 11.

References: (*Decoration de Bretagne — Un Jour d'Eté*) Le Barc de Boutteville, 1895, no. 53 or 54; Jaworska, p. 147; Hans Hofstatter, *Symbolismus und die Kunst der Jahrhundertwende,* Cologne, 1965, fig. 7; London, 1966, no. 174; (*Decoration de Bretagne — Bretonnes au bord de la Mer*) Le Barc de Boutteville, 1895, no. 53 or 54.

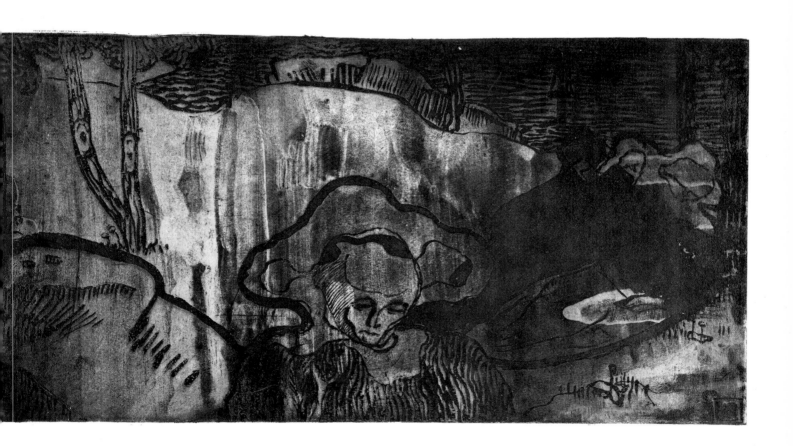

S.26 LA PRIMAVERE, 1894
(Primavera)

Field, 84. Zincograph

214×315 mm (image), 230×317 mm (plate mark)
On heavy wove paper: 323×483 mm
In brown
Signed in plate, lower left: "Seguin"
Green stamp, lower right: "AS"

Published in *Ymagier*, no. 2, January, 1895

Seguin's *Primavère* strongly recalls a painting by Bernard, *Madeleine au Bois d'Amour*, 1889 (Luthi 140, Musée d'Orsay, Paris) with its large-scale female figure rather awkwardly filling the foreground. The pose also relates to the foreground figure in Gauguin's *Ramasseuses de Varech*, 1889 (W 348, W 349)[1]. A study for Gauguin's painting was in the collection of Marie-Henry, the innkeeper in Le Pouldu, so that Seguin would certainly have known it. Even the subject is similar to Gauguin's image: a woman at rest leans on one hand, while another figure (or figures) works behind her.

In contrast to Gauguin's portrayal, Seguin's figure is elegant and delicate. She more closely resembles Bernard's *Madeleine* with her dreamlike face and the flowers around her. These features, as well as the title, all contribute to thoughts of spring and suggest yearning. Her reverie contrasts with the laboring woman behind her, reminding us that Bretons had little time for such dreaming. She may have been a well-to-do Breton or perhaps a model. She is one of Seguin's few individualized figures.[2]

The setting of both Gauguin's and Seguin's works is Le Pouldu. While Gauguin's scene occurs on the beaches south of the village, Seguin's is on the eastern bluffs, near his home in St. Julien. The view across the bay is similar to that seen from his house.

When Seguin took up zincography in 1894, the technique already used by Gauguin and Bernard in their Volpini series five years earlier, he exploited its possibilities in a style that differed markedly from his other prints of that year. The smooth, flowing outlines swell and fall in graceful arabesques as they would in a drawing. He used crayon and pen to achieve both crisp lines and softer modeling. His goal was to create soft effects, not the harsh lines and distortions of his woodcuts and woodcut-inspired etchings (S.23, S.25) or the more brittle lines of his etchings. The print's darkness, however, is reminiscent of the two *Decorations de Bretagne* (S.24, S.25), and the flowers in both the zincograph and the *Decoration de Bretagne — Un Jour d'Eté* are identical.

1. Field, p. 78, fn. 102
2. Seguin did only a few portraits that have been identified, although other figures may also be portraits of Seguin's friends or models. Field lists only three among Seguin's thirty-one paintings and drawings (*Portrait of Marie Jade*, *Portrait of Eric Forbes-Robertson* and *Portrait of Countess d'H.*, Field, pp. 69–70). There is only one print identified as a portrait by name, *Alice* (Field 88).

References: Le Barc de Boutteville, 1895, no. 74; London, 1966, no. 182; Jaworska, pp. 140–141.

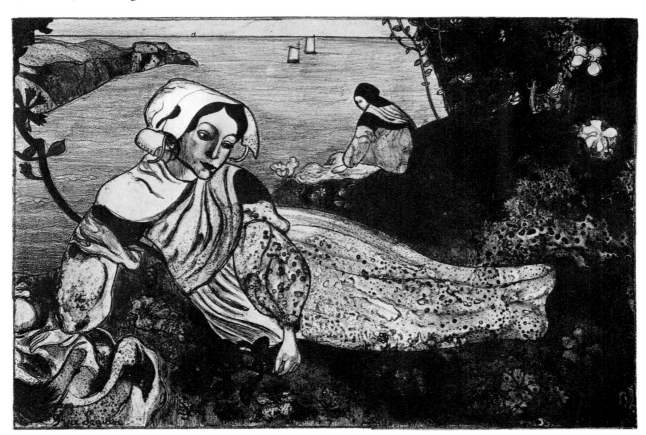

S.27 BRETONNE, c. 1895
 (Breton Girl)

Field, 82. Etching

163×62 mm (image)
On heavy cream paper: 328×252 mm

Planned edition of 15

Continuing his experimentation with woodcut-like etchings, Seguin etched this portrait of a Breton girl wearing the coiffe of either Vannes or Le Pouldu. One

of Seguin's most sympathetic portraits, the girl is not a "type" but rather has the features and wistful expression of a believeable young woman. Drawn in the style of a woodcut, the long, thinly etched lines approximate wood graining, but the thinness of the lines gives the print a delicacy not found in contemporary woodcuts. His design is elegant, with the large masses of the forms standing out in bold relief and creating patterns of their own. Only the tree in the left background displays the swirling lines so typical in Seguin's works of 1893.

The elongated format of the print was most likely influenced by the shape of Japanese scrolls or prints.

References: Le Barc de Boutteville, 1895, no. 65 (?); London, 1966, no. 179; Quimper, 1978, no. 84.

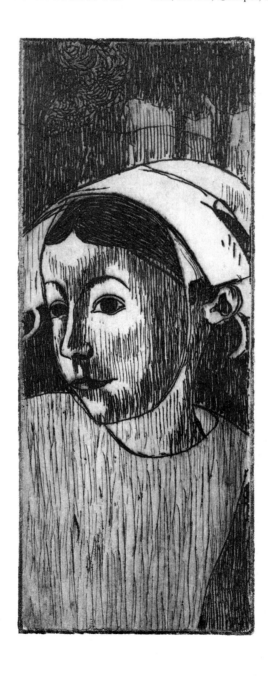

S.28 JEUNE GARCON, 1894–95
(Breton Boy)

Field, 83. Zincograph

240×286 mm (image)
On medium-weight beige wove paper: 281×381 mm

Inscribed in the plate, lower left: "1894"
Planned edition of 5

S.29 DEUX BAIGNEURS, 1895
(Two Bathers)

Field, 86. Zincograph

273×237 mm (image)
On medium white wove paper: 356×277 mm

Signed in plate, lower left: "AS 1895"

In 1894–95, Seguin produced at least five zincographs[1], most likely in Paris, where there were printing facilities for this process. Seguin's friend Sérusier was actively engaged in lithography for his theater programs at the time and may have influenced Seguin's use of the medium[2].

The *Jeune Garcon* is probably the most successful of his zincographs. Here, Seguin relied almost entirely on the tusche to create a very painterly effect; the fluid lines of the man mirror those created by the vaguely naturalistic trees behind him. The print bears a remarkable resemblance to Bernard's 1889 zincograph of a Breton festival (illus. 12), for both depict Breton men wearing festival hats in similar settings, and both use the tusche to produce interesting, fluid textures.

The zincographs of 1894–95 all present a proliferation of detail not seen in earlier works. Meticulous settings are depicted and figures are shown with more anatomical detail than ever before. Compare *Les Rouisseuses* (S.21), for example, with *Les Deux Baigneurs* (S.29), whose complicated tonal variations contrast sharply with the clean backgrounds and empty spaces in earlier works.

In these zincographs, compositional complexity overwhelms any linear patterns and the flat decoration characteristic of Seguin's earlier works is replaced by tonal gradations. The prints all refer to Brittany, with views of Pont-Aven (S.29) or Breton coiffes (Field 85,

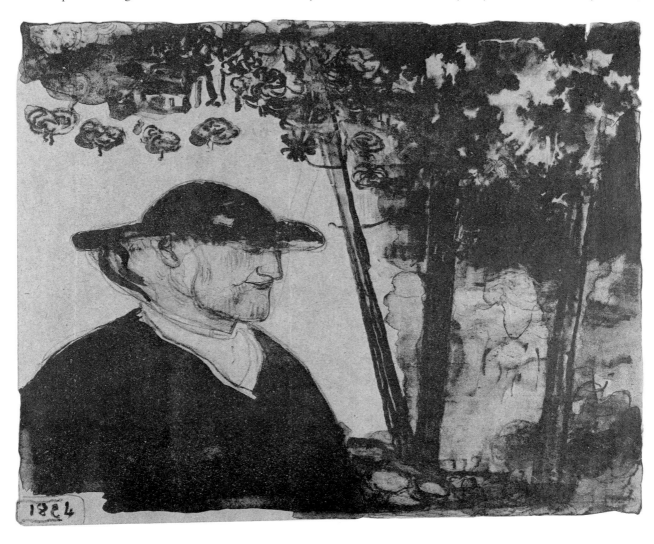

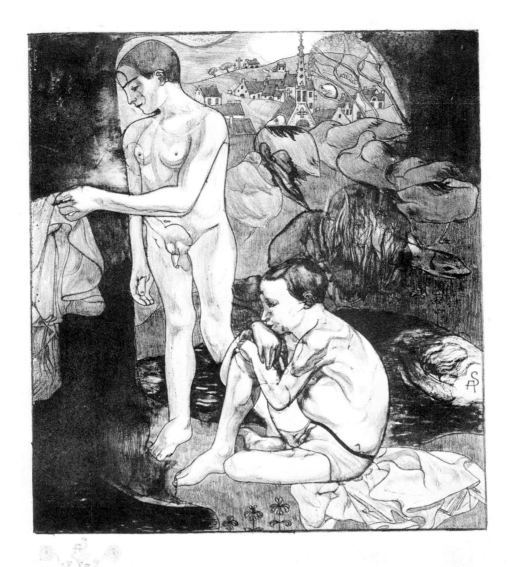

87) and hats (S.28), but they are far removed from the abstract concepts of Synthetism.

Les Deux Baigneurs is a curious work. Only close inspection reveals that the large rock-like forms in the middle ground are actually sleeping geese. The bush in front of them contains flames, and a huge snake slithers between them. The bathing figures[3] appear oblivious to these images of menace. The juxtaposition is unsettling and effective, although the meaning of the symbols is unclear. Gauguin used similar mysterious elements in several works, such as the face in the sea in his zinco-graph, *Les Drames de la Mer,* 1889 (Guerin 8) and faces in the waterfall of *Enfants Luttant,* 1888 (W 273. Coll. J.) and *Dans le Jardin de l'Hôpital d'Arles,* 1888 (W 300. The Art Institute of Chicago).

1. The five zincographs include the two in this section, *Les Pêcheurs de Goemons* (Field 85), *La Primavère* (S.26), and a strange print depicting Breton girls and toads in front of a cave, called *Les Crapauds* (Field, no. 87).

2. Sérusier produced programs for the Théâtre de L'Oeuvre and lithographs for *La Revue Blanche* and *L'Estampe Originale* (SR.2). In addition, Seguin's *Les Pêcheurs de Goemons* relates directly to a painting by Sérusier called *Allegorie d'après Dur-er,* signed and dated 1895 (Guicheteau, *Paul Sérusier,* no. 113, Collection Bernheim). Both the painting and the print refer to Durer's engraving of *St Anthony* (Adam Bartsch, *Le Peintre Graveur,* vol. VII, Vienna, 1808, no. 58) in the depiction of their background cities. Field points out the relationship between the Seguin and Durer prints, p. 21.

3. The figures themselves may be controversial. What appear at first glance to be two young boys may turn out to be two androgynous figures. The sitting one could even be a pregnant female, which would relate to the image of the snake in the print.

References: (*Jeune Garçon*) Le Barc de Boutteville, 1895, no. 77; Chassé, *Gauguin et le Groupe de Pont-Aven,* 1921, p. 21; London, 1966, no. 183, (Deux Baigneurs) London, 1966, no. 184;

S.30 EVANTAIL – BRETONS AU BORD DE LA MER, 1896
(Fan – Breton Couple by the Sea)

Field, 89. Zincograph, monotype, and watercolor

179×403 mm (entire image)
On heavy cream wove paper with watermark of "Ganson et Montgolfier": 209×414 mm

Signed in plate, lower left: "AS"
Signed in blue pencil, lower right: "*no 5. A Seguin*"

Seguin had always had financial woes, but by the mid-1890s, he was desperate. Responding to popular taste for fan-shaped images, he produced several for an exhibition in 1897[1], which failed miserably[2].

In keeping with the commercial intention of his fans, this one is extremely decorative. Seguin's work before this had always been characterized by two-dimensional patterns created by flat forms and curving lines. This flatness, however, was always tempered by the slight modeling of forms and a swelling quality in the lines. The resulting tension between flatness and fullness kept his works from becoming mere decorations. While this fan may be technically intriguing and visually pleasing it reveals the distance Seguin had travelled away from the inspired works of a few years earlier.

Technically the fan is a puzzle. The brown-black lines were produced on a zinc plate and the blue lines were apparently printed as well, although no registration marks are visible. The yellow and green areas could have been added with watercolor, as was the gold in the lower corner next to Seguin's printed initials. More likely, he printed the additional colors using the zinc plate as a support for a watercolored monotype impression over the printed lines. Gauguin, after all, did many monotypes and may have encouraged Seguin to do so as well.

Only one impression of this fan is now known. The inscribed "no 5" may refer to an exhibition number.

1. Field, p. 78, fn. 110.

2. Jaworska, p. 141

S.31a BRETONNE DE PONT-AVEN, c. 1896
(Breton Woman from Pont-Aven)

Field, 90. Woodcut

162×113 mm (image)
On white laid, Chinese paper: 343×130 mm (irregular bottom edge)
In brown
Inscribed in block, lower left: "Pont-Aven"

S.31b SAME WORK

On cream laid paper with watermark, "Andrieux", 362×240 mm (image)

Printed in red, blue and green à la poupée
Signed in pencil, lower right: "*A. Seguin no. 3 tiré 5 épreuves*"

Probable edition of 5[1]

This young woman of Pont-Aven, wearing the "coiffe de basin," is very delicately drawn within the confines of the woodcut technique. When compared to his *Bretonnes* (S.23), it is obvious that Seguin took more care here to render such details as the flowers, folds of cloth, hair and facial features. The wide hatches and cross-hatches and the rough, often uneven woodcut gouges seen in the earlier woodcut are seen again in this print. The colored version was printed in a process called *à la Poupée*[2].

The influence of the printmaker Charles Maurin (1854 – 1914) may have been a factor in Seguin's execution of this print. Maurin, whom Seguin knew[3], produced a series of woodcut portraits in the mid-1890s. His etching style has nothing in common with Seguin's, but his portraits in woodcut are very similar in their rough carving, minimally suggested landscape setting, and the way in which the face and upper torso fill the picture frame. Maurin experimented with color and may have inspired Seguin's use of colors for his own woodcut portrait[4].

1. Although the print is inscribed "no. 3 tiré 5 épreuves," it is not clear whether five proofs in color or five proofs in total were planned. This print is the only color proof known at this time.

2. This process consists of daubing different colored printer's inks on separate parts of a single woodblock before printing. Each ink is placed in a cloth bag which is tied at the top so that by pressing on the bag, the printer can control the amount and placement of the ink emitted. Because the bag looks a little like a rag doll, the process has become known as *à la poupée* (rag doll = la poupée). Only one woodblock is needed to achieve a multi-colored impression, and all the problems of registering several cut blocks are eliminated. Consequently, a monotype is almost made on top of a cut woodblock, since the coloring often is done by the artist himself and can vary with each impression.

3. Evidenced in two unpublished letters to Delâtre from 1895, in which Seguin speaks of Maurin. Coll. J.

4. See Maurin's woodcut portraits in the Bibliothèque Nationale in Paris.

Reference: London, 1966, no. 185.

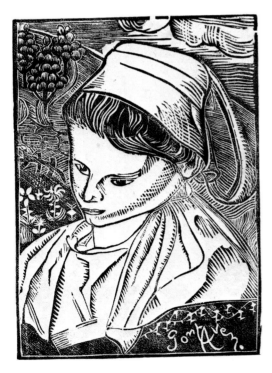

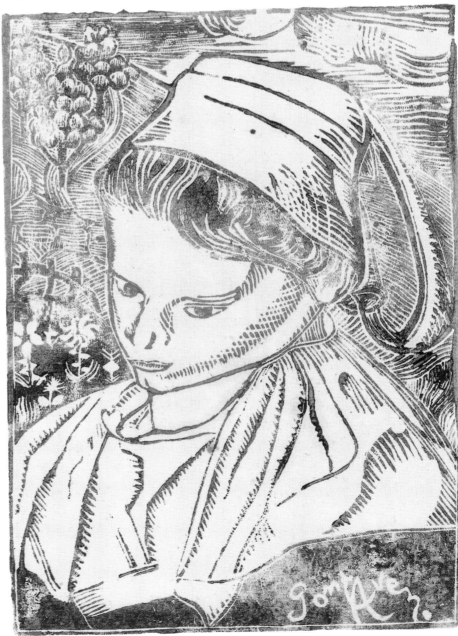

GAUGUIN (attributed)

G.5a LA FEMME AUX FIGUES, 1894–95 (Woman with figs)

Trial proof before publication in the album, *Germinal*, in 1899 (no. 15) and before the plate was cut down. Etching, lavis and soft-ground etching on zinc[1]

268×438 mm (image and plate mark)
On heavy white wove paper: 324×501 mm (left and top), 326×497 mm (right and bottom)

Inscribed in plate, upper left: *"Chez Seguin à St. Julien"*

G.5b SAME WORK

Posthumously printed

268×420 mm (Image and plate mark)
On thin laid Ingres paper: 477×639 mm

This controversial print has been assigned to Seguin, to Gauguin, and even to a collaboration of both artists[2]. Until there is more proof, no definite attribution can be made, but present evidence favors Gauguin as the artist, with possible technical assistance provided by Seguin.

A stylistic case can be made for either artist[3]. Practical considerations favor Gauguin, even though it is not one of his more successful works. For example, the print was published in *Germinal* in 1899 as a work by Gauguin. Since both artists were alive then, it seems inconceivable that denials or accusations would not have come down to us if the print had been misattributed[4]. Furthermore, if Seguin were the artist, why would he inscribe "Chez Seguin" on the print? And finally, Eugène Delâtre, who printed the edition in his Paris atelier, stated that the print was by Gauguin[5]. It may be true that Gauguin drew the composition, with Seguin applying the acids since he knew more about the technique. A few trial proofs exist from the time when the print was first executed, but it was only finally published five years later, in *Germinal*[6].

To produce this print, the artist first applied a soft-ground to his plate and pressed a cloth into some areas, which wore out after only a few impressions, leaving only a faint grey shadow in later impressions and finally disappearing entirely in late impressions (G.5b).

In the trial proofs, the soft-ground, lavis, and the scratched and pitted plate provide a rich variety of textures. In the *Germinal* edition, which was printed in a distinct greenish-grey ink, these nuances are somewhat attenuated, and many of the scratches and much of the pitting are absent. The soft-ground and lavis in the early proofs and published impressions add a grey tonality that acts as an intermediary between the printed lines and the white paper. All these nuances are gone and almost all the greys have disappeared in the frequently seen restrikes, such as the one here, and the print has become an unattractive, harsh black and white composition.

Part of the confusion surrounding the attribution of the *Femme aux Figues* may have arisen from the fact that Gauguin had executed only one etching before this print, the portrait of Mallarmé in 1891 (Guérin 12). He may have been experimenting with an unfamiliar medium while working with Seguin in St. Julien at Le Pouldu where he could have looked closely at Seguin's etchings. This, in turn, may have led to his adoption of Seguin's style of drawing the trees, for example. Compare the trees in this print to those in Seguin's *Les Sapins* (S.17). While both prints are characterized by a heavy outline that defines the mass of the foliage, the lines utilized to draw the interior of each mass are quite different. In *La Femme aux Figues* they appear more uniform than in any of Seguin's works, and the lines of the table and the bench (?) behind the woman display none of the quavering quality so often observed in Seguin's lines.

The work's compositional complexity is more typical of Gauguin than of Seguin. The hands and face are poorly drawn, although they are almost identical to those in Gauguin's woodcut *Auti te Pape* (Guérin 35). The large unidentifiable curved form between the girl and the window is hard to decipher; the subject, too, is perplexing for the woman's clothes and hat are not Breton. Yet according to the inscription *"Chez Seguin à St. Julien,"* the scene takes place at Seguin's home in Le Pouldu, where there was a fig tree in the back yard, although the inscription could also refer to where the print was made.

The woman's face is reminiscent of Madeleine Bernard, Emile Bernard's sister, to whom Gauguin had been attracted since 1888. Her portraits by Bernard, *Portrait de ma Soeur Madeleine*, 1888, (Luthi, 141) and *Madeleine au Bois d'Amour*, 1888, (Luthi, 140), exhibit similar facial features. When Gauguin's *Jeune Bretonne* of 1889 (W 316, illus. 18) is studied in reverse, remarkable similarities in the shape of the faces, hairstyles, expressions, and poses are noticed. Madeleine's fiancé,

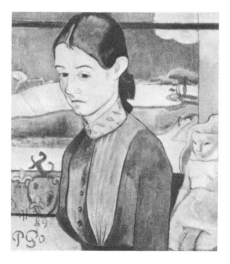

Illustration 18. PAUL GAUGUIN, *LA JEUNE BRETONNE*, (1889, oil on canvas, 460×380 mm, W316). The facial features of this young girl bear a remarkable resemblance to those of *La Femme aux Figues* (G.5), especially if we remember that in the etching the image is reversed.

Charles Laval, a close friend of Gauguin's for several years, died of tuberculosis in 1894. Gauguin may have remembered her with his print, or Madeleine may have visited Le Pouldu in the months before she herself died in November, 1895.

The meaning of the man with the hat who peers into the scene, partially obscured by the bushes and house in the background, is unclear[7]. The artist may have tried to remove the face from a previous design by covering it with lines rather than going through the painstaking process of burnishing the plate. The partially hidden figure may also be intended to add a threatening note to the scene. Gauguin had used this device in earlier paintings, such as *Dans le Jardin de l'Hôpital d'Arles* (W. 300, Art Institute of Chicago).

1. Two other trial proofs, one printed in brown, the other in green, are in the Kornfeld collection, Berne.

2. See "references," below.

3. Field, p. 19.

4. Douglas Druick points out, however, in a letter to the author, June 1986: "In the title page which appeared with the publication [of *Germinal*], no distinction was made between original prints made by the artists themselves (e.g. Toroop's lithograph) and reproductions (e.g. Clot's lithographic translation of Degas' pastel"). In other words, it may be possible that Seguin made an etched translation of a drawing by Gauguin for the publication.

5. The letter is in the possession of his daughter, Mme. J. Delâtre.

6. The controversy surrounding *La Femme aux Figues* continues today around the plate itself. At some point, two centimeters were cut off its right side, at the edge of the sailboat. The size of the reduced plate is 268×418 mm. It is often thought that the plate was cut before it was printed in *Germinal*. The *Femme aux Figues* in the complete *Germinal* album in the Bibliothèque Nationale, Paris, however, was pulled from the larger plate, as was the proof in the Fondation Doucet's complete album. In the 1940s or 1950s, a set of ten prints was pulled from the cut plate by Mme. Delâtre, who then cancelled the plate by gouging three crosses into the cloth on the table. The prints in her edition were numbered one through ten. The plate subsequently disappeared only to resurface in a 1966 auction at the Hôtel Drouot in Paris. (Information from Arsène Bonafous-Murat, Paris.) It is still being used today to print very poor quality proofs, usually on large sheets of thin, laid, Ingres paper measuring 477×639 mm. The lines are now even much wider and cruder than in the restrike disussed here (G. 5b). It is as if they have been recut and none of the lavis is in evidence. There is no sign of the cancellation marks gouged into the plate by Mme. Delâtre, indicating that the marks have either been burnished out or that an electroplate of the original zinc plate is being used for these restrikes.

7. Field, however, stated that he is certain that the face was drawn by Seguin. He Wondered if it could have been an old plate of Seguin's, with the face already drawn, upon which Gauguin, or Seguin, drew this composition? Field in conversation with the author, August, 1985.

References: Published in *Germinal*, Paris, 1899, no. 15, edition of one hundred (as Gauguin); Guérin 88 (as Seguin); Vente O'Conor, 1956, no. 36 (as Gauguin); *Gauguin: Paintings-Drawings-Prints-Sculpture*, exhibition catalogue, The Art Institute of Chicago, 1959, p. 76 and no. 126 (as Gauguin, done in 1886); Quimper, 1958, no. 121 (as Gauguin); Quimper, 1978, no. 8l (as Seguin and Gauguin); Jaworska, pp. 141 and 24, note 108 (as Seguin); Field 89, (as Seguin).

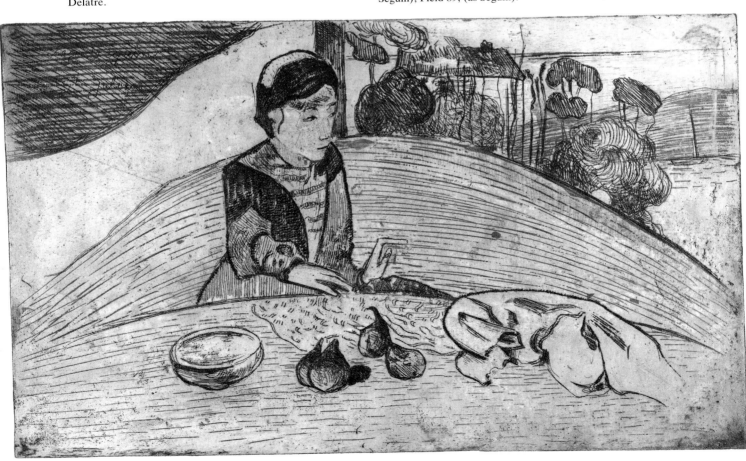

Roderic O'Conor

(1860–1940)

The Irish artist, Roderic O'Conor, studied in Dublin, Antwerp, and Paris before he arrived in Pont-Aven in 1892, where he stayed at the Pension Gloannec[1] and became friendly with Gauguin, to whom he later loaned his Paris studio (1894–95). Seguin, Sérusier, Forbes-Robertson, Amiet, and other members of the group also became his close friends.

His friendship with Gauguin is evidenced in a monotype, *l'Angelus en Bretagne,* 1894 (Coll. J.), on which Gauguin wrote in English, "*To my friend O.* [sic] *Conor one man of Samoa. P Gauguin 1894.*" O'Conor generously aided both Gauguin and Seguin financially, and Gauguin invited him, together with Seguin, to travel to Tahiti. O'Conor declined, reportedly saying: "But really, can you see me setting out for the South Seas in the company of that maniac?"[2] Despite this, he saw a great deal of the two artists in the mid-1890s and absorbed the style of the Pont-Aven Circle from them, grafting it on to his own more Expressionistic vocabulary.

O'Conor may have learned printmaking while studying with Karel Verlat in Antwerp[3]. If so, he did not actively pursue it until the summer of 1893 when he came to Le Pouldu, where Seguin encouraged him to try his hand at etching. As a result, O'Conor created at least twenty-five prints that summer. With the exception of a few etchings that he executed in 1895[4], the prints of 1893 represent his complete *oeuvre* in that medium. O'Conor produced one lithograph, in addition to his etchings. Although a minor work of little artistic merit, it is the only one of his prints that was ever actually published[5].

Seguin probably had a press at hand in St. Julien, which might have encouraged O'Conor not only to try etching but also to experiment with selective plate wiping and pulling the prints himself. The number of impressions O'Conor made of his etchings was extremely small. Many images are known in only one or two impressions, and no editions as such were ever produced[6].

O'Conor's assembled etchings resemble pages from a sketchbook, for he took prepared plates to a site and then drew directly from nature onto each plate. He then carried them back to the studio where they were etched and printed, often after extensive drypoint was added. According to Roy Johnston, all the plates were zinc, except for a copper plate used for *Les Grands Arbres* (O.2)[7]. This habit of carrying plates outside may account for the considerable number of scratches that appear as faint, black lines in the prints.

Johnston explains O'Conor's working method this way: "O'Conor...appears to have defined his subject with a lightly incised line and then to have built up the tonal areas and contrasts by moving the etching tool with rhythmic movements across the plate"[8]. O'Conor's lines are smooth, flowing, and usually show little variation within one print. This helps to differentiate his work from Seguin's, whose lines tend to be shorter, choppier, and more diverse.

Because he worked on the site and not in the studio, many of O'Conor's prints were drawn in one sitting without intervening acid baths. This produced a uniformity of lines of equal depth and weight throughout the work. He sometimes added drypoint to his etched plate and obtained very effective tonalities by carefully and selectively wiping the ink on the plate before pulling each proof. Prints with subtle atmospheric effects as well as painterly passages were thus created. Because he wiped and inked the plate differently every time he printed a work, each proof became almost a unique image.

O'Conor's 1893 etchings are essentially landscapes of the coastal area around Le Pouldu. His scenes depict neither the peasants in their environment favored by Gauguin, Bernard, and Sérusier nor the geographically diverse, dramatic sites that interested Maufra.

O'Conor and Seguin worked closely together in Seguin's studio, but they preferred to depict different areas around the village in their prints. Seguin stayed closer to the harbor, where he lived. This quieter area looks out on the Laita River and distant farmlands. O'Conor chose the more exposed southern coastal region two kilometers away, with its dramatic rocky cliffs, crashing waves, high dunes, wide beaches, and scrubby bushes and trees beaten mercilessly by the wind. The movement and energy of the windblown trees and turbulent skies were his favorite subject matter.

O'Conor's Synthetist design precepts were derived from Gauguin's and Bernard's work. The overall two-dimensional surface pattern of the composition was his primary concern. Trees, bushes, clouds, and land formations were freely distorted to fit the dominant rhythm of the work, which was based on the artist's perception of primeval energy as expressed in the wind, the growing trees, or the ocean-carved dunes.

While the rhythms sought by Gauguin and Bernard were languorous and sinuous, O'Conor was more intrigued by a violent, thrashing movement. His forms whip about and writhe in a staccato beat, as in *Arbres et Toit* (0.6). These jagged and twisted lines nonetheless link one form to the next, and reinforce the artist's preoccupation with the total surface rhythm of the image, independent of its natural subject.

Besides linear rhythms, Synthetism called for repeated patterns of flat shapes. O'Conor achieved this in his trees and bushes, most of which are represented as flat masses of lines silhouetted against either a light sky or a plain ground. The flat quality of the forms was sometimes further accentuated by uniform plate tones in these areas. Forms were persistently repeated, from the rounded shapes in *Paysage Panoramique* (0.11) to the jagged forms in *Arbres dans le Vent* (0.12). The kind of

shapes the artist chose to depict are consistent within each work. That is, they are either smooth and rounded, or sharp and angular within any given print.

O'Conor saw Van Gogh's works in Paris[9] and greatly admired the Dutch artist's sense of energy and the rhythms conveyed by the divided, striped brushstrokes. While O'Conor repeatedly employed this technique in his own paintings, such as *Yellow Landscape, Pont-Aven* of 1892 (illus. 19), he often used webs of throbbing lines to approximate this energy in his prints.

It is difficult to chronologically place O'Conor's prints from 1893 since they were completed over such a brief period. Nevertheless, one assumes he began simply, approaching the plate with the etching needle as if it were a pencil on paper (0.4, 0.5). Later, as he grew more confident and familiar with the technique, he experimented with different tones, variations of lines, plate wiping, and drypoint. As his skill developed, his versatility and boldness increased and probably culminated in such works as *Arbres dans le Vent* (0.12) and *Effet de Soleil dans un Nuage* (0.7).

O'Conor's affiliation with the Pont-Aven artists ended gradually in the late 1890s, when he began to spend more time in Paris and became friends with British intellectuals such as Roger Fry and Clive Bell. He also knew Somerset Maugham and may have been the model for the Irish artist, Clutton, in *Of Human Bondage*[10].

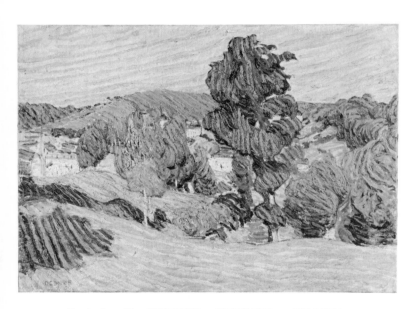

Illustration 19. RODERIC O'CONOR, *YELLOW LANDSCAPE, PONT-AVEN,* (1892, oil on canvas, 68×92 cm).

1. Johnston, 1984, p. 12.

2. Jaworska, 222.

3. Johnston, 1984, p. 51.

4. Johnston lists one etching (a portrait of Sérusier) dated 1895 in the plate and four others that may be from the same time period. Johnston, 1985, nos. 111–116.

5. Johnston, 1984, no. 82; and Johnston 1985, no. 117.

6. Many of O'Conor's etched zinc plates are still in existence. Twelve were sold at the Hotel Drouot in Paris, in 1975, and reprints of some of these plates and others are seen on the market today. They are often printed on large sheets of heavy grained white paper. These restrikes lack the nuanced plate tone as well as the subtleties of O'Conor's plate wipings. The twelve plates were sold by the auctioneers Laurin, Guilloux, Buffetaud, Tailleur. They were listed as follows, with measurements in centimeters: *Chemin sous bois,* 33,8×31; *Coucher de Soleil,* '93, signé, 26,5×34; *Côte Rocheuses,* 1893, signé, 25×39,4; *Le Verger,* 25,9×33,4; *Le Golfe,* '93, signé, 19,6×27,7; *Deux Glaneuses,* 18,4×27,6; *La Lande,* signé 19,5×27,2. *Maison des Arbres,* 1893, signé, 13,4×27,l; *Maisons sur la Falaise,* 14,2×23; *Buste de Bretonne,* 13,1×12; *Buste de Jeune Fille,* signé, 16,2×14,4; *Femme nue et Deux Tetes,* ll,4×17,2.

7. In a conversation with the author, October, 1985.

8. Johnston, unpublished notes.

9. Jonathan Bennington, "From Realism to Expressionism: The early Career of Roderic O'Conor," *Apollo,* April, 1895, p. 254.

10. Denys Sutton, "Roderic O'Conor," *The Studio,* November, 1960, p. 196.

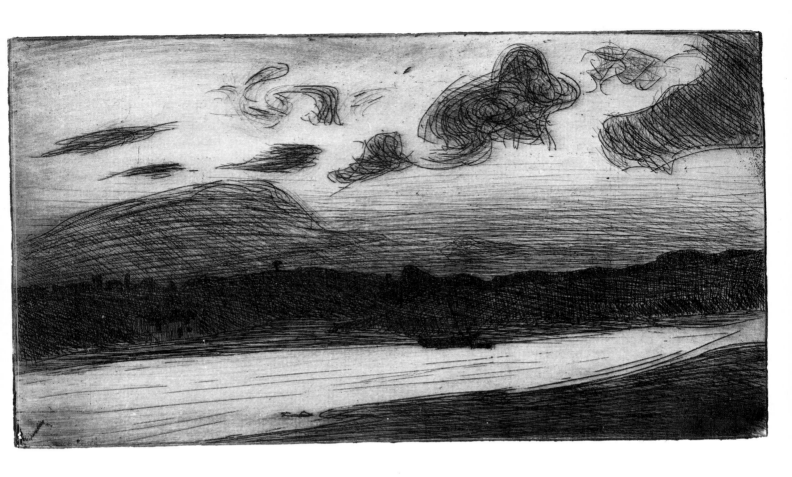

O'CONOR

0.1 LE SOIR, 1893
(Evening)

Etching

143×253 mm (image and plate mark)
On medium-weight cream laid Arches paper: 270×446 mm
In dark brown

Signed in plate, lower left: "R. O'Conor 93"

O'Conor used conventional hatching and cross hatching to create a dense web of lines in the land masses and further darkened the print by the use of a heavy plate tone. The long, straight lines used in the land areas emphasize the scene's horizontality as well as its calm mood. The upper clouds, on the other hand, seem full of movement produced by the curving, dancing lines and the lighter plate tone enhances the feeling of dusk.

The scene depicts the Laita River near Seguin's house. The mountain-like shape in the background is an invention of the artist, since nothing exists on the site that approximates this shape. Compositionally, however, it is important to the scene: without it, the insistent horizontality of the land mass on the far shore would be of little interest.

References: Johnston, 1984, no. 75; Johnston, 1985, no. 103 (titled *La Laita* in both)

O'CONOR

0.2 LES GRANDS ARBRES, 1893
(The Large Trees)

Etching

196×182 mm (left and top), 191×184 mm (right and bottom) image and plate mark.
On heavy cream wove paper: 385×345 mm

0.3 PLEINE LUNE SUR LA COTE, 1893
(Full Moon on the Coast)

Etching and drypoint

142×183 mm (image and plate mark)
On heavy cream laid paper: 261×284 mm
Signed in plate, lower left: "R. O'Conor 93"

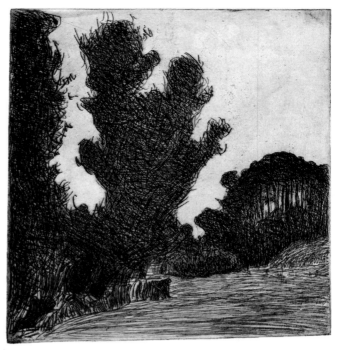

In both works, O'Conor relied totally on line, not using plate tone as he did in so many of his other prints. In the trees of *Les Grands Arbres,* lines often escape from the silhouetted masses of the trees to generate a feeling of motion and energy. The central tree, for example, corkscrews upwards, suggesting energy and growth through turbulent movement reminiscent of Van Gogh's work.

In both prints the foreground is vaguely defined by long, sweeping lines, while the middle ground is the darkest, most dense area. Although the regularity of lines in the dramatic sky of *Pleine Lune sur la Côte* is unusual for O'Conor, each line still reflects the energy of nature.

References: (*Les Grands Arbres*) Johnston, 1985, no. 96.

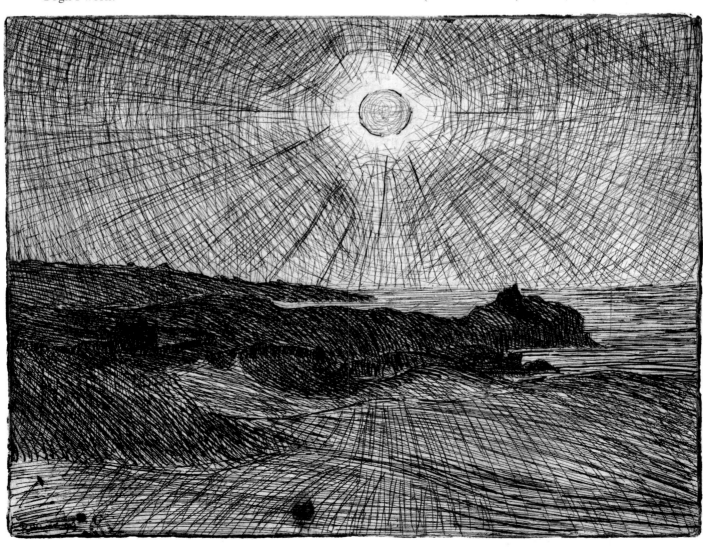

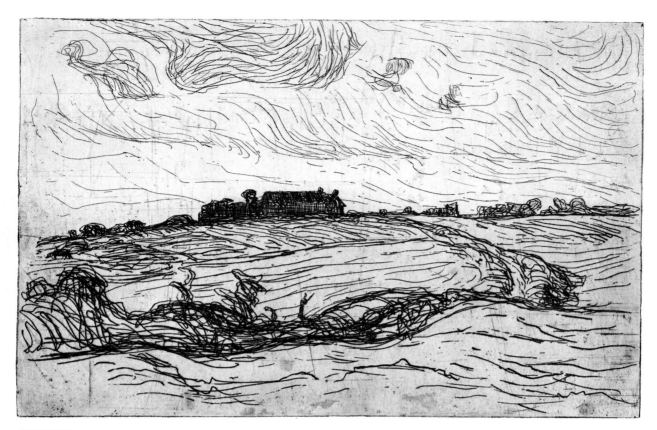

O'CONOR

0.4 PAYSAGE AVEC MAISONS SUR UNE COLLINE, 1893
(Landscape with Cottages on a Hill)

Etching

154×233 mm (image and plate mark)
On medium-weight cream laid Arches paper: 309×447 mm
In brown

Signed in pencil, lower right: "R. O'Conor 93"

0.5 LES DUNES, 1893
(Sand Dunes)

Etching

197×178 mm (image and plate mark)
On thin cream laid Arches paper: 305×445 mm

In each of these landscapes, O'Conor used only one acid bath to create lines of equal width. The absence of drypoint and selective wiping place these prints among the artist's most straightforward etchings. The heavily scratched surfaces of the plates suggest that they were not carefully handled and that O'Conor carried them to the sites south of Le Pouldu where he drew upon the prepared surfaces in the open air.

As in many of O'Conor's compositions, empty spaces occupy the foregrounds of these prints. A single diagonal line marks the middle ground, making the composition asymmetric. This reinforces the feeling of spontaneity and lends the print a "slice of life" quality by suggesting that the scene continues on either side of what is actually shown, a characteristic of many Japanese prints.

References: (*Les Dunes*) Johnston, 1984, no. 74; Johnston, 1985, no. 93.

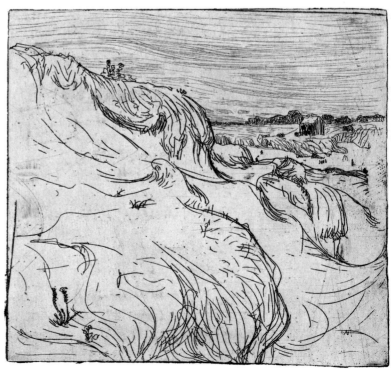

O'CONOR

0.6 ARBRES ET TOIT, 1893
(Trees and Roof)

Etching

160×245 mm (image and plate mark)
On heavy wove cream paper: 355×516 mm

0.7 EFFET DE SOLEIL DANS UN NUAGE, 1893
(Sunlight through the Clouds)

Etching

263×337 mm (image and plate mark)
On heavy cream wove paper: 375×420 mm

Signed in plate, lower right: "R. O'Conor 93"

A startling, abstract effect is achieved in these prints by the thickness and boldness of the lines. O'Conor did not wipe the plate clean of surface ink, as in the previous two works, but instead used a coarse cloth to pick up ink trapped in the etched lines and to carry it across the surface of the plates, which created rich velvety lines with a background of grey tonalities. In *Arbres et Toit*, more ink was obviously pulled from each etched line than in *Effet de Soleil dans un Nuage*, thereby creating more greys and tonal variations.

In *Arbres et Toit*, the coarse wiping cloth was also used like a paint brush to pull the ink along the surface in various patterns that do not always follow the etched lines. This process resulted in lines that resemble those of drypoint, adding to the feeling of movement already suggested by the swirling and lashing lines of the foliage. Even the skies in both prints were wiped to create very subtle effects of grey and white. Other

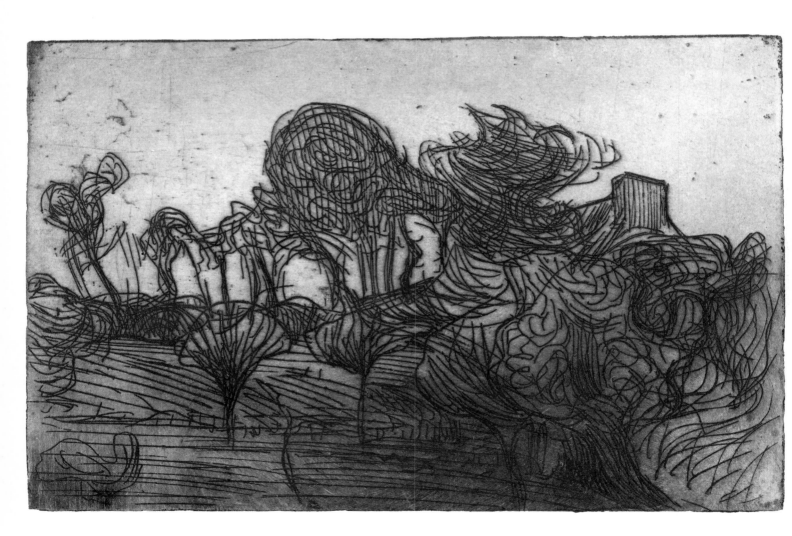

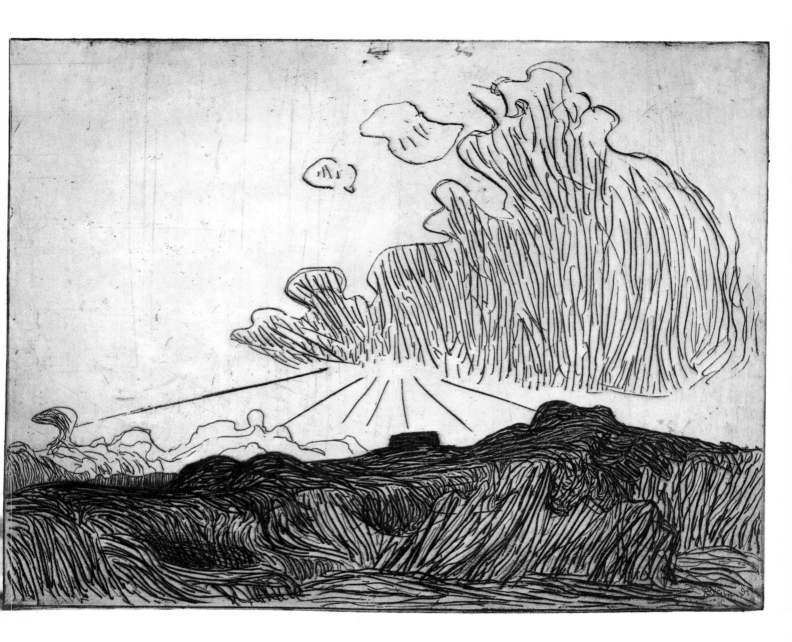

known proofs of these prints show very different inkings and wipings, making each impression unique[1].

Elements of the foreground landscape in *Effet de Soleil dans un Nuage* are differentiated by "stripes" or parallel lines. As noted before, this was probably inspired by works of Van Gogh[2]. O'Conor's strokes, however, are longer and the effect is less agitated. Each striped area in these prints appears as a flat shape, carving the landscape into Cubist-like planes.

The bold, thick lines and dramatic sense of movement, as well as the subtle wiping effects, place these two works among O'Conor's most powerful prints.

1. The *Effet de Soleil dans un Nuage* in the *O'Conor* exhibition in Pont-Aven in 1984 has a sky full of ink, with the sun carefully wiped clean. Roy Johnston has seen a proof of *Arbres et Toit* that was much more heavily inked than the one in this exhibition.

2. See Van Gogh's *House at Auvers*, 1890, gouache and charcoal on paper, J.B. de la Faille, *The Works of Vincent Van Gogh, His Paintings and Drawings,* New York, 1970, no. 1640, Rijksmuseum Vincent Van Gogh, Amsterdam.

References: (*Arbres et Toit*) Johnston, 1985, no. 99, entitled *Maison et des Arbres;* (*Effet de Soleil dans un Nuage*) Johnston, 1984, no. 71; Nantes, 1974, no. 145; Quimper, 1978, no. 72.

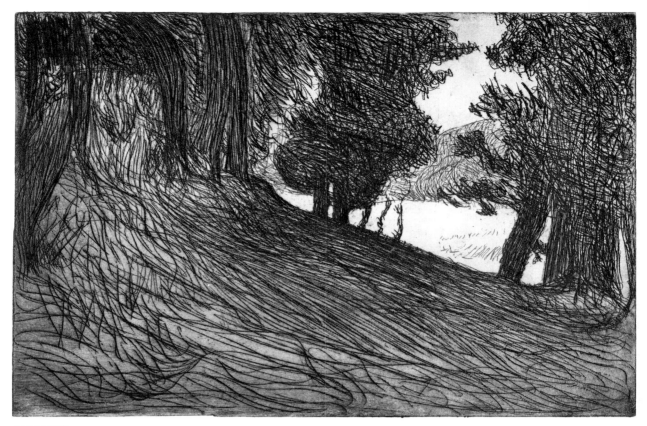

O'CONOR

0.8 LE BOIS D'AMOUR, 1893
(The Bois d'Amour in Pont-Aven)

Etching and drypoint

220×326 mm (image and plate mark)
On heavy wove cream paper: 391×475 mm

0.9 MAISON ET ARBRES, 1893
(House and Trees)

Etching 185×182 mm (image and plate mark)
On heavy cream wove paper: 357×510 mm

Signed in plate, lower right: "R. O'Conor 93"

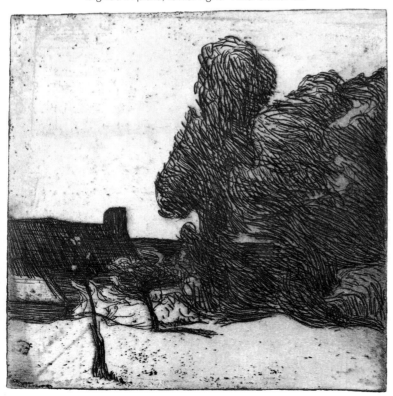

Short strokes, lines exceeding the silhouette of the trees and long sweeping lines in the foreground distinguish both prints. The sense of movement created resembles tortured and directionless dancing; the introduction of drypoint in the *Bois d'Amour* accentuates this feeling of frenzy. At the same time, a judicious use of plate tone in the earth and trees creates different tonalities and allows the white paper to suggest luminosity. In *Maison et Arbres,* O'Conor used longer, parallel strokes in the trees to correspond to the strong winds that often blow off the sea into Le Pouldu.

The title *"Le Bois d'Amour"* may not be accurate, for many of these works may have been given titles later by collectors and dealers and not by O'Conor, who produced the prints only for himself and friends. While the slope of the ground in this print is reminiscent of the Bois d'Amour in Pont-Aven — the site of so many works by Gauguin and others — the image could also be of any of the abundant woods around Le Pouldu, especially the area called *"La Petite Suisse."* On the other hand, Pont-Aven is close enough to Le Pouldu that round-trip travel by boat or carriage in a day was possible. O'Conor, then, could have drawn his composition while visiting the famed woods in Pont-Aven, but the evidence is not strong enough to specify any site.

References: (*Le Bois d'Amour*) Jaworska, p. 220; Johnston, 1984, no. 67; Johnston, 1985, no. 97; (*Maison et Arbres*) Johnston, 1984, no. 73; Johnston 1985, no. 98. (Both entitled *Maison dans les Arbres*)

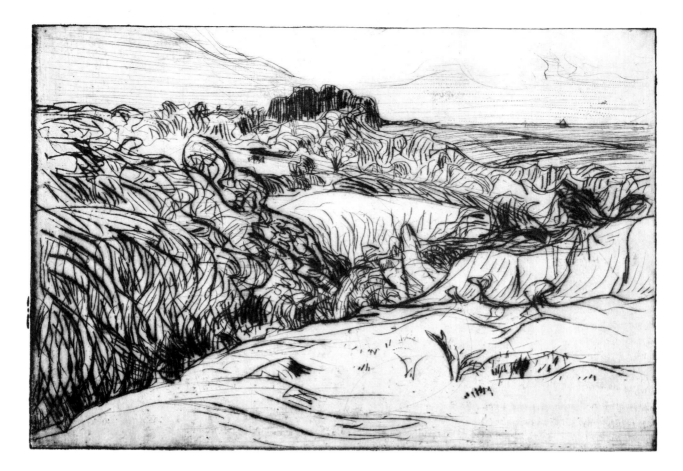

O'CONOR

0.10 DUNES, 1893
(The Dunes)

Drypoint

200×285 mm (image and plate mark)
On medium cream wove Arches paper: 305×447 mm

Stamped in lower right: "Atelier O'Conor"

0.11 PAYSAGE PANORAMIQUE, 1893
(Horizontal Landscape)

Etching and drypoint

144×280 mm (image and plate mark)
On medium cream laid Arches paper: 305×444 mm
In brown

In these two prints, O'Conor experimented with dry-point and various plate wipings to suggest boundless energy. The drypoint lines are heavy and rich with burr and the wiping technique of lifting the ink from the etched lines and dragging it out even beyond the burr of the drypoint further emphasizes the movement of the twisting, turning lines. Both works reflect the tremend-ous energy and force of the turbulent winds along the

Breton coast and the roughness of the terrain. As in several of O'Conor's other prints, the trees actually seem to dance.

Another impression of *Paysage Panoramique* (Museum of Fine Arts, Boston) exhibits much coarser wiping, resulting in richer lines and a stronger feeling of movement. There is also another impression of *Dunes* (Coll. J.) whose plate wiping led to a dark, murky appearance.

Closely related to the *Paysage Panoramique* is a painting entitled *Pâturage Breton* (Petit Palais, Geneva), tentatively dated 1891–92. In subject matter and composition both the print and the painting depict wind-tossed trees around a foreground pasture. This scene is so typical of the Le Pouldu area, that the painting should probably be redated 1893.

References: (*Les Dunes*) Johnston, 1984, no. 76; Johnston, 1985, no. 94 (entitled *Paysage sur la Côte.*)

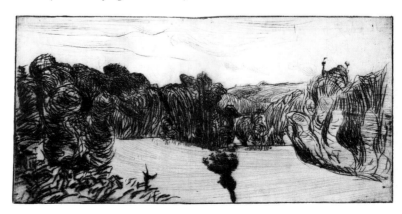

0.12 ARBRES DANS LE VENT, 1893 (Trees in the Wind)

Etching and drypoint

255×327 mm (image and plate mark)
On heavy cream wove paper, irregularly
cut: c. 376×474 mm

One of O'Conor's most dramatic and abstract etchings, this work relies on turbulent lines, the silhouetting of dark and light areas, and the manipulation of plate tone for its powerful effect. To achieve the dense, twisting forms, O'Conor first drew tight masses of curved lines to define the shapes of each tree and its foliage. Over these, he added straight lines in tight zigzags, the edges of which often protrude from the curved outlines, exaggerating and contributing to the movement.

The piling up of forms in three almost abstract horizontal areas, dark against light, and the absence of O'Conor's usual empty foreground, as well as the turbulent sky, create the menacing effect of unleashed, hurricane-like power[1].

1. Another impression of this print has more irregular wiping, especially on the left-hand side, and has streaks in the sky. (Private collection, see illustration in Johnston, 1984, no. 70.)

Reference: Johnston, 1984, no. 70. (entitled *Le Verger*)

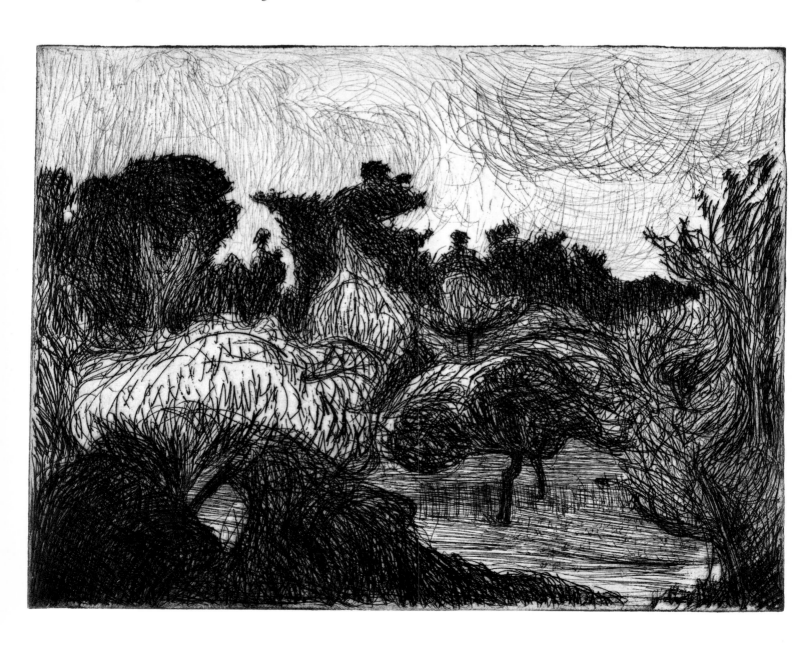

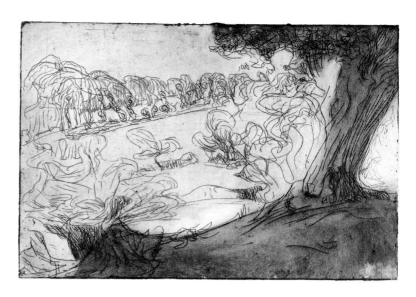

0.13 PAYSAGE AVEC ARBRES A L'AVANT PLAN, 1893
(Landscape with Trees in the Foreground)

Etching

209×297 mm (image and plate mark)
On medium-weight cream laid Arches paper: 304×447 mm

Signed in pencil, lower right: "R. O'Conor 93"

0.14 PAYSAGE AVEC MAISONS ET ARBRES, 1893
(Landscape with Houses and Trees)

Etching

231×284 mm (image and plate mark)
On medium-weight cream laid Arches paper: 340×447 mm

Signed in plate, lower left: "R. O'Conor"

Several of Van Gogh's pictures of 1891 are brought to mind by the *Paysage avec Maison et Arbres,* whose violent, thrashing forms embody tremendous energy. Here, O'Conor used two techniques to achieve his different tonalities. First, he created a light grey tonality throughout the image by covering the foreground and sky with thin lines etched in a very brief acid bath. Then, after etching the darker lines of the landscape elements, he wiped the plate with a coarse cloth which pulled ink from the etched lines to create an uneven, darker grey in the foreground and a lighter grey in parts of the sky. The strange cloud to the right was wiped clean of ink to make it appear almost solid and still give luminosity to the scene. Like smoke or mist, the clouds to the left rise and billow in the offshore winds, while the trees resemble a continuous mass of thrashing shapes, similar to those in Seguin's *Les Sapins* (S.17). In *Paysage avec Arbre à l'Avant Plan,* the ink was manipulated on the plate with fingers, a cloth, and a brush only one centimeter wide. The clearly visible white lines of the brushstrokes add texture to the work. The print was executed with an uncharacteristic sketchiness to the forms and a great deal of empty space. The large tree trunk was so quickly drawn that the ink "painted" on afterwards is essential to identify its form.

References: (*Paysage avec Maisons et Arbres*) Field, no. 29, attributed to Seguin; (*Paysage avec Arbres a l'Avant Plan*) Johnston, 1985, no. 92. (entitled *Landscape*).

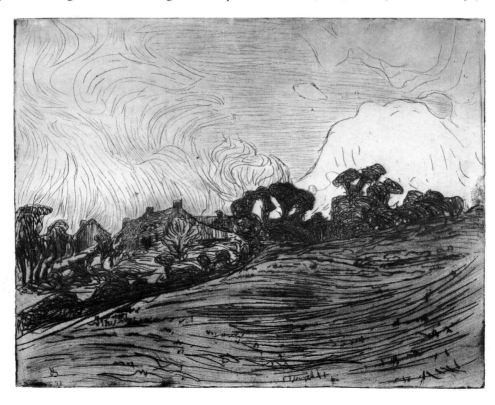

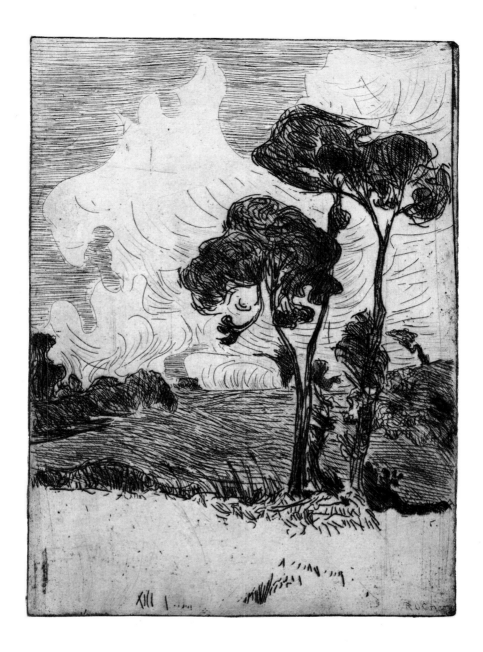

O'CONOR

0.15 PAYSAGE AUX DEUX GRANDS ARBRES, 1893
(Landscape with Two Large Trees)

Etching and drypoint

271×194 mm (image and plate mark)
On heavy wove paper: 517×358 mm

Signed in plate, lower right: "R. O'Conor 93"

In this powerful landscape, O'Conor evokes the force of the wind through bold clouds that seem as solid and heavy as the earth. Their rising, sweeping movement is suggested by both their silhouettes and the lines that define them. Each line throws the eye upward and the thrust of the two trees in the foreground reinforces this movement.

The plate was bitten twice for this print before the drypoint was added to attain such rich blacks. Plate tone across the meadow area produces an illusion of spacial recession but this implied depth is negated by the bold forms of the dominating clouds that crowd to the front of the picture plane.

Robert Bevan

(1865 – 1925)

Robert Polhill Bevan was the fourth of six children born to a banker in Brighton, England. Despite parental pressure to attend Oxford, he enrolled in the West-minister School of Art in 1888. In 1889 – 90, he attended the Académie Julian in Paris, where Sérusier, Denis, Vuillard, and Bonnard were fellow students.

Bevan journeyed to Brittany in 1890 and again in 1891 where, in addition to filling three sketchbooks and working on a few paintings, he also produced three etchings (Dry 1 – 3). From there, he travelled to Spain and Morocco, where he probably engaged in more fox hunting than drawing or painting[1].

During the summer of 1893, Bevan returned to Brittany and stayed at the Villa Julia in Pont-Aven. There he became close friends with Forbes-Robertson, who may have introduced him to Bernard, Delavallée, Seguin and O'Conor[2].

Bevan met Gauguin in Pont-Aven in 1894. Although they were never close friends, Gauguin dedicated his 1894 monotype, Two Standing Tahitian Women, *"à l'ami Bavan* [sic] *P. Go"*[3]. Bevan certainly knew Seguin by 1895[4], and his drawing of a girl wearing the coiffe of Le Pouldu (Coll. J.), suggests that he may have visited that village when Seguin and O'Conor were actively involved in printmaking. Sérusier was in nearby Huelgoat and visited Le Pouldu in August of the same year.

Bevan's lithographs of the 1890s exhibit a remarkable affinity to the etchings of O'Conor. Both used long, fluid, rhythmic lines to depict the wind-buffeted trees along the Breton coast. Like other artists of the Pont-Aven Circle, Bevan was fascinated by the landscape and the people of Brittany (illus. 20 and 21)[5]. He admired the flowing rhythms created by the smooth contours of the hills and hedges (illus. 22) and he found the Breton labors of beating flax, making sabots, and threshing grain of such interest that he sometimes even participated in the work himself[6]. Stylistically, Bevan favored the Synthetism developed by Gauguin and the

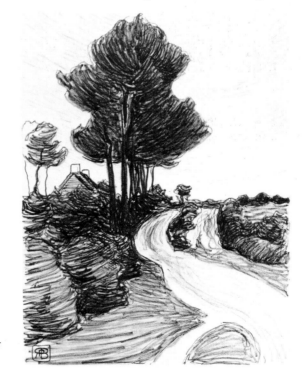

Illustration 20. ROBERT BEVAN, *TREES BY THE ROAD,* (1893 – 94, lithograph, 345×254 mm. Dry 6)

Pont-Aven Circle; he emphasized flat shapes and rhythmic contours in most of his work of the mid and late 1890s. His prints appear less spontaneous than those of O'Conor and Seguin, probably because he did several preparatory sketches for them, whereas Seguin and O'Conor often drew directly onto their plates[7]. Bevan employed a forceful line charged with energy, which implies that he may have known Van Gogh's work in Paris[8].

Bevan left France in late 1894 for an isolated farm house at Hawkridge on Exmoor, in southern England, where he pursued his two life long passions of hunting and art. He finally settled in London in 1900 and beginning in 1911, became an active member of the Camden Town Group and in 1914, of the London Group. His later prints demonstrate an intriguing mixture of Synthetist and Cubist ideals.

Bevan's printmaking activity was limited to the years 1890–91, 1893–94, 1898–1900, and then again after 1919. His artistic output in Brittany was small; only two small paintings of 1893–94 plus a number of drawings, some colored with watercolor are known. Graham Dry's catalogue raisonné of the prints consists of thirty-nine works, but only eight of the lithographs and three etchings were created in Brittany[9]. After 1891, Bevan abandoned etching for lithography. He preferred stone rather than zinc plates, and drew his previously worked out designs directly on the stone[10].

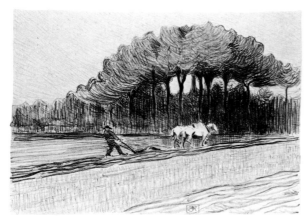

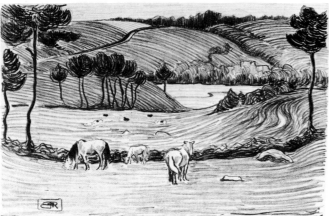

1. R. A. Bevan, *Robert Bevan, A Memoir by his Son,* London, 1965, p. 9.

2. Seguin made numerous drawings of Forbes-Robertson, who in turn completed several portrait drawings of O'Conor and Seguin. Bernard painted Forbes-Robertson's portrait and Delavallée dedicated a trial proof of his etching *Bretonne Assise* (D.2) to him. Since Bevan was close to Forbes-Robertson, they surely travelled in the same circles in Brittany. Thus Bevan probably also knew Seguin, Bernard, and many of the other artists.

3. Collection Bevan Family. See Richard S. Field, *Paul Gauguin's Monotypes,* Philadelphia Museum of Art, 1973, no. 16.

4. Letter from Seguin to Delâtre, June 8, 1895, Collection Jules Parassant, Nantes.

5. R. A. Bevan, *Robert Bevan, A Memoir by his Son,* p. 9.

6. Letter from Bevan to his mother, quoted in R. A. Bevan, *Robert Bevan, A Memoir by his Son,* p. 9.

7. A number of these studies have survived and are in public and private collections. For illustrations of some of them, see *Robert Bevan, Drawings and Watercolors,* exhibition catalogue, Anthony d'Offay Gallery, London, 1981.

8. Family members have stated that Bevan never met Van Gogh but was influenced by him. (R. A. Bevan, *Robert Bevan, A Memoir by his Son,* p. 10). Bevan had seen paintings by Cézanne in Paris and may well have seen Van Gogh's work there also.

9. See Dry.

10. P. and D. Colnaghi and Co, *Robert Bevan, the Complete Graphic Works,* undated exhibition catalogue, London, n.d. p. i.

Illustration 21. ROBERT BEVAN, *THE PLOUGH,* (1893–94, lithograph, 254×345 mm. Dry 7) and *A BRETON VALLEY,* (1893–94, lithograph, 194×292 mm. Dry 11).

BV.1 THE POPLARS, 1893–1894

Dry 5. Lithograph

254×352 mm (image)
On thin white paper (chine appliquée) laid over thick
white wove paper: 360×518 mm

Signed in lower right of image in the stone with artist's
monogram, "RPB"
Estate stamp in lower right corner

Edition of six

The long fluid strokes of the lithographic crayon that
depict the fields and road and the way the landscape is
divided into gently swelling elements, are strongly
reminiscent of Sérusier's *La Terre Bretonne* (SR.1) and
contemporary etchings by Seguin and O'Conor[1].
Bevan's longer stroke takes advantage of the greater
freedom offered by lithography and creates a sinuous,
languid rhythm.

The trees in this print all seem to twirl in the wind, an
effect Bevan achieved by first outlining the shape of
each tree's foliage and then filling in the form with long,
even strokes. While O'Conor and Seguin also used this
technique in their 1893 landscapes, Bevan muted the
violent motion evident in many of their trees by repeat-
ing insistently parallel lines of uniform length and
width. These lines form natural objects that can also be
read as flat, abstract shapes.

1. See Seguin's *Paysage avec Chevaux et Bateaux* (S.13) and
 O'Conor's *Paysage avec Maisons et Arbres* (0.13).

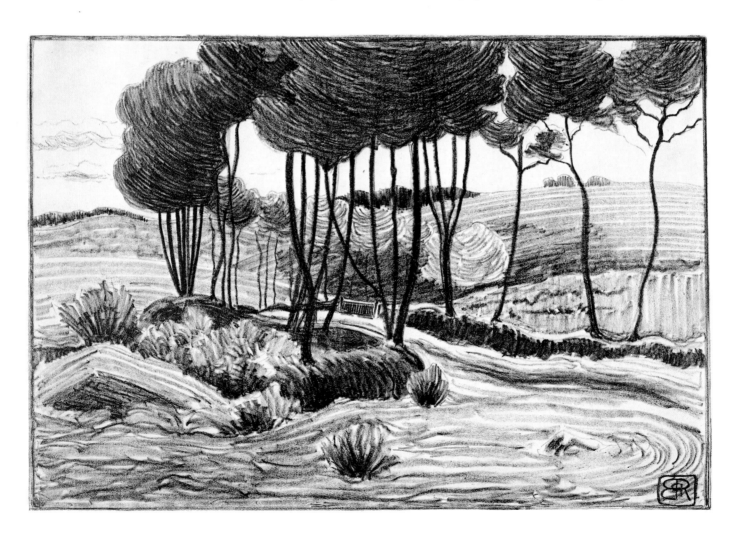

BEVAN

BV.2 HAWKRIDGE

Drawn in 1895, printed in 1899[1]
Dry 22. Lithograph

346×406 mm (image)
On thin cream wove paper: 460×590 mm
In dark green

Signed in stone in lower left of image with artist's monogram, "RPB"
Estate stamp lower right corner.

Edition of 18

This print can be considered the culmination of the Bevan's stylistic development in Brittany, although it was conceived immediately after his return to England.

It is remarkably Synthetist in feeling, with its outlined, flat areas, repeated patterns, and curiously tilting space. Using shorter, choppier strokes than those in *The Poplars* (BV.1), Bevan caused each form to writhe and twist with an energetic movement similar to that seen in O'Conor's prints, and reminding us of works by Van Gogh. While *The Poplars* presents the clear light and open spaces of Brittany, *Hawkridge* suggests an atmosphere more characteristic of England.

1. Bevan drew *Hawkridge* in crayon soon after he left Pont-Aven in late 1894 and settled in Hawkridge on Exmoor, England. (Anthony d'Offay Gallery, *Robert Bevan, 1865–1925, Drawings and Watercolors,* exhibition catalogue, London, 1981, no. 13.) In 1898, after he moved to Brighton, he finally drew it on stone and pulled an edition of eighteen prints. (Colnaghi and Co., *Robert Bevan, 1865–1925, The Complete Graphic Works,* exhibition catalogue, London, n.d., no. 23.).

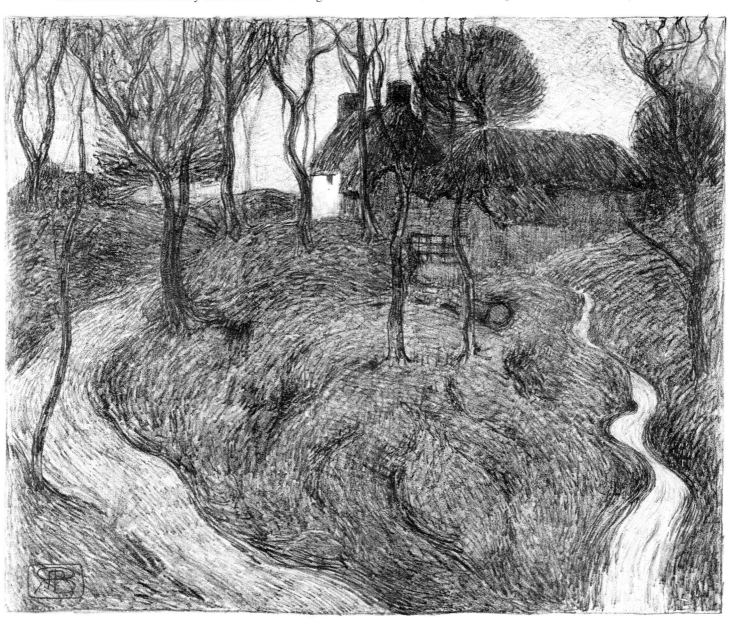

Cuno Amiet

(1868–1961)

Amiet was a Swiss artist who studied at the *Académie Julian* in Paris in 1888, which Sérusier and other members of the fledgling Nabis also attended at the same time. In the spring of 1892, on the advice of the Hungarian artist Hugo Poll, Amiet travelled to Pont-Aven, where he became friendly with Bernard, Sérusier, de Chamaillard, and especially Seguin and O'Conor[1]. He worked with Seguin and O'Conor in Le Pouldu during the summer of 1893, and was encouraged by them to try his hand at printmaking. Amiet made three small etchings that summer, each of which is known in only three or four impressions (Mandach, 1, 2, 3; illus. 23). Soon after, he returned to Switzerland, where he continued to execute prints and paintings that incorporated many of the stylistic concepts of the Pont-Aven School.

He is considered to be one of Switzerland's major artists and achieved a considerable reputation even in his lifetime. A highly respected member of Die Brucke, he was also associated with the Vienna Secession, where he exhibited thirty paintings in 1904[2]. The works from his Pont-Aven period have become extremely rare because most of them were destroyed by fire at a 1931 exhibition in the Glaspalast, Munich.

1. George Mauner, "Cuno Amiet à Pont-Aven," *Cuno Amiet*, exhibition catalogue, Musée de Pont-Aven, 1982, p. 9.
2. Mauner, "Cuno Amiet," p. 16.

Illustration 22. CUNO AMIET, *BRETONNE AVEC UNE CRUCHE,* (1893, etching and aquatint, 183×110 mm. Mandach 1).

A.1 LES VACHES, 1893
(The Cows)

Mandach 2. Etching and aquatint

181×82 mm (image and plate mark)
On medium-weight cream wove paper: 330×220 mm

Signed in pencil, lower right: "C. Amiet"

In this work, Amiet drew upon the styles of his two friends, Seguin and O'Conor. He conceived his forms as flat shapes defined by tight masses of hatchings and cross hatchings. The areas are all delimited by thick, forceful outlines which are more pronounced than those in Seguin's or O'Conor's works, and closer to Bernard's Cloisonist technique. The curves and emphatic, flowing lines in Amiet's print are dramatically heightened by the silhouetting of dark shapes against the undefined white background.

Amiet seems to have encountered considerable difficulties in producing this striking little print. Originally, he tried to create his image by using either aquatint or direct biting in areas not masked by varnish. Some of the varnish in the covered areas subsequently came off in the acid bath, resulting in unwanted tones in the landscape. He then tried to burnish off these areas, leaving only enough biting to give an appearance of texture. His inexperience with the medium is suggested further by the fact that he left the plate in the acid bath too long, etching the area of the cow too deeply. To rectify this, he tried to burnish out some of these areas. It is gratifying that the artist's persistence in mastering the difficulties of a medium new to him finally resulted in this highly successful image.

The bold cropping of the cow's head and the background trees, the abstract effect created by the arabesques, cut-off forms, and even the shape of the print itself all reflect the influence of Japanese woodcuts. Yet this print is almost Art Nouveau in style. In fact, the distance between the schools of Pont-Aven and Art Nouveau is not great, since both movements shared many common sources and goals.

References: *Cuno Amiet, Giovanni Giocometti,* exhibition catalogue, Kunstmuseum Bern, 1968, no. 123; *Cuno Amiet,* exhibition catalogue, Musée de Pont-Aven, 1982, no. 76.

Maxime Maufra

(1861–1918)

A Breton by birth, Maxime Maufra was born in Nantes in 1861. Although his early career as a marine businessman prevented formal art studies, two of his paintings were nonetheless accepted by the 1886 Salon and were praised by Octave Mirbeau[1]. He finally abandoned commerce for art in 1890.

Maufra met Gauguin briefly in Pont-Aven in 1890, moved to Montmartre in 1892, and began to experiment with making prints that winter, probably under the tutelage of Eugène Delâtre, who was also his printer[2]. Felix Bracquemond and Auguste Lépère were also among his earliest influences. His stylistic development was further influenced by repeated contacts with Gauguin in 1893–95[3], as well as trips to Brittany throughout the early 1890s, where he encountered other artists of the Circle of Pont-Aven. Gauguin visited Maufra's studio in November 1893 to thank the latter for defending his art and to encourage Maufra to continue his work. And after Gauguin's disastrous sale at the Hôtel Drouot in February 1895, Maufra brought the despondent Gauguin back to his studio for dinner and consolation.

While Maufra adopted some of the stylistic characteristics of the Pont-Aven printmakers — flat, decorative shapes, linear rhythms, and Breton subject matter — he rejected its inherent abstraction, along with labels such as "Synthetist". He preferred a more direct approach to nature, choosing as his subjects sunsets, waves, rocky cliffs, buildings, villages, and boats rather than people.

Maufra's landscapes and written accounts reveal his affinity for what may be called "Symbolist landscapes". A naturalistic attempt to copy nature was rejected in favor of painting a reflection of the artist's sensitivity, which in Maufra's quiet landscapes implied withdrawal and, at times, silence[4]. As he tried to express his feelings in response to a subject, he often distorted, exaggerated, and re-arranged forms to capture his spiritual sensation.

When Maufra exhibited his work at Le Barc de Boutteville's gallery in 1891, he divided his works into three categories — *"Les effets," "Synthèses de la Bretagne,"* and *"Les phénomènes,"* — which are respectively defined as fugitive aspects of nature, syntheses of feelings about the physical environment of Brittany, and rare and emphemeral natural occurrences, such as rainbows[5]. All of these works imply a synthesis not of form, but of feelings about landscapes and natural phenomena that are calculated to evoke similiar emotions in the viewer. Maufra's use of some of the formal vocabulary of Synthetism, then, was calculated to evoke a specific emotion.

In Brittany, Maufra sketched in front of his subject. Some of his plates were then etched in his Breton studio[6], but more often they were sent via friends to Eugène Delâtre in Paris, who both etched and printed them[7].

Apart from the twenty lithographs in *Paysage de la Guerre* published in 1917, Maufra intended to sell only five or six of his 126 prints[8]. The others were printed in small editions by Delâtre and given to friends. Printmaking seems to have been a relaxing, creative outlet for him, a relief from the pressure he felt to produce paintings under his contractual obligations to Durand-Ruel[9]. Nonetheless, he was a knowledgeable printmaker who mastered the various and complicated techniques of the medium. Many prints exist in several states, witnessing Maufra's striving for perfection.

By the end of the 1890s, Maufra felt a need for both stricter compositions and a return to what he called "style." In his subsequent prints, he reverted to a classic, nineteenth-century print vocabulary of small, thin lines, careful shading, and timid compositions. Yet throughout his life, he retained his love of Breton subjects, exploring them again and again[10].

1. Octave Mirbeau, *La France,* 1886, recounted by Mirbeau in *Echo de Paris,* 30 January, 1894.

2. Morane, p. 7.

3. Arsène Alexandre, *Maxime Maufra,* Paris, 1926. pp. 63 and 100.

4. For a discussion of Symbolist landscapes, see Taube Greenspan, "Charles-Marie Dulac, the idyllic and mystical landscape of Symbolism," *Gazette des Beaux Arts,* April, 1982, pp. 163−166.

5. V.E. Michelet, *Maufra, Peintre et Graveur,* Paris, 1908, p. 38.

6. Maufra lived in various places in Brittany, usually spending the summers in a different location each year, before returning to Paris for the winter. (See Alexandre, *Maxime Maufra,* p. 103, for an account of his yearly trips.) After two visits to Pont-Aven in 1890−92, he rejected it as too crowded. He preferred to live in greater isolation amongst fishermen and peasants.

7. According to Daniel Morane in a conversation with the author, 1984.

8. *Notre Dame de la Clarté* and *Tonquedec* were sold as a set in an edition of one hundred; *Le Chemin au bord de la Mer* was published for *l'Estampe Originale,* and a few other lithographs were published respectively by *Le Crayon* and *Le Depêche de Toulouse.* See the catalogue raisonnée of the works of Maufra: Morane, *Maxime Maufra.*

9. Daniel Morane, in a conversation with the author, 1984.

10. No posthumous printings of his plates have appeared, although Maufra himself had at least *La Vague* (M.4) reprinted during his lifetime. (Unpublished letter from Maufra to Delâtre, Coll. J)

M.1 LE PONT DE LEZARDRIEUX, 1893
(The Bridge at Lezardrieux)

Morane, 7. Early state. Etching and aquatint

200×254 mm (image and plate mark)
On cream simili-Japan paper: 280×379 mm

Signed in pencil, lower right: "Maufra"
Stamp of August Delâtre (Lugt no. 105): lower right, in image

This print, showing a bridge in northern Brittany, reveals Maufra's extensive experimentation with different tonal effects. He scratched through the aquatint or burnished it in places, and used aquatint and hatching to juxtapose the composition's large, flat masses. In the final state, the sky was reworked, and the bridge and smoke became less obvious. The curious lone tree resembles those in Bernard's *Les Bretonneries* series (B.4−8).

Typical of Maufra, the composition comprises a large triangular shape in the left foreground[1], a winding road receding from a prominent foreground position, and a straight horizon line that runs across the upper third of the image. Even though Maufra never denied depth in his landscape prints of the 1890s, he often built the space with horizontal bands that appear to be stacked up on the picture surface instead of receding into it. This is common in many prints of the Pont-Aven Circle.

1. A fact pointed out by Daniel Morane, in a conversation with the author, 1985.

Reference: La Depêche de Toulouse, May 15, Paris, 1894, no. 42 (exhibition organized by Edouard Ancourt).

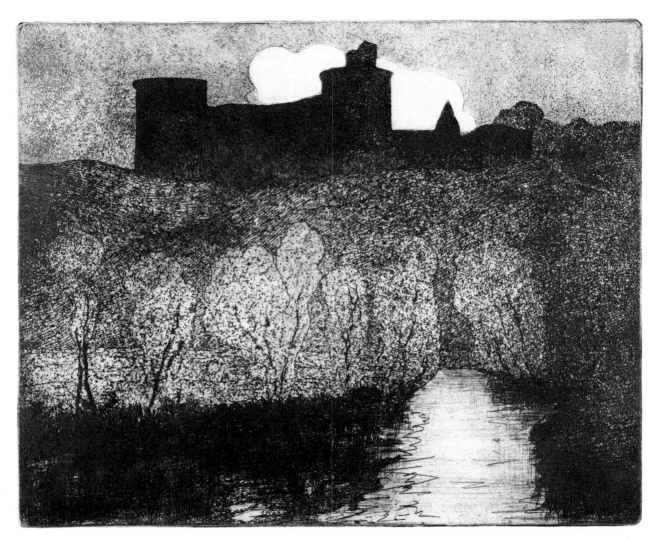

MAUFRA

M.2 TONQUEDEC, c. 1894
(The Castle at Tonquedec)

Morane, 17. iii/iii. Etching and aquatint

300×355 mm (image and plate mark)
On heavy cream wove paper: 422×594 mm

Signed in blue pencil, lower right: "Maufra, no 53"

Edition of 100

In 1894, Maufra frequently saw Gauguin, who had just returned to Paris from the South Seas and set up a studio on the rue de Vaugirard[1], where frequent social gatherings often included Maufra, Sérusier and Seguin. The insistently flat shapes seen here may have been the result of the intense discussions about Synthetism that took place there.

The technical virtuosity of this etching and its bold use of aquatint, however, are purely Maufra's, for none of the other artists of the Circle of Pont-Aven was as proficient in the consistent use of aquatint. In Maufra's own categorization of his work, this would be classified as a "synthesis" of Brittany, since it evokes feelings of mystery and power, and memories of Brittany's medieval past.

Three states of this print are known. In the first, the trees along the river are simply outlined, while in the second, a preliminary use of aquatint is seen[2]. *l'Estampe Originale* published the third and final state with *Notre Dame de la Clarté* in 1894, as a separate work, along with a cover by Eugène Delâtre and a text by Gustave Babin.

1. Arsène Alexandre, *Maxime Maufra*, Paris, 1926, p. 102.

2. Morane, p. 17

M.3 BATEAU DE PECHE, 1894
(Fishing Boat)

Morane, 11. Early state. Drypoint on zinc

297×357 mm (image and plate mark)
On heavy cream wove paper: 480×633 mm

Signed in plate, lower left: "Maufra 94"
Signed in blue pencil, lower right: "Maufra"

Maufra began this work with a traditional nineteenth-century print vocabulary of fine lines organized in tight webs. The resulting forms are similar to Maufra's later, post-1900 works[1] which bear little relation to the Synthetist ideals of flat, simple shapes suggested in *Tonquedec* (M.2). With a second application of drypoint lines, however, he tightened the boat, figures, and reflections in the water into flat shapes consistent with Synthetist ideas.

Seascapes were a common theme in Maufra's work, particularly in his paintings and watercolors. He loved the solitude of the rugged coastal areas of Brittany, finding there the *"beaux effets"* of nature he so admired[2]. With a subtle plate tone, achieved by careful wiping, he produced a misty, quiet effect rather than a narrative or specifically topographic scene.

In a later state of the work (Coll. J), Maufra reinforced some of the lines, used a darker plate tone, and created a sun and its reflection by wiping round and oblong shapes in the plate tone.

1. See collections of the Bibiliothèque Nationale, Paris and Quimper Musée des Beaux Arts.

2. Arsène Alexandre, *Maxime Maufra,* Paris, 1926, nos. 54 & 61. See, for example, his painting *Pointe de Raz*, Durand-Ruel, Paris.

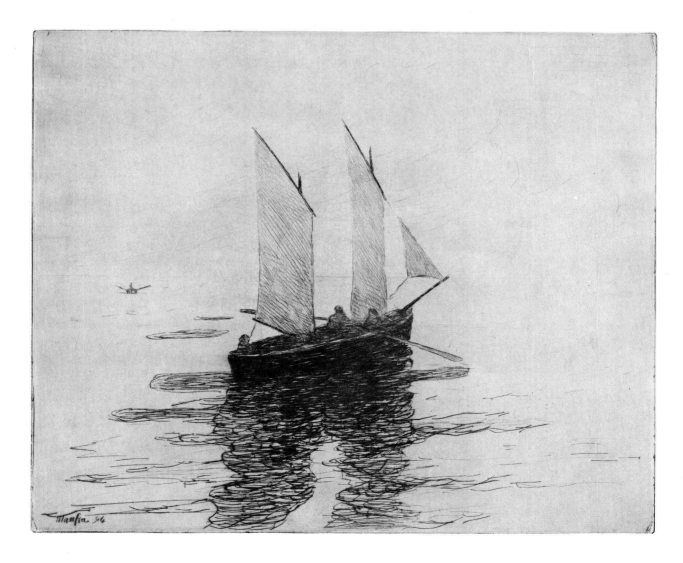

M.4 LA VAGUE, 1894
(The Wave)

Morane, 10. viii/viii. Etching and aquatint

342×535 mm (image and plate mark)
On heavy cream laid paper: 374×578 mm (left and top),
378×568 mm (right and bottom)

Signed in pencil, lower right: "Maufra, 1894"
Signed in plate, lower right: "Maufra 1894"

Maufra wrote to Eugène Delâtre that his goal in this print was to emphasize the sensation or impression of the pounding, exploding waves along the Breton coastlines[1]. He frequently returned to this theme as he travelled the entire southern coast of Brittany between his hometown of Nantes and the Pointe de Raz on the far western edge[2].

The idea of capturing waves frozen in air was not unique to Maufra in the 1890s, but offered a fascinating challenge to quite a few of his contemporaries, many of whom were inspired by Japanese prints[3]. Maufra's large, white wave may derive from Japanese design principles that stress simple shapes and decorative patterns. Yet its irregularly rounded contours and its suggestion of three-dimensionality are not at all Japanese. The long, smooth swells of the waves moreover, seem designed to evoke a feeling of the power of the deep waters along the Breton coasts and not merely to create a decorative ensemble of lines and shapes based on wave patterns.

In the first five states of this print, Maufra used only etching to delineate the composition (first state with pastel and pencil additions) and gradually to work out the rocks (second state), waves, and sky (third to fifth state). His signature was added with the aquatint in the sixth state. In the last two states, Maufra accentuated the contrast of tonal values and increased the textural differences between the rocks and water.

This final image proved to be so popular that in 1908, Maufra asked Delâtre to print five more proofs, taking care to whiten the foam near the rocks and on the curling wave during the plate wiping. Maufra's precise directions added: "They must be carefully done artistic proofs"[4].

1. Unpublished letter, May 20, 1908. Coll. J.

2. See the four paintings and drawings reproduced in Jaworska, pp. 194–5.

3. These prints included Hokusai's *Great Wave off Kanagawa* from the *36 views of Mt Fuji*, 1823–31, and many in *The Manga*, vol. 2, 1815. Henri Rivière used the motif in his *La Vague*, a color lithograph of 1893, as did Gustave Jossot in 1894 in another color lithograph of the same name (Published in *l'Estampe Originale*). Closer to Maufra may have been George Lacombe, a Nabi who spent a great deal of time in Brittany and whose paintings of the sea and cliffs of western Brittany contain stylized, very Japanese-like wave patterns. See his *The Grey Sea*, 1890, in the Museum of Fine Arts, Utah; *Les Falaises à Camaret,* c. 1892 and *La Mer Jaune, Camaret,* c. 1892, Musée des Beaux Arts, Brest.

4. Unpublished letter, May 20, 1908, Coll. J.

References: Salon des Indépendants, 1894; *Maxime Maufra, Emile Dezaunay,* exhibition catalogue, Musée des Beaux-Arts, Nantes, 1960, no. 60; Quimper, 1978, no. 59.

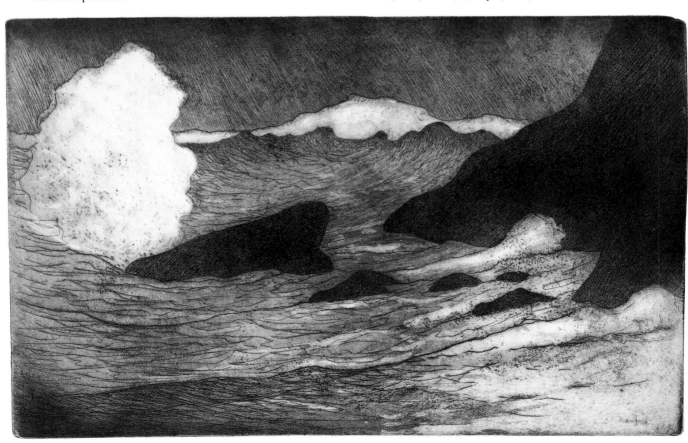

Selected Bibliography and Abbreviations

Bold face indicates the abbreviations used in the text

Alexandre, Arsène, *Maxime Maufra*, Paris, 1926.

Cuno Amiet, exhibition catalogue, Musée de Pont-Aven, 1982.

Baas-Field: Baas, Jacquelynn and Field, Richard S., *The Artistic Revival of the Woodcut: France 1850–1900*, exhibition catalogue, The University of Michigan Museum of Art, Ann Arbor, 1984.

Le Barc de Boutteville, 1895: *Exposition Armand Seguin*, Galerie le Barc de Boutteville, Paris, February-March, 1895.

Benington, Jonathan, "From Realism to Expressionism: The early career of Roderic O'Conor," *Apollo*, April, 1985, pp. 253–261.

Boyle-Turner, Caroline, *Paul Sérusier*, Ann Arbor, 1981.

Bremen-Lille: *Emile Bernard, Rétrospective*, exhibition catalogue, Palais des Beaux-Arts, Lille; Kunsthalle, Bremen, 1967.

Chassé, 1921: Chassé, Charles, *Gauguin et le Groupe de Pont-Aven*, Paris, 1921.

Coll J.: Collection Josefowitz.

Dry: Dry, Graham, *Robert Bevan, 1865–1925, Catalogue raisonné of the Lithographs and other Prints*, London, 1968.

Field: Field, Richard; Strauss, Cynthia; Wagstaff, Samuel, Jr.; *The Prints of Armand Seguin, 1869–1903*, exhibition catalogue, Davison Art Center, Middletown, Connecticut, 1980.

Gauguin, Paul, "Préface," *Armand Seguin*, exhibition catalogue, Galerie Le Barc de Boutteville, Paris, 1895. Reprinted in Field.

Gauguin, Paul, *Letters to his Wife and Friends*, trans. Henry J. Stenning, London, 1946.

Gauguin, Paul, *Correspondance de Gauguin*, edited by Victor Merlhès, vol. 1., Paris, 1984.

Goteborg, 1969: *Emile Bernard*, exhibition catalogue, Goteborgs Konstmuseum, 1968–69.

Guérin: Guérin, Marcel, *l'Oeuvre Gravé de Gauguin*, two volumes, Paris, 1927. (Catalogue raisonné of the prints)

Guicheteau, Marcel, *Paul Sérusier*, Paris, 1978. (Catalogue raisonné of the paintings)

Jaworska: Jaworska, Wladislawa, *Gauguin and the Pont-Aven School*, Greenwich, 1972.

Johnston, 1984: Johnston, Roy, *Roderic O'Conor*, exhibition catalogue, Musée de Pont-Aven, 1984.

Johnston, 1985: Johnston, Roy, *Roderic O'Conor*, exhibition catalogue, Barbican Art Gallery, London, 1985.

London, 1966: *Gauguin and the Pont-Aven Group*, exhibition catalogue, The Tate Gallery, London, 1966.

London, 1980: Stevens, Mary Anne, *Post-Impressionist Graphics, original prints by French artists 1800–1903*, exhibition catalogue, Arts Council, London, 1980.

Lorilleux, A., *Traité de Lithographie*, Paris, 1889.

Luthi: Luthi, Jean-Jacques, *Emile Bernard*, Paris, 1982. (Catalogue raisonné of the paintings)

Mandach: Mandach, C.v., *Cuno Amiet, vollständiges Verzeichnis der Druckgraphik des Künstlers*, Bern, 1939. (Catalogue raisonné of the prints)

Mannheim: Fuchs, Hans, *Die Nabis und ihre Freunde*, exhibition catalogue, Mannheim Kunsthalle, 1963–64.

Michelet, V.E., *Maufra, peintre et graveur*, Paris, 1908.

Morane: Morane, Daniel, *Maxime Maufra*, exhibition catalogue, Musée de Pont-Aven, 1985. (Catalogue raisonné of the prints)

Musée du Prieuré, 1985: *Le Chemin de Gauguin*, exhibition catalogue, Musée du Prieuré, St. Germain-en-Laye, 1985.

Paris, 1971: *De Pont-Aven aux Nabis*, exhibition catalogue, Société des Artistes Indépendants, Paris, 1971.

Pont-Aven, 1961: Malingue, Maurice, *Gauguin et ses Amis,* exhibition catalogue, Musée de Pont-Aven, 1961.

Quimper, 1958: *Hommage à Sérusier et aux peintres du Groupe de Pont-Aven,* exhibition catalogue, Musée des Beaux-Arts, Quimper, 1958.

Quimper, 1978: *l'Ecole de Pont-Aven dans les collections publiques et privées de Bretagne,* exhibition catalogue, Musée des Beaux-Arts, Quimper, 1978.

Rewald: Rewald, John, *Post-Impressionism,* 2nd ed., New York, 1962.

Seguin, Armand, "Préface," *12e Exposition des Peintres Impressionnistes et Symbolistes,* exhibition catalogue, Galerie Le Barc de Boutteville, Paris, 1896.

Seguin, Armand, "Paul Gauguin," *Occident,* March and April, 1903.

Sutton, Denys, "Roderic O'Conor," *The Studio,* November, 1960, pp. 170−196.

Thirion, Yvonne, "l'Influence de l'Estampe Japonaise dans l'Oeuvre de Gauguin," *Gazette des Beaux Arts,* XLVII, January-April, 1956, pp. 95−114.

Vente O'Conor, 1956: "Ateliers Roderic O'Conor et Renée Honta," Sales catalogue of the Hôtel Drouot, Paris, by M. Alph. Bellier, February 4 and 7, 1956.

Vente Sérusier: "Succession of H.Boutaric," Sales catalogue, Hôtel Drouot, Paris, by Ader, Picard, Tajan, June 19−20, 1984. (Mlle Boutaric inherited the Sérusier estate.)

Welsh-Ovcharov, Bogomila, *Vincent Van Gogh and the Birth of Cloisonism,* exhibition catalogue, Art Gallery of Ontario, Toronto, 1981.

W: Wildenstein, Georges and Cogniat, Raymond, *Gauguin, Catalogue,* Paris, 1964. (Catalogue raisonné of the paintings and pastels)

This work was designed by Jean-Pierre Castelli, Vevey, Switzerland
Printed by Bron S.A., Lausanne, Switzerland
Photolithography by P. Ducommun S.A., Ecublens, Switzerland

MADE IN SWITZERLAND